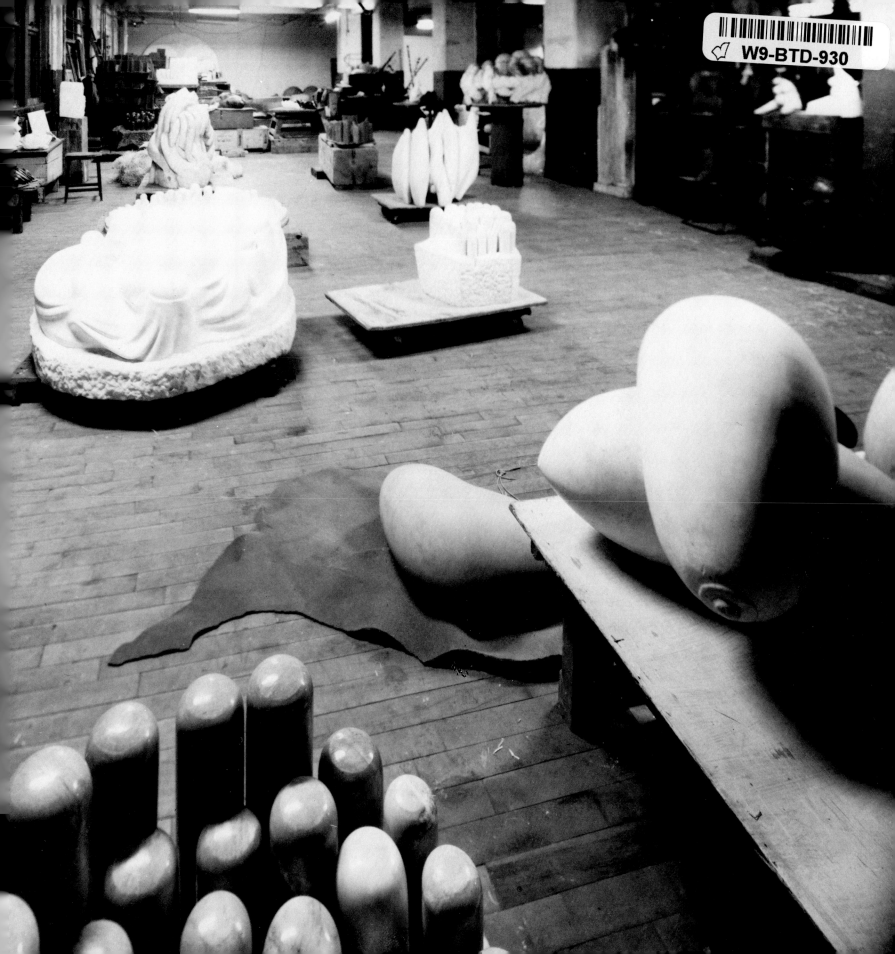

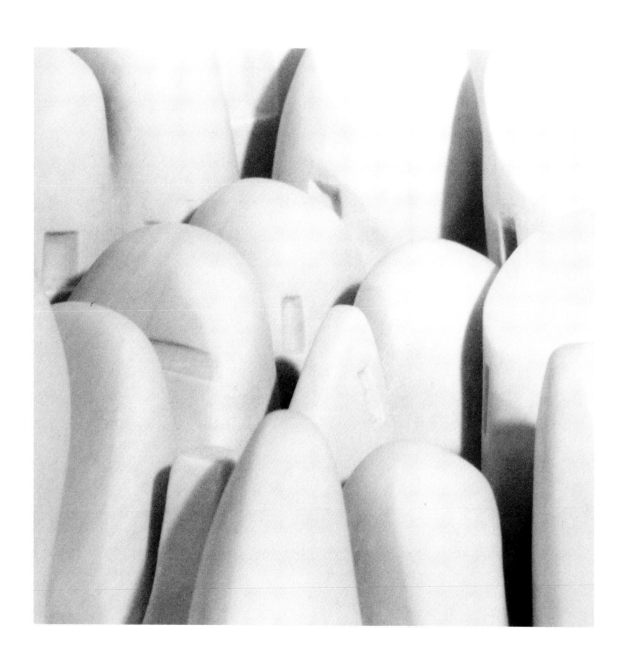

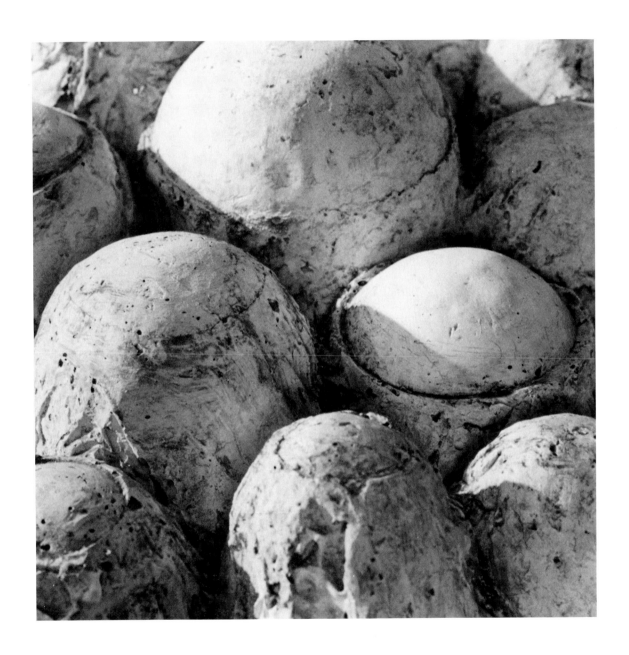

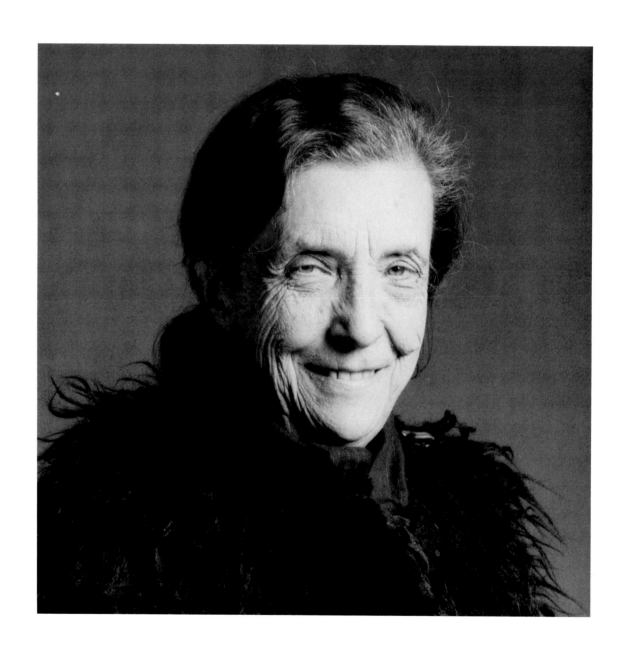

LOUISE BOURGEOIS

DEBORAH WYE THE MUSEUM OF MODERN ART, NEW YORK

LOUISE BOURGEOIS has been published on the occasion of a retrospective at The Museum of Modern Art, New York, November 3, 1982–February 8, 1983. The exhibition has been funded in part by a grant from the National Endowment for the Arts, Washington, D.C.

Designed by Keith Davis

Type set by Boro Typographers, New York
Printed by Eastern Press, New Haven, Connecticut

The Museum of Modern Art
11 West 53 Street
New York, New York 10019

Printed in the United States of America

Front cover: *Partial Recall,* detail. 1979. Painted wood, ca. 9′ x 7′ 6′′ x 66′′. Private collection, New York. Photograph by eeva-inkeri, New York

Back cover: Louise Bourgeois wearing a costume from the performance "A Banquet/ A Fashion Show of Body Parts." Photograph by Duane Michals, 1980. Courtesy *Vogue,* Copyright © 1980 by The Condé Nast Publications Inc.

Page 1. Brooklyn studio, April 1982

Page 2. *Eye to Eye,* detail. ca. 1970. Marble, 31½′′ high x 29⅞′′ diam. Private collection, New York. See pl. 125

Page 3. *Avenza Revisited,* detail. ca. 1972. Plaster and cement, 23½′′ high x 41′′ diam. Private collection, New York. See pl. 118

Frontispiece. Louise Bourgeois, 1982. Photograph by Robert Mapplethorpe

Page 10. Figures. ca. 1950s–1960s. Wood and plaster, each ca. 66′′ high. Private collection, New York. See pl. 69

Page 12. *Spiral Women,* detail. Early-mid-1950s. Painted wood and plaster, ca. 60′′ high. Private collection, New York. See pl. 70

ACKNOWLEDGMENTS

This book and the exhibition it accompanies are the result of my research on the work of Louise Bourgeois since early in 1977. At the time, the idea for a retrospective exhibition had not yet occurred. I first met Bourgeois when organizing a group exhibition at the Rose Art Museum, Brandeis University, and that occasion provoked a serious interest in her work. For providing that opportunity, my first debt of gratitude is owed to Carl I. Belz, Director of the Rose Art Museum. In addition, he deserves my thanks for his continuing support and encouragement and, in particular, his reading and criticism of the present essay. Next I must thank my former colleagues at the Fogg Art Museum, Harvard University, for their contribution to my continued research on Bourgeois. It was through the Fogg Museum that I received a year-long grant for museum professionals from the National Endowment for the Arts to pursue the study and documentation of her work. I would like to thank, in particular, Professor Konrad Oberhuber for his constant encouragement and, in addition, Professor Seymour Slive, Director, Ms. Suzannah Fabing, Deputy Director, and Ms. Marcia Coburn, former Business Associate, for their help. I also wish to thank Daniel Robbins, former Director, for his support. And the National Endowment for the Arts must be acknowledged for providing the resources to gather the material which was the foundation of this exhibition.

Here at The Museum of Modern Art, I am particularly grateful to William Rubin, Director of the Department of Painting and Sculpture, and his entire staff for their belief in this project and for giving me the opportunity to direct this exhibition in a department other than my own. For this opportunity, I must also thank Riva Castleman, Director of the Department of Prints and Illustrated Books, on whose staff I am Associate Curator. Miss Castleman has helped me throughout the many stages of this project, as have my other friends and colleagues in the Print Department, Audrey Isselbacher, Wendy Weitman, Ruth Friend, Marcie Gitlin, and Elinor Grasheim, who have shared my everyday concerns.

This project could not have been accomplished without the collaboration of Alicia Legg, Curator in the Department of Painting and Sculpture. Her wisdom, counsel, and good cheer have been overriding factors at every stage. Of the other members of the Museum staff, I would like to thank in particular Elise Sinatro, who filled in as exhibition assistant for several months. It was a pleasure to work with her. Diane Farynyk, Curatorial Assistant, has contributed greatly, from much appreciated help with the most modest tasks to creative handling of the most complicated ones. Susan Mason has helped in a variety of ways, as did Marianne Brunson Frisch in the early stages of the exhibition. Sharon McIntosh, Jane Sanders, and Ruth Priever also gave cheerful and much-needed assistance. Donald Steele deserves special thanks for his month-long service as manuscript typist. Janis Ekdahl, Assistant Director of the Library, made a substantial contribution to the bibliography. She gave my listing the professional polish it needed, added several new references, and provided a model for its final form. Her careful assistance, advice, and friendly support were much appreciated. Vlasta Odell of the Registrar's Office and Patricia Houlihan, Conservator of Sculpture, played very important roles in dealing directly with the works of art. Special thanks also go to Arthur Drexler for sharing with me his memories of Bourgeois's early sculpture and the exhibitions in which it appeared.

I wish to thank Richard L. Palmer, Coordinator of Exhibitions, and his Associate Coordinator, Caroline Jones, whose good advice on countless questions I sought almost daily. In addition, Jerome Neuner, Production Manager, deserves special credit for his helpful and imaginative suggestions for all aspects of the installation. Waldo Rasmussen, Director, and Elizabeth Streibert, Associate Director, of The International Program were responsible for all aspects of the international tour, as were Mr. Palmer and Ms. Jones for the domestic tour.

Christopher Holme of the Department of Publications oversaw many details of this publication. Jane Fluegel edited the manuscript with both patience and enthusiasm, and Keith Davis designed the book with sensitivity and originality. It was a very creative and enriching experience to work with them. Timothy McDonough and Susan Schoenfeld showed special care in all areas of the book's production, and Barbara Ross and Jean Foos were of special assistance.

On behalf of the Board of Trustees of The Museum of Modern Art, I would like to thank all the lenders to the exhibition, whose names appear on the following page.

Those who have worked closely with Bourgeois for a long time and who have helped immeasurably with the exhibition are Jerry Gorovoy and Mark Setteducati, whose familiarity with and belief in her work were of inestimable value throughout. Jean-Louis Bourgeois, the artist's son, has carefully read the manuscript and made suggestions, as well as provided general support. In addition, I would like to thank John Cheim and Robert Miller of the Robert Miller Gallery for help with innumerable questions. Also, special thanks go to Jill Wineberg, Margaret Parker, and Xavier Fourcade of Xavier Fourcade, Inc., for their help, especially in the early stages of my research, and to Patricia Hamilton and Jay Gorney of the Hamilton Gallery of Contemporary Art. The photographer Peter Moore deserves special mention because of his documentation of Bourgeois's work over many years. Both he and his wife, Barbara Moore, have been very helpful.

The most profound relationship in connection with this exhibition has of course been with Louise Bourgeois herself. These last five years of close association with her have been unforgettable for me. Her work, her life, and her friendship have deeply affected me. She has been a source of wonder and inspiration throughout.

Special personal thanks must go to my sister Pamela Wye for her steady support and encouragement, and specifically for her thoughtful and thorough reading of this manuscript. In addition, thanks go to my brother-in-law Jacques Roch for his personal support, and also his special help on questions pertaining to French art, language, and culture. And it is my husband, Paul Brown, who must receive the greatest thanks. He has shared every aspect of this project with me—both its problems and its thrills—and I am sure it has affected him deeply. It is to him that this catalog is dedicated.

Deborah Wye

LENDERS TO THE EXHIBITION

American Medical Association,
Washington, D.C.

Arthur Drexler, New York

Ella M. Foshay, New York

The Grenoble Collection of Mr. and Mrs.
Eugene P. Gorman, New York

Helen Herrick and Milton Brutten,
Philadelphia

John D. Kahlbetzer, Santa Barbara,
California

Mr. and Mrs. Oscar Kolin, New York

Lucy R. Lippard, New York

Jerry and Emily Spiegel, Kings Point,
New York

Several anonymous lenders

Greenville County Museum of Art,
Greenville, South Carolina

The Metropolitan Museum of Art,
New York

Museum of Art, Rhode Island School of
Design, Providence

Whitney Museum of American Art,
New York

CONTENTS

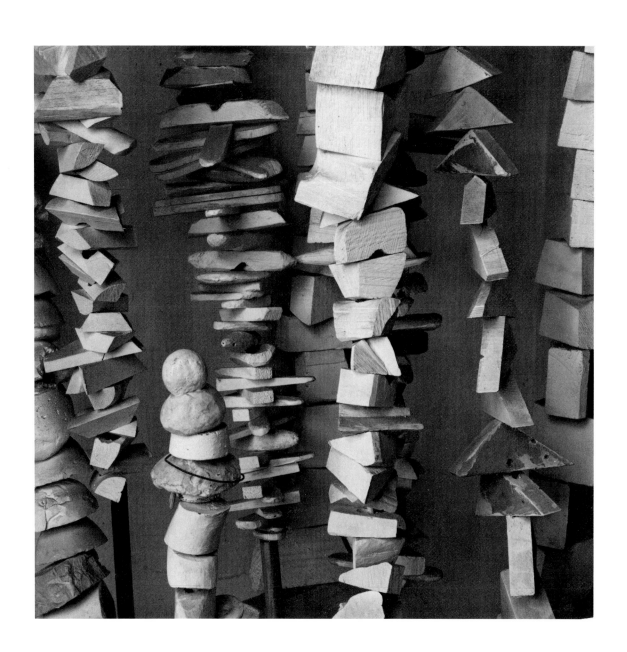

There are few studios one can visit these days so likely to produce in one feelings of such sheer exhilaration. In this pluralistic period, when collective taste suffers from wavering convictions and evanescent excitements, it is a source of immense pleasure and reassurance to confront Louise Bourgeois's sculpture. Her strongly etched artistic profile—which transcends the mutations in typologies and methodologies of her varied oeuvre—is felt in the consistency of her concerns and in the high order of her realization.

Today virtually everybody is a "loner," doing his or her own thing, largely because of the dearth of those towering figures whose work, in more normal, less transitional periods, acts as a magnet for lesser artists, arranging the artists' world into constellations and hierarchies. Louise Bourgeois is a loner of another order, whose bona fides goes back four decades to a period when maintaining a wholly individual profile in the face of Jackson Pollock, Willem de Kooning, David Smith, et alia involved an immense force of artistic and personal character.

Thus a kind of quiet inner heroism led Louise Bourgeois to observe the artistic developments of the times from close up, but to stand apart from them in her own work. As a Frenchwoman who emigrated to America in the late thirties, she knew the language of Surrealism well enough to perceive that, in sculpture, it had far from exploited its possibilities. The organic, biomorphic language of the abstract side of Surrealist art *wants* to be three-dimensional, wants materials of more organic allusiveness than paint. Louise Bourgeois understood this, and picked up where certain veins of Surrealist art had left off, rendering certain of its ideas viable in a new way.

In painting, the profound shift into abstraction that overtook many American artists between 1947 and 1950 constituted a break that put an end to the exploration of the biomorphic and organic: Arshile Gorky died, de Kooning literally tore the biomorphic to shreds in his 1948–49 black paintings, and William Baziotes commenced treading water. No such radical revolution took place in sculpture; it remained allusively figural, even in Smith's most abstract work, and determinedly organic in the work of Herbert Ferber and Seymour Lipton. The history of sculpture thus favored the flowering of an art based on the kind of allusive, psychic poetry Louise Bourgeois had made her own.

How much her own is made clear when we follow her development into images that pull further and further away from those of other artists even as they seem to reach deeper and deeper into her own psyche. The clustered small forms rising from the surface of their support in the Landscapes suggest societal groupings. The lumpish figure of the 1970 *Fragile Goddess* refers not to the ferocious Women of de Kooning but to the padded folds of the tiny Venus of Willendorf. The many breasted latex costumes draped on students and friends for a 1978 performance recall the cult image of Diana of Ephesus. By the force of her personality, Bourgeois continues to maintain her own distinctive vocabulary, avoiding the rhetoric of the times, creating works of great poetic and plastic resonance.

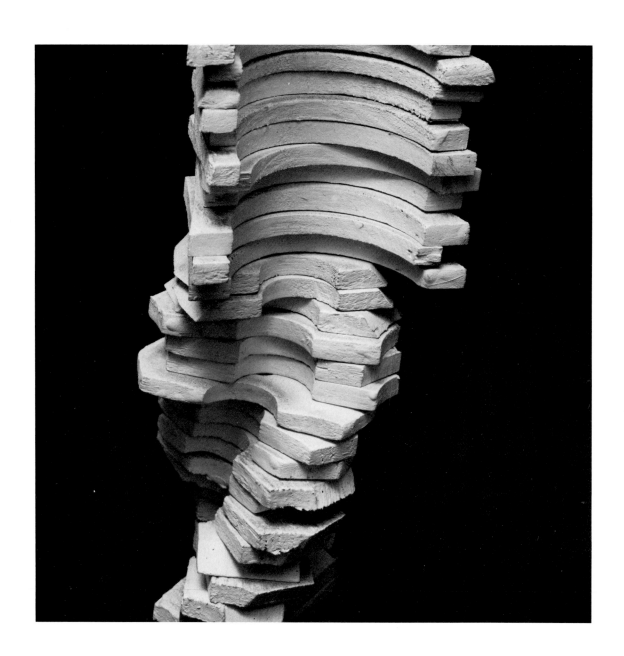

LOUISE BOURGEOIS: ''ONE AND OTHERS''

Louise Bourgeois is an artist of remarkable power and mystery. Her works invite private encounters that engender responses on both visceral and imaginary levels. They stir up previously unacknowledged feelings or force exploration of totally unfamiliar emotional terrain. They awaken the imagination to new realms and also tap memories of past experiences. From an object such as *Fragile Goddess* (pl. 108), which creates an intense experience of physical identification, to an environment such as *Confrontation* (pl. 137), which explores the mythic dimension of relationships, groups, and societal preoccupations, Bourgeois's forms and their content communicate strongly and directly.

Bourgeois's work is best understood when it is examined as a significant, singular entity, its distinctive features identified, and its essence revealed. This approach does not fall within the intellectual framework established by contemporary art history, which examines an individual artist's work as a link in the logical progression in the development of style. The independent course of Bourgeois's work, and its multiplicity of forms, limits the results of this traditional approach.

In 1981, Bourgeois turned seventy. She has been a New York artist for over forty years, and throughout those years, a participant in the movements and related activities that have made New York the art capital of the world. Yet she remained an outsider. For years, Bourgeois's work, rather than representing a current stylistic trend, has been a singular presence in the New York gallery scene. Her solo shows were infrequent and her work always eccentric, although of vivid expressive power. Hers was clearly a serious and unique vision, but one not easily placed in a context nor readily understood. In fact, after her debut as a sculptor in 1949, she had only four solo sculpture shows in New York in the next thirty years. By 1978, however, the artistic atmosphere had changed, and Bourgeois's individuality and intensity became widely appreciated. In the next three years, between 1978 and 1981, she had seven solo shows (including five in New York), some re-examining earlier periods of her work, others exploring recent developments.

The aesthetic milieu of the mid-to-late seventies did not foster any one trend or category in art. A looser, pluralistic atmosphere prevailed. Indeed, on a deeper level, the very basis of critical thinking about art was undergoing a change. The overriding emphasis on stylistic analysis, prevalent for so long, no longer satisfied the intellectual and emotional needs of the art public. Instead, personal content and deeply felt themes were sought and explored. Bourgeois's work spoke directly to these new needs, which welcomed stylistic diversity and deeply expressionist content.

Upon viewing Bourgeois's work as a whole, one realizes that undue emphasis on stylistic analysis would be inherently unrewarding. Encompassing abrupt changes in medium and form, it moves unexpectedly from rigid wood poles to amorphous plaster nests; from pliable masses to stiff protrusions in rubber and plastic; from bulbous bronze configurations hanging on hooks or cords to their reappearance in solid marble on sturdy bases; from a tiny four-inch fetish pincushion to a room-size environment. Such variety in material, shape, and size is outside our experience of the formal development of much contemporary art. It presents difficulties for the eye that seeks the representative work by an artist. And yet, although a vocabulary of shapes does emerge as being Bourgeois's alone, the more profound basis of her work can be found only by uncovering and tracing her personal themes and their unique examination of basic instincts, needs, and behavior.

Even in Bourgeois's early paintings, the humanistic thrust of her sensibility was evident. Fragments of women were depicted in imaginary and symbolic settings in an attempt to define a female reality. Similarly, in her early wood figures, works of fragility, simplicity, and singularity, she explored the plight of the solitary individual, isolated because of an inability to communicate. When these same wood pieces were arranged together in couples or in groups, they assumed tenuous, hesitant, yet dependent relationships. As her work developed, the same themes grew in complexity as she explored helplessness, fear, self-protection, nurturing, and sexuality, as well as anger, aggression, rage, and protest.

Bourgeois is articulate about the underlying psychological motivations for her art. In this regard, she is situated within the Surrealist tradition, which sees the exploration and expression of the unconscious as art's primary

aim (she also shares the Surrealists' literary and poetic predilections). The work of art serves a psychological function for Bourgeois, for she believes that making art is the process of giving tangible form to, and thus exorcising, the gripping, subconscious states of being that fill one with anxiety—a belief that places her in line with the Expressionist tradition, as well.

By fulfilling this function, Bourgeois's art achieves emotional intensity. She captures those exorcised feelings in her work and thereby animates it. The result, whether four inches in diameter or forty feet long, is sculpture with an inner force resembling magnetic powers. Her work has the kind of indwelling energy of an amulet with good-luck charms, an object with a hex on it, a chalice having a religious aura, or even a tombstone. Her sculpture radiates a vital spark that thoroughly absorbs the viewer, as if something inside the object were alive. This emanation rivets the viewer. Through a suggestiveness of form or resonance of representation, her sculpture conveys a quite specific experience—whether anxious, frightening, or repellent; poignant, humorous, or calming. Bourgeois's achievement of such potent emotional intensity within a wide range of inventive and meaningful images is ultimately the real mystery of her artistic powers.

THE EARLY YEARS

According to Bourgeois, the underlying motivations for her art lie in unresolved psychological conflicts originating in her childhood years in France rather than in the psychological fabric of her adult life.[1] These motivations stem primarily from what she believes to be the polarity created by a nurturing, calm, and clear-thinking mother, on the one hand, and a powerful, volatile, and anxiety-causing father, on the other; and from her place in this family between an older sister and younger brother. In this scheme of relationships, it is anxiety, pain, and anger, rather than harmony, equilibrium, and order, that have more often been the sources of art for Bourgeois.

Bourgeois's early memories include World War I, which broke out when she was two years old. Her father was in the army, and she remembers that her mother followed him to cities near his encampments so that brief family visits could be arranged. The young Louise was brought along to please her father, for she resembled him and was the favorite. In 1915 he was wounded and sent to a hospital in Chartres, where Louise also visited him. As a result, she shared with her parents the personal trauma of those war years, as well as the frightening sight of wounded soldiers.

Later, a tutor of English came into Bourgeois's family. This teacher caused serious tensions because of her eventual liaison with Louise's father, a very handsome and charming man. The complications inherent in that triangle are still a recurring source of anxiety and rage for Bourgeois, and she rids herself of them, she believes, through the creation of art. Such betrayals and primordial jealousies seem to constitute a convincing origin for the violence in a significant part of her oeuvre.

In recalling these childhood years during a recent public talk on her work, Bourgeois showed a great many slides made from old family snapshots.[2] Subjects included her father, of whom she spoke in a mixture of devoted and disparaging terms, and also the infamous English teacher, Sadie, whom she described at length. The random interspersing of these early family slides with those of her powerful sculptures made a vivid and unusual artistic statement.

On another occasion, when asked about the meaning of her 1974 environmental tableau, *The Destruction of the Father* (pl. 133), Bourgeois told a long and fantastic tale of her childhood dinner table. She described a burdensome and self-important father holding forth to his captive family audience night after night. She fantasized that finally the family pulled him onto the table, dismembered him, and devoured him! "After that, we felt better." Although Bourgeois told her tale with a certain glee and humor, the piece itself is frightening and ominous. She said: "This is an act of exasperation and justice...with *The Destruction of the Father* I wanted to relive and make other people relive that experience."[3]

Bourgeois's childhood memories of her mother evoke calm, order, and a sense of the respect in which she was held as the head of the family workshop for the restora-

tion of tapestries. (Bourgeois's parents had a tapestry gallery in Paris.) The world of nature, nurturing, and the profundity of maternal love belong to this end of the continuum of Bourgeois's artistic motivations. She remembers vividly being held closely by her mother and being comforted by her. She describes one of her "chances in life" as stemming from the fact that her mother loved her: "...I felt that what I represented was the true naked body of the child with the mother. I can still feel her body and her love."[4] These experiences of maternal love and protectiveness are the underlying sources of such pieces as the nestlike Lair series of the early sixties and the depictions of the pregnant woman (vulnerable in her great responsibility) at various points throughout her oeuvre.

Bourgeois loved her school years at the Lycée Fénelon in Paris, and was a very good student. The most significant factor of those years in relation to her artistic development was her study of mathematics, especially geometry. The manipulations of shapes in this branch of mathematics, which deals with solids, surfaces, lines, and angles, helped her visualize order and rationality. Its eternal and reliable rules signified stability and harmony. She has said: "I got peace of mind only through study of rules that nobody could change, that were safe."[5] After the Lycée, she pursued the study of mathematics and philosophy at the Sorbonne. She often links an early interest in the three-dimensionality of geometry to her later evolution as a sculptor. Of course much came between that school experience with mathematics and her serious development as an artist, but the fact that she recognizes a symbolic and psychological link between the two is significant. She related the principles of mathematics to her understanding of herself and the world. She responded to the fact that it could serve a philosophical and psychological function for her. She would later be drawn to sculpture because of its similar ability to serve such a function.

Bourgeois eventually left to pursue the study of art. This was not a surprising choice given her family's interest in the arts. Bourgeois had in fact first demonstrated her abilities as a draftsman in the family workshop where,

in her early teens, she helped in the restoration of tapestries by drawing in torn and missing segments of the designs. From 1934 to 1938, she studied at several art schools and ateliers, including the Ecole des Beaux-Arts, the Académie Ranson, the Académie Julian, and the Académie de la Grande-Chaumière, where she came in contact with such artists as Fernand Léger, Yves Brayer, Roger Bissière, André Lhote, Othon Friesz, and Robert Wlérick. She absorbed a Cubist-based abstractionist style, and was influenced by the Art Deco manner, as in the posters of A. M. Cassandre and Paul Colin. She actually studied for a time with Colin. She enjoyed the free, independent atmosphere in the ateliers and the international group of students she met there.

In 1938, Bourgeois met and married an American professor, and moved permanently to the United States. Although she was married for over thirty years and raised three sons, she strongly separates this adult experience from what she believes are the underlying motivations for her art.

THE FORTIES

The period from 1938 to 1945 marks Bourgeois's transition from student to exhibiting artist. Almost immediately upon her arrival in the United States, she enrolled at the Art Students League to continue her studies. These classes provided continuity with her life as an art student in France and a stability that helped her adjust to her new home. She studied under Vaclav Vytlacil, who recognized her shyness and whom she remembers fondly for his personal encouragement as well as his thorough instruction in the formal aspects of painting. Despite her primary involvement with psychological motivation, Bourgeois considers her background in formal issues indispensable. As she once observed: "I seek formal perfection, that goes without saying."

Bourgeois's artistic focus during these early years was on painting, printmaking, and drawing. Compositionally, her first works exhibited the geometricized format of a relaxed Cubism and a stylized line drawing that stems from Purism of the twenties. She often depicted figures

in interiors, with the outlines of walls and furnishings serving as the basis for a geometric surface design. In addition, she made symbolic references to her move from France to the United States. In a greeting card from December 1938, just months after her arrival, Bourgeois depicted the ocean, a ship, the Statue of Liberty, and a skyscraper with the familiar system of intersecting shallow planes and a patterning of lights and darks that contributed to an overall symbolic tone. Reminders of the home she left in France are also seen in a group of paintings she refers to as "nostalgia pictures." For example, *Reparation* (pl. 7) represents the young Louise bringing flowers to her grandmother's grave in Clamart. In other prints and drawings of the period, we see rivers and towns suggestive of France rather than New York.

In the early forties, Bourgeois set about making prints at home. (Her printmaking activities would culminate in the mid-to-late forties with her work at Atelier 17 in New York.) In the early years, she worked quietly on metal plates at the corner of the family table, as children came and went in the apartment. Later, she brought the plates to the Art Students League for printing. She remembers being especially pleased and proud when these early prints were accepted for competitive exhibitions. As early as 1939 she showed them at The Brooklyn Museum, and during the forties she exhibited there again, as well as at the Library of Congress in Washington, D.C., and at the Philadelphia Print Club.

Stylistically, by 1944 and 1945 a grid scheme began to dominate the compositions of Bourgeois's paintings. She relates her use of this surface structure to her early family connection with tapestries and the delineation of their weave. In fact, her continued interest in tapestries was demonstrated when she entered six pieces in the 1945 exhibition "Textile Design" at The Museum of Modern Art. In addition to being the structural basis of weaving, the grid system was for Bourgeois an outgrowth of her training in Cubist abstraction, and was generally an important formal concern of painting in the mid-forties.

Natural History (pl. 6) and *Connecticutiana* (pl. 5) are two paintings that demonstrate her use of this sophisti-

cated formal structure in conjunction with a symbolic orientation to subject matter. Bourgeois describes *Natural History* as the portrayal of procreation in the plant world. She means to universalize the elements to signify both individual personal identity and general human completeness. *Connecticutiana* represents the peaceful accord in the animal world of the Connecticut countryside, and the strict grid arrangement serves to symbolically perpetuate this state of being.[6]

Twelve paintings, primarily in the symbolic grid style, comprised Bourgeois's first solo show, held at the Bertha Schaefer Gallery, New York, in 1945. One reviewer said:

> Keynoting the exhibition is the painting, *Natural History,* whose wide surface is divided into three segments. Against a glowing rust background...are deep harmonies embodied in growing tree and leaf designs. Here, as in many of the companion pictures, Americana inspiration is coupled with that of classic tapestry making....[7]

Given the nature of her paintings at the time, it is not surprising that Bourgeois took part in numerous group shows with artists of her generation who would later be known as Abstract Expressionists: for instance, William Baziotes, Adolph Gottlieb, Willem de Kooning, Robert Motherwell, Jackson Pollock, Mark Rothko, and Bradley Walker Tomlin. Artistic concerns that involved balancing the formal issues of abstraction with the depiction of symbolic subject matter were in the forefront during the formative years of Abstract Expressionism, and Bourgeois shared these concerns. One of the most significant of these group exhibitions defining the early currents of this trend was the 1945 show "Personal Statement: Painting Prophecy 1950," organized by David Porter for his gallery in Washington, D.C. Porter brought these painters together in an attempt to identify what he considered the most significant impulse in the art of the day. (His subtitle, "Painting Prophecy 1950," underlined the fact that he believed this direction would be the dominant one in five years.) Calling this phenomenon "personal symbolism," Porter pointed to "evidence of an unique blending of...Romantic and Abstract painting." It was the "union of a highly poetic and personal art with a kind of painting which has for many years been expressed by inventions in pure line, form and color...."[8]

This period of artistic ferment occurred at the height of the war years. The "Personal Statement" catalog acknowledged its effect when Porter suggested that painters were "forming a new set of painting ideologies...for which the war has been a catalytic agent."[9] Bourgeois, who had only recently moved to the United States, was, of course, involved and concerned, especially about her home in France. Tangible evidence of this concern is seen in an unusual exhibition she organized at the Norlyst Gallery in 1945 called "Documents France 1940–1944: Art-Literature-Press of the French Underground." She assembled posters, photographs, newspapers, tracts, periodicals, letters, and other documentation, as well as paintings by Pablo Picasso and Pierre Bonnard, poetry and prose by Louis Aragon, Jean-Paul Sartre, André Gide, Gertrude Stein, and others. The undertaking was meant as a demonstration of solidarity with French intellectuals and certainly was a distinctive and concerned gesture by the young French-born Bourgeois.

Later in the decade, Bourgeois's painting began to move toward a more personal, quasi-figurative imagery, with an underlying spirit of Surrealism. One might expect that Bourgeois would already have been influenced by the Surrealists during her student years in Paris. In fact, she was then absorbed in an abstractionist style relying on Cubism. Her work only began to exhibit Surrealist principles in New York in the forties, when she, like other members of the first-generation New York School, responded to the incredible influx of Surrealist artists from war-torn Europe. It is a misconception to consider Bourgeois as one of the group of celebrated European Surrealists in exile. In fact, she was in step with American artists who for a brief moment at mid-decade were wedding certain Surrealist principles, such as the exploration of subconscious subject matter, to abstract structural tenets.

In the next few years, Surrealism would serve as a springboard for many of these artists in achieving mature personal styles. The future Abstract Expressionists, for example, chose to make use of one aspect of Surrealism; Bourgeois chose a different one. Through emphasis on the technique of automatism, most New York School painters moved in the direction of a pure abstraction involving large format, allover composition, atmospheric fields, and sublime and mystical content. Bourgeois, in contrast, moved toward a greater psychological literalness through representational work of a symbolic nature. In contrast to her early use of geometric abstraction as a symbolic means of expressing calm and order, she now began to acknowledge her affinity with Surrealism, which stressed the exploration of subconscious reality. In effect, Surrealism encouraged her to tap the complex texture of her personal life as a source for art.

By the time of her second solo show, at the Norlyst Gallery in 1947, Bourgeois's subconscious personal motivations had begun to emerge fully in her imagery. Interpreting this imagery in the generalized terms of urban alienation, Nemecio Antunez poetically writes in his statement on the exhibition announcement: "These are paintings of a city dweller...brown stone houses and jails ...the bee sleeps in the dark and her domain is the sky. In her reduced geometrical space a cruel and blind life goes on..."[10] Another reviewer at the time pointed out the paintings' feminist aspects: "Hers is a world of women. Blithely they emerge from chimneys, or, terrified, they watch from their beds as curtains fly from a nightmare window. A whole family of females proves their domesticity by having houses for heads."[11]

The *Femme-Maison* (Woman House) paintings (pls. 9–12), those portrayals of women with houses perched on their bodies in place of heads, are among Bourgeois's most powerful images. They are also symbols, moving in thematic directions that will preoccupy her throughout her career. In them, a woman's most obvious sign of identity, her face, has been replaced by a house. The implication is devastating. Domesticity becomes the very definition of these women, since they have no other means by which to speak. They are prisoners of the house and also hide behind its facade, thereby both denying and defining their female identity through this challenge to, as well as determination of, their wholeness. In addition, Bourgeois establishes her thematic relationship to house, building, home, and shelter. Anthropomorphized architecture will recur again and again as she delves into the

romantic and symbolic dimensions of dwellings. Most fundamentally, with these paintings, Bourgeois characterizes the self, wherein outer appearance is transformed by inner perception. The *Femme-Maison* is truly a felt image of the self and thus, for Bourgeois, a perceived and felt depiction of reality.

The generally feminist dimension of this early imagery was recognized thirty years later. A *Femme-Maison* (pl. 9) was used on the cover of a book of essays by Lucy Lippard on women and art in 1976,[12] and, again, on the poster for an exhibition of women in architecture in 1977.[13] In addition, the strength and viability of the underlying concept were dramatized in an ambitious undertaking by a California women's art collective called, interestingly, "The Womanhouse." This project involved taking over an actual building and using its rooms as an exhibition place for specific aspects of feminist art.[14]

In other paintings of the late forties, Bourgeois continued to explore symbolic figuration, sometimes situating presences in roomlike or architectural settings (*Abstract Figure*, pl. 16), sometimes simply depicting empty architectural environments (pl. 17). These pictures are charged with implications of secret, somewhat allegorical meanings, and their formal organization exhibits the ease and inevitability of a maturing artist in the grip of a private momentum.

Bourgeois's last paintings came during the final years of the forties. In some, she made specific allusions to sculptural concerns, as in *Red Room* (pl. 15). In others, such as *Roof Song* (pl. 21), she incorporated sculptural presences into her now familiar symbolic imagery. In *He Disappeared into Complete Silence* (pls. 29-37), a suite of prints engraved at Atelier 17, sculptural implications are also evident. This small portfolio represents Bourgeois's most ambitious undertaking in printmaking. Together with their enigmatic accompanying parables, they demonstrate Bourgeois's symbolic intentions in this period. In his introduction to the portfolio, Marius Bewley describes them in this way:

> They are all tiny tragedies of human frustration: at the outset someone is happy in the anticipation of an event or in the possession of something pleasing. In the end, his own happiness is destroyed either when he seeks to communicate it, or, perversely, seeks to deny the neces-

sity for communication. The protagonists are miserable because they can neither escape the isolation which has become a condition of their own identities, nor yet accept it as wholly natural.[15]

Until her debut as a sculptor in late 1949, the art public was unaware that Bourgeois had begun to work in a new medium. She felt inhibited by painting and remembers wanting to free herself from the limitations of two dimensions. She was "not satisfied with its level of reality."[16] Painting, by its very definition, was an abstraction. Considering her increasing desire to convey the intensity of symbolic meaning as directly, and thus specifically, as possible, it is not surprising that Bourgeois explored the possibilities of the three-dimensional medium, with its greater level of substantiality and physical impact. Bourgeois refers to her experiments with sculpture as having "fantastic reality."[17] This statement is indicative of her need for concreteness in the portrayal of her underlying meanings. Her sensibility required a physical tangibility that would rival the vividness of the feelings she was attempting to express. She has said: "I could express much deeper things in three dimensions."

About 1947 Bourgeois began making her sculptures in earnest, although she remembers being involved with wood carving as the background to her painting activities for much of the forties. By 1950, she had made over thirty sculptures and had achieved a wide range of mood through an increasing formal sophistication.

In her first solo sculpture show at the Peridot Gallery in October 1949 (pls. 40, 41), Bourgeois exhibited seventeen pieces that were, for the most part, simple, elemental upright poles and beams.[18] At the time, they were referred to by some critics as "spare" and "starkly simplified,"[19] or as "planks,"[20] and "rough-hewn wooden forms."[21] But they were also seen as "introspective personages"[22] with a range of expressive dispositions. One reviewer commented: "Although the human form is reduced to elemental terms in these works, great variety of mood and gesture is conveyed by subtle changes in contour and slight inclinations of the body."[23]

These figural personages show Bourgeois at an early stage of a new visual language, revealing a powerful,

sometimes brutal, evocation of feeling. At times, her rudimentary posts evoke something akin to a primordial utterance. At other times, they attempt to capture distinct individuals or personalities. Although some of Bourgeois's original titles have been lost, changed, or transformed in the intervening years, others have remained the same. The titles listed on the announcement have the same particularity and directness of mood, person, or place as the pieces themselves: *Friendly Evidence, Persistent Antagonism, Portrait of C.Y., The Tomb of a Young Person, Captain's Walk on Irving Place Building,* and *New York City Doorway with Pillars.*

Among the most simplified and abstracted of the sculptures from this first show is *Dagger Child* (pl. 46), as it is known today. Its figural dimension is recognized only when it is placed in the company of other pieces. Alone, the podlike, layered pole has a crude and brutish strength as it stands, enigmatically, in rigid immobility. At the opposite extreme of Bourgeois's range of expression in this early exhibition is *Observer* (pl. 44), with its hat firmly in place and its clearly defined arms hanging at its sides. The clearly figural quality of *Observer* lends a human aura to its companions. *Portrait of C.Y.* (pl. 45), on the other hand, becomes a particular subject only when we know its title. Its squared-off, rodlike appearance is humanized only by the tiny cutout at the height of a face. Its identity as a fetish object, revealed by nails aggressively piercing it, is unmistakable. *Portrait of Jean-Louis* (pl. 48) is a telling example of the greater concreteness Bourgeois achieved in her shift from painting to sculpture. It uses the anthropomorphized architectural imagery recognizable from the *Femme-Maison* paintings (pls. 9–12), done about the same time, with an upper body, balanced on thin legs, forming a skyscraper. Bourgeois has said that these early pieces "had nothing to do with sculpture, they meant physical presences. That was an attempt at not only re-creating the past, but controlling it."[24]

In October of 1949, the same month as her sculptural debut at the Peridot Gallery, a painting by Bourgeois was reproduced in *The Tiger's Eye,* the prestigious art and literary magazine published in New York. The title of that painting, *Woman Placing a Beam in a Bag,* reflected Bourgeois's present concerns as a working sculptor.

Bourgeois's concept of sculpture pertains to the vivid clarity of her emotions and the need for concreteness in their release. These qualities, and how she incorporates them into her artistic process, are the primary factors linking her method to the primitive. For Bourgeois a plank of wood can, on some level, be identified as a replacement for a specific person rather than as a symbol of that person. The impulse to work on this level of transference and embodiment is her link to the primitive world. After the initial primitive impulse of the wood figures, however, her growing involvement with sculpture's formal components seemed to distance her somewhat from total identification with subject. This development can be seen as the wood pieces evolved. The process of formal refinement and elaboration within the vocabulary of Western art separates her from the primitive. In addition, Bourgeois's sculptures differ from the primitive in that they issue from an individual mythology and have personal meanings, whereas objects of tribal cultures are most often made by skilled artisans using an established system of forms agreed upon over generations as having precise meanings for the society as a whole.

Although this process of primitive identification and subsequent aesthetic refinement is most clearly evident in the development of Bourgeois's early wood sculptures, I would suggest that it might also be uncovered in the development of her subsequent imagery. The relationship within her work of primitive and intuitive impulses, in combination with our recognizable visual language, is a complex and intriguing question.

Bourgeois's second exhibition at the Peridot Gallery in 1950 (pls. 42, 43) brought together fifteen more figural wood sculptures. By then, Bourgeois's familiarity with the new language of forms had led her toward greater stylistic inventiveness. Greater psychological detachment allowed for more experimentation, and resulted in a sophistication of handling in details. Sometimes color and drawing were added to surfaces. There was greater complexity in attached elements and in overall silhouettes. She also incorporated laminated woods. Among the works included, *Spring* (a present-day title; pl. 39) has a stylized, tuliplike head; *Pillar* (pl. 57) has a skirt fashioned as a fluted col-

umn, and *Breasted Woman* (pl. 56) has bulbous protrusions flowing down the front of its body and an elongated carved head attached at a slight tilt. These details go much further than the simple niches and cutouts that predominated in the earlier show. As one reviewer observed:

> Handsomely installed, these vertical and suggestively carved and painted skeletal objects seem to stalk about the room like gigantic matchsticks. These have long been her basic shapes and if this year's group seems the best so far it is because she has decorated them somewhat, thus adding the right to their being recognized as ideographic sculpture.[25]

Bourgeois has said that the figures became more "articulated" in their structure and more "articulate" in their meanings. They went "from crude to nuanced." Rather than the specific moods, portraits, and places that were reflected in the titles from the first Peridot show, those on her second announcement indicate the conceptual complexity of daily actions, such as: *Figure Who Brings Bread, Figure Gazing at a House, Figure Leaving the House.* I imagine these to be self-portraits of the artist defined by her daily routine. In addition, a psychological level is indicated by such titles as *Figures Who Talk to Each Other without Seeing Each Other.*

An important aspect of both early Peridot shows was Bourgeois's installation of the sculptures. The arrangement signified her relationship to the pieces and added to their meaning as figural presences. The sculptures filled the gallery as people might, scattered about, alone or in couples. "The figures were," Bourgeois says, "presences which needed the room, the six sides of the cube....It was the reconstruction of the past."[26] Upon entering the exhibition, the viewer literally entered the world of the artist. These symbolic installations represented some of the earliest attempts at exploring the environmental possibilities of sculptural space. As one observer aptly noted: "These simply carved wood figures are inhabitants of a private world through which the sculptor has attempted to express a conception of human relationships as well as of spatial relations."[27]

Yet, the concept of creating a sculptural environment did not find immediate acceptance, as is attested to in one reviewer's comment (in an otherwise favorable notice):

"Complete works of art must stand alone and do not necessitate a stage setting to compliment them..."[28] From a later perspective, however, critic Rosalind Krauss understood the historical significance of Bourgeois's presentations and made this observation:

> There the empty gallery was understoood to function as a room that was rhythmically punctuated by polelike sculptures which would create "an environment of abstract personnages." Interested not only in the individual pieces but in the space as a whole, Bourgeois imagined it as a kind of ritualized atmosphere through which she could "summon all of the people I missed. I was not interested in details; I was interested in their physical presence. It was some kind of an encounter." And the nature of this encounter was that kind of projection of the Unconscious onto the space of the real that formed the model of surreality.[29]

Although Bourgeois's involvement with sculpture eventually led her to give up painting entirely, she continued to draw (and has up to the present day). These drawings do not employ the kind of specific imagery seen in her final paintings. While some make reference to sculptural formations, many are amorphous and only vaguely defined. They come from what Bourgeois describes as a "necessity," a kind of "compulsion," a need to represent "the void of anxiety."[30] Executed mainly in India ink (pls. 22–28), they often use repetitive, undulating curves and suggest landscapes or organic, evocative atmospheres. Bourgeois explains that terrain was often expressed in such curves in seventeenth-century tapestries. "That is a satisfying expression of land for me." Other drawings allude to skeins or shuttles, which she believes derive from her childhood association with wools and yarns in the tapestry workshop. Some skeins are immersed in overall formless atmospheres (pl. 65), but others are clearly indicated, dangling from lines (pl. 24) or taking on nestlike, pendulous contours (pl. 80).

THE FIFTIES

In the first years of the fifties, Bourgeois confirmed her new identity as a sculptor within the art world at large. In 1951, for the first time, she exhibited a sculpture in the Annual of the Whitney Museum of American Art, having

shown paintings and drawings there throughout the second half of the forties. Also in that year, Erick Hawkins invited her to design the sets for his dance, "The Bridegroom of the Moon," performed the following January. Earlier, in April of 1950, she took part in the now historic three-day "Artists' Session" at Studio 35 on Eighth Street. These discussions on aesthetic issues of the day brought together twenty-six artists, including Baziotes, Gottlieb, Peter Grippe, David Hare, Hans Hofmann, de Kooning, Ibram Lassaw, Seymour Lipton, Motherwell, Barnett Newman, and David Smith. Transcripts of these sessions were later published by Robert Motherwell and Ad Reinhardt in *Modern Artists in America* (1951), which also included an illustration of Bourgeois's 1949 sculpture exhibition as part of a pictorial review of the current season.

In May 1950, Bourgeois was one of ten sculptors who joined eighteen painters (mainly from the group listed above) in protest against an upcoming painting exhibition at The Metropolitan Museum of Art, which was thought by advanced artists to be conservative. This event later grew in fame because of a photograph in *Life Magazine* of fifteen of these painters, referring to them as "The Irascibles."[31]

Such events as the "Artists' Session" and the "Irascibles" protest letter were activities that demonstrated the growing self-consciousness of this generation of artists, whose work would prove so significant in contemporary art history and who would come to be known as the New York School. The remainder of the fifties would be defined by the ramifications of this artistic self-awareness among New York artists.

In 1953, Bourgeois's third solo show at the Peridot Gallery featured a large group of India ink drawings and two or three sculptures. One critic described the evocative variety of the drawings in the following way:

> One group of drawings suggests masses of wavy hair, cross sectional diagrams of rock strata, the rolling movement of a heavy sea. Another group might be of intertwined corn husks, or of muscles and sinews.... But the drawings most closely related to Miss Bourgeois's sculpture are of large black free-standing shapes which resemble Indian clubs, bananas, or ears of corn.[32]

In addition to one or two wood figures similar to those

in her 1949 and 1950 shows, Bourgeois exhibited a work embodying an entirely new sculptural concept. *Forêt* (also known as *Night Garden*; pl. 63) demonstrated the continuing process of refinement and elaboration that would characterize Bourgeois's formal and thematic development in wood sculptures in the fifties. A growing fluency with her vocabulary of wood forms allowed Bourgeois greater structural as well as thematic complexity. Whereas earlier on, "rough planks,"[33] poles, and "up-ended clubs or oars"[34] poignantly, and sometimes brutally, expressed personal isolation (and its resulting pain and loneliness), in her radically new piece, *Forêt,* Bourgeois crowded a large assemblage of unusual and subtly shaped elements together on a single base, suggesting a primordial grouping of plants. Its placement almost directly on the floor enhanced its interpretation as a growth emerging from the ground. The black coloring heightened its air of strangeness and mystery. One reviewer observed: "it is a forest, a garden, a grouping of separate forms.... Fruit-like, pod-like, seed-like, slowly twisting, round, flat, incised or smooth, these black forms constitute the vocabulary of a sensibility. They speak a private poem of restraint and seclusion."[35]

The formations in *Forêt* resembling sprouting seeds and pods, and the formal structure of the piece, are further explored in Bourgeois's *One and Others* of 1955 (pl. 66). With its colorful, separate spools, this piece looks like a garden or a bouquet. Yet, viewed from certain angles, it takes on the form of a single flower whose blooming petals create an organic symbol of health and burgeoning fecundity. The title, however, brings the sculpture back to the human world, suggesting individuals of various sizes and shapes huddling in mutual support and interdependence. *One and Others* is, simultaneously, an expression of individuality and of communication and relationships. A consideration of the individual, the group, and the correspondence between all living things is a foundation of meaning throughout Bourgeois's sculpture.

Since her introduction in the fifties of clustering and crowding elements set on a base, Bourgeois has persistently used this form as a visual counterpart or symbol for the interactions of groups. This arrangement resembles

a small stage whereupon fragments, carefully spaced, serve as actors performing a drama. Bourgeois's imagination is often played out in these small tableaux. In this regard, *Forêt* and *One and Others* can be understood either as tiny dramatic scenes or as discrete sculptural objects with distinctive overall outlines. Bourgeois continues to explore this sculptural concept, from small enactments of object-size, such as these two, to room-size enactments (in the seventies) taking on the proportions of environments and sometimes seeming like actual stage settings (pl. 137). With this formal course, she exploits aesthetic issues of objectness as well as theatricality.

Bourgeois's Quarantania sculptures demonstrate her further use of the tableau format in the fifties. Assembled initially in the early and middle part of the decade, the Quarantanias have often undergone transformation in ensuing years. They are made primarily of life-size wood personages that had once stood alone or in uncertain couplings. Now they are members of families, with parts maintaining separate identities while also being bonded in relationships. *Quarantania, I* (pl. 61) incorporates *Woman with Packages,* initially seen alone in Bourgeois's 1949 Peridot show, now proudly at the center of a whole collection of personages. As Bourgeois pointed out in the fifties: "My work grows from the duel between the isolated individual and the shared awareness of the group. At first I made single figures without any freedom at all. …now I see my work as groups of objects relating to each other.…But there is still the feeling with which I began—the drama of one among many."[36]

The fifties witnessed a second direction in the development of Bourgeois's wood sculpture: evolution in the construction of the single wood figures. Again, changes in Bourgeois's vocabulary of forms are linked to her attempts to achieve greater subtlety of meaning. *Memling Dawn,* 1951 (pl. 67), is a columnar piece of human scale to which Bourgeois related in figural terms, as she had to her earlier monoliths. Made from separate black wood squares piled on top of each other and held together by a central rod, *Memling Dawn,* with its movable elements positioned slightly askew, stands ready "to protect itself" from all sides. According to Bourgeois, the separate sec-

tions function as antennae, giving the piece an internal "radar" and thus a seeming sensitivity to its surroundings. Through this means, Bourgeois has modified her inflexible monolith toward a greater expressiveness. *Memling Dawn* constitutes an intermediary step between the absolutely rigid monolith structure of the earliest wood figures and the potential agility and responsiveness of the segmented pieces that follow.

Femme Volage (Fickle Woman; pl. 68), also made up of unconnected wood elements strung together on a single central rod, comes later, and creates, in Bourgeois's view, an utter contrast to the strength and solidity of *Memling Dawn.* She refers to a "sexual polarity" when these two pieces are mentioned. After comparing the graceful, extravagant, and fanciful silhouette of *Femme Volage* and the guarded, self-protective solidity of *Memling Dawn,* the polarity is clear. In fact, *Femme Volage,* with its pronounced freedom and sensitivity to movement, is a rarity in Bourgeois's repertoire. In contrast to her usual evocations of frightened inwardness and self-protection, Bourgeois's *Femme Volage* gives an impression of flightiness, gaiety, and even a slight recklessness.

Bourgeois continued to make flexible, segmented, standing figural sculptures in various sizes and materials throughout the fifties and, in fact, from time to time right up to the eighties, frequently combining and recombining elements from existing pieces (pls. 69–72). Her most recent work in this idiom makes use of audaciously shaped and colored fragments of wood, as she continually explores greater expressiveness and what she believes to be "the emotional responsiveness of the separate but interlocking parts." Some of these additive pieces bend and sway in a motion reminiscent of the tilt of a flowering forsythia branch. When seen in clumps, these works, spanning almost thirty years, create an image of dense growth and spontaneity.

With her developing vocabulary of sculptural forms, solo exhibitions, and other art-world activities, Bourgeois would seem to have been very much a part of the growing excitement in the New York art community during the early part of the fifties. I believe, however, that the deeply personal nature of her mature sculpture set her at a

distance from the artistic trends and surrounding "art scene" of the decade. The creation of her sculpture demanded solitude, isolation, an atmosphere that would allow subconscious motivations to come to the surface, to be exorcized through containment in appropriately satisfying forms. This process, and the work that resulted, set Bourgeois apart and defined her as a loner in the art world.

As the fifties wore on, the initial impulse that had brought fame to New York art began to attract an accompanying scene. The art produced was often repetitive and mannered. In painting, there developed the "Tenth Street Touch," so called because of the sameness of so many canvases and the area in New York where many art-world activities took place. In sculpture, a comparable academicized mode of welded-steel construction was spawned. Business in contemporary American art also began to flourish, with the resultant packaging of certain "looks." Work of a personal or idiosyncratic nature had difficulty imposing itself in this climate. It is not surprising, then, that as early as 1954 Bourgeois was mentioned as one of "10 Artists in the Margin" in a *Design Quarterly* essay by Belle Krasne, who described the margin as "outside the mainstream but...where the new impulses arise as movements stiffen into academies." Bourgeois was one of those who: "Unassuming, unassimilable,...pursue their private aims....[She was one of] those artists who have found—and persisted in exploring—personal directions outside the 'movements' of modern art."[37]

Eleven years would separate Bourgeois's solo shows in New York. After the 1953 show at the Peridot Gallery, there was no other until 1964 at the Stable Gallery. She did, however, take part in numerous group shows, meetings, and panels throughout the fifties. She remembers enjoying most the very large group shows, such as the Stable Gallery Annuals, where one could see the work of dozens of artists together. So, as idiosyncratic and out of the mainstream as Bourgeois's work was, it remained a presence in the midst of the decade's activities at the prominent galleries, in the shows of the American Abstract Artists and the Federation of Modern Painters and Sculptors, and in the Whitney Annuals from 1953 to 1957.

THE SIXTIES

The transition in Bourgeois's formal development from the fifties to the sixties was quite abrupt, although her thematic content continued to involve similar investigations of psychological and symbolic meaning. This entire decade represented a time of wide experimentation for Bourgeois, leading to a staggering variety in her work. Then in her fifties, she revealed a new maturity. The rather shy, timid, isolated, and even repressed artist of the earlier years gave way to one more confident and willing to explore a whole range of areas she might not have dared to earlier. She experimented with plaster, cement, rubber latex, and plastics, as well as marble and bronze, creating a multitude of shapes and images that defy easy categorization or systematic stylistic analysis. She has said, generally, of her relationship to this variety of materials:

> The wish to say someting antedates the material....When you want to say something, you consider saying it in different ways, just as a composer would play in different keys, or different instruments. Little by little, and generally by a process of elimination...I find the medium that suits me. Sometimes the same idea or subject appears in several different media.[38]

Bourgeois's imagery of this period was equally varied and reflected a deepening complexity in her interpretations of the basic themes she began with—the self and others. In addition, it demonstrated her use of forms and concepts in different contexts. Throughout the sixties shapes appeared, disappeared, and reappeared, sometimes intact, sometimes transformed and barely distinguishable. And this approach continued into the seventies and eighties. Themes that emerged within the varied vocabulary of the sixties cover a wide range and include: woman and self-image; pregnant woman; human body shaped as weapon; human body in relation to nature; body parts as isolated shapes; weapons, skeins, tapestry shuttles, nests; fecundity, nurturing, food; landscape, earth, topography; growth, seeds, sprouting; the terrain of the unconscious; hiding, protection, inner sanctums; mystery, fear, pain, anger; the human world in relation to the animal world; individuals, groups, families; balance and harmony; formlessness and loss of control.

The critical arena of the sixties was not one in which a method of art-making with such varied themes or imagery could receive sustained attention. This was a period when particular critical opinions and specific aesthetic theories were strongly adhered to. The situation was so pronounced that by the early seventies, the rigid critical atmosphere itself had become the subject of scrutiny and was attacked by such writers as Tom Wolfe in his essay "The Painted Word."[39] Bourgeois, however, was at a point in her artistic development where her inventiveness had its own momentum and was not affected by any restrictive critical mood.

In the early sixties, after more than a decade of producing wood sculpture on primarily figural themes, Bourgeois shifted to experiments with intricate twisting arrangements, labyrinthine formations, and amorphous masses of plaster, cement, and occasionally rubber, usually with complex, mysterious interiors and seemingly formless exteriors. With these eccentric pieces, she attempted to make visible psychological states such as fear, vulnerability, and loss of control, as well as basic instincts and forms of behavior, including withdrawal, hiding, protection, sheltering, and nurturing. Bourgeois now says that she felt that the stiffness and frontality of the wood pieces had become too resistant for her and she wanted to work with flexible and yielding materials. In a statement from that period, Bourgeois describes the stylistic development in her work as a "change from rigidity to pliability," saying of the earlier work that "rigidity then seemed essential. Today it seems futile and has vanished."[40]

The first pieces were spiral configurations, fashioned from wire mesh that had been sewn into tubular lengths and covered with plaster (pl. 76). Other wrapped clay constructions, such as *Etretat* (pl. 74), gave the suggestion of interiors and exteriors. Such pieces evolved into a series of plaster and cement works that Bourgeois characterizes as "Lairs" (pls. 75, 77–79, 81), encompassing within this term the suggestion of refuges and places of hiding, as well as the dictionary definition, "the resting place or living place of a wild animal." The Lairs are cavernous, amorphous plaster structures resembling cocoons or nests,

and contain intricate interiors visible through openings in the exterior shells—the insides suggesting protection, the outsides camouflage.

A psychological identification with the elemental workings of the animal kingdom is seen quite specifically in *The Quartered One* (pl. 79) and *Fée Couturière* (Fairy Dressmaker; pl. 81). These pieces hang from the ceiling in pendulous formations, and on one occasion Bourgeois installed one of them outside in a tree.[41] The resemblance of the two to nests, and their removal from the traditional pedestal, places them outside the usual realm of art. *The Quartered One* even has pocketlike attachments suggesting that little creatures are meant to curl up inside.

Bourgeois's objects of the early sixties reveal two different approaches in her artistic process. The first, the Lairs, appear to be the result of a continuous action or transformation, like a growth; they have a designated purpose, such as camouflage, protection, or shelter. These works, in effect, are the residue of a psychological process and have an outward randomness that attests to unfathomable inner motivations.

Bourgeois, however, also made several sculptures in plaster that, in contrast to the first group, are deliberate, preconceived, specific images. They include such stylistically disparate works as *Labyrinthine Tower* (pl. 83), with its phallic suggestion that in later works will become much more evident; the brutal *Torso/Self-Portrait* (pl. 82), which makes physical an almost painful sense of self and hangs on the wall in a way that implies shamanistic powers; and the charming *Still Life* (pl. 73), with its rounded fruits connoting bountifulness and fecundity and whose features in later works become breastlike masses. None of these images, however, can be seen as a logical formal progression from the one before. Instead, they are good examples of the contrariness of Bourgeois's artistic process and of the difficulty her work presents from a purely evolutionary and stylistic point of view. The disparateness of these pieces demonstrates the fertility of Bourgeois's imagination and her originality as an inventor of images.

Many of the plaster pieces, along with some works in rubber, were seen together in Bourgeois's 1964 Stable Gallery solo exhibition (pls. 85, 86), her first in New York since 1953, and the first since 1950 devoted entirely to

sculpture. Some critics responded with surprise to the change in Bourgeois's formal vocabulary, and with delight at its originality and power. One noted: "It was as if an old acquaintance once darkly lean, elegant and aloof, had come back from a long journey transformed: fleshy, chalky, round and organic."[42] While mentioning her "strikingly fertile imagination" and "highly individual sensibility," he further noted: "Its formal independence and the even more difficult question of its precise relationship to mid-twentieth-century art are elements of an artistic and historical mystery."[43]

Bourgeois's audacious experiments with rubber latex in the Stable Gallery show were described by one reviewer as "a couple of small works…cast in a disagreeable brown rubber substance."[44] By the fall of 1966, however, the innovative quality of these pieces was also acknowledged. Shown in the exhibition "Eccentric Abstraction," organized by Lucy Lippard at the Fischbach Gallery, these works were examples of an impulse in sculpture that was emerging concurrently with the Minimal aesthetic so widespread at the time. Lippard says of Bourgeois:

> The internal-external, earthly-visceral aspects of Louise Bourgeois's flexible latex molds imply the location of metamorphosis rather than the act. Her work is less aggressively detached and more poetically mature than that of the younger artists, but like them, she does not ignore the uneasy, near repellent side of art."[45]

Even today, almost twenty years after it was made, the latex *Portrait* (pl. 90), made in 1963 and shown in the Fischbach exhibition, is shocking and almost offensive in its revolting color, texture, and formlessness. Yet its outrageousness, bordering on the absurd, is also exhilarating and amusing.

In mid-decade, the bubbling, blistering eruptions of *Portrait* had coagulated and regularized into repetitive mounds that came to be known as "Cumuls" (pls. 113–15). Implied in the undulations of her early drawings as far back as the forties, these grouped, repeating ovals appeared first in plaster studies in 1966, and then in a Landscape series of 1967. They crystalized into their most monumental occurrence in the marble *Cumul, I* of 1969 (pl. 113). These accumulative, burgeoning mounds constitute a major feature of Bourgeois's formal vocabulary. She has even used their rhythmic outlines on the iron-rod gates of the entrances to her home and loft (pl. 148). She derived the name "cumul" from "cumulus," the term for the massy, rounded cloud form.

The Landscape series of 1967 (pls. 88, 89, 91, 92), with its poured formations, developed from the amorphous plaster and latex pieces of the early sixties. Molten masses suggestive of the eruptive beginnings of the earth are arranged, as if on a base, in a tableau format. This structure is a formal development from the tiny scenes of clustered elements in *Forêt* (*Night Garden*; pl. 63) and *One and Others* (pl. 66) in the early and mid-fifties. In the Landscapes, configurations bubble, hatch, and sprout into existence. Bourgeois says of this series, of which there are variations in alabaster, aluminum, and bronze, as well as the original hardened plastic: "they are anthropomorphic and they are landscape also, since our body could be considered from a topographical point of view, as a land with mounds and valleys and caves and holes. It seems rather evident to me that our own body is a figuration that appears in Mother Earth."[46]

Whereas these Landscapes bear the suggestion of human contours, later pieces will evolve into specifically sexual imagery. It has been observed in reference to the works of this period that "frequently throughout Miss Bourgeois' career as a mature artist, we are in the world of germination and eclosion—the robust sexuality of things under and upon the earth."[47] However, these topographical works of the mid-sixties have only the beginnings of a sexual connotation. Bourgeois's explicitly sexual works will come later.

In the mid-sixties, Bourgeois isolated from her groupings a single oval ("cumul") form and created her most openly sexual image to date. The result of this transformation is *Sleep*, made first in 1966 in plaster, eight inches high, and then in 1967 in marble, twenty-three inches high (pl. 117). Its isolation as a single ovoid, and its anthropomorphic form, heightens its sexual connotation and makes it a direct descendant of the plaster *Labyrinthine Tower* of 1962 (pl. 83). Bourgeois identifies the underlying meaning of this piece as the embodiment of a shy presence in the animal world. She claims that the suggestive configuration

is motivated by its similarity to "a little animal recoiled in upon itself in order to gather its forces for waking up the next morning and starting again."[48] This act of recuperation, and the resultant configuration, is similar to the self-protectiveness that provided the basis for the earlier plaster Lairs, which also folded inwardly, seemingly as the result of an organic process. The Lairs, with their sense of hiding and protection, and *Sleep,* suggesting the need for rest to regain strength and resources, both express aspects of self-preservation.

Bourgeois's method of reusing and transforming specific images is seen clearly with the Sleep form (itself a variation of the Cumul). In addition to its repeated usage in the monumental marble Cumuls (pls. 113, 115), it is also recognized in the two-sided linkage of the Hanging Januses (pls. 95, 96). The sexuality of this element shifts from implied to explicit in its different uses.

Bourgeois's imagery of massed, nestling, or clinging shapes congregating together on a base is powerfully evident in the marble pieces she produced in Italy during periodic visits from 1967 to 1972. Seen not only in the burgeoning Cumuls, which she identifies with fecundity, this imagery also appears in the gathered shafts of *Clamart* (pl. 120), which are partially warmed and protected by a flowing drapery, and in the erectly standing columns of *Colonnata* (pl. 119), emerging from their massive base as if sprouting up from the earth. In *Eye to Eye* (pl. 125), the segments take on the familiar spool shape of the early *One and Others* (pl. 66). Here, though, the individuals (now with simply demarcated faces) are pulled together in such cohesion that one's focus on the parts is equally balanced by attention to the whole. When looked at as a totality, the piece resembles a blossoming flower, one of the principal symbols in feminist art. In Bourgeois's earlier work, the mysterious interior, another feminist symbol, was also suggested by the series of intertwining plaster Lairs.

Bourgeois's ingenuity within the "crowding/clustering" conception is further exhibited in the rough-hewn marble *Baroque* (also known as *Irate Creature* and *Hostile and Angry Woman;* pls. 123, 124). Parts take on a strange and wild internal energy, wrapping themselves around each other in a seemingly perpetual state of fury. As in *Eye to Eye,* however, the discrete parts unify into a generalized structure. *Baroque* alludes to a writhing figure rather than to a flower, as suggested in *Eye to Eye.*

The most gigantic of the marble "crowd" pieces, and the one most closely related to an enactment because of its size, is *Number Seventy-two (The No March;* pls. 128, 131, 132), an environmental work made up of more than a thousand multi-colored and -sized units, each sliced across the top at an angle and massed together directly on the floor. In its first installation at the Whitney Museum of American Art Biennial of 1973, this piece formed a clustered assembly in the corner of the room. Bourgeois saw in that presentation a throng of individuals who had banded together in a silent march and mass demonstration, prompted by the political activities of that period. She was also motivated by the idea of showing creatures pressed together symbolically as well as physically in their need to relate, adjust, and ultimately depend on each other.

The highly politicized atmosphere of the late sixties and early seventies brought attention to certain works by Bourgeois because of the thematic issues they raised. But also the atmosphere itself had an effect on Bourgeois's art, since she was actively involved in the political issues of the time. The environmental-scale marble, *Number Seventy-two (The No March),* and the small-scale and potentially easily carried bronze, *Molotov Cocktail* (pl. 100), are examples of Bourgeois's abstract vocabulary of grouped elements or of bulbous solid masses brought to the service of political motivations and given a specific representational responsibility.

In the same period, feminism was also gathering strength, sometimes as a militant force. Bourgeois took part in many of the meetings, demonstrations, exhibitions, and panel discussions that resulted. In fact, Bourgeois's work, even pieces made twenty years earlier, became a rallying point for some feminist artists. In the late sixties, sexuality finally emerged explicitly in her work. It took bold form in several pieces of the period, and then retreated again beneath the surface. As the momentum of the feminist movement grew, however, many of the explicitly sexual sculptures were exhibited in group shows, and Bourgeois even took part in several exhibitions at the Gallery of

Erotic Art. Familiarity with these works, and the similarity of their forms to others in Bourgeois's oeuvre, has led to her work being categorized as "erotic art." Where previously her work had defied classifications, it now, for the first time, seemed to fit a category. But such a label tends to distort and diminish its visual variety and its many levels of meaning.

It should be pointed out here that words such as erotic, sexual, and feminist are used interchangeably, without benefit of precise distinctions, by the general public and even by Bourgeois herself. It is in so doing that Bourgeois's work can be misinterpreted. The dictionary defines sexual as relating to the behavior, characteristics, and differences of the sexes, with their accompanying instincts, functions, and drives. The term erotic refers to arousing or stimulating sexual behavior. Bourgeois's work deals with the sexual as opposed to the erotic. Part of the feminist movement has also dealt with a free examination of sexuality, which is the level on which Bourgeois's work should be understood.

Early on, Bourgeois had this to say about the sexual element in her work: "I am not particularly aware, or interested in, the erotic in my work…Since I am exclusively concerned, at least consciously, with formal perfection, I allow myself to follow blindly the images that suggest themselves to me. There is no conflict whatsoever between these two levels."[49] However, she later stated: "There has always been sexual suggestiveness in my work." And she went on to characterize specific shapes: "Sometimes I am totally concerned with female shapes—clusters of breasts like clouds—but often I merge the imagery—phallic breasts, male and female, active and passive."[50] As Bourgeois discusses particular pieces now, however, she characterizes them as "pre-sexual,"[51] meaning that they function at the most basic level of the life force itself.

Speaking of the small group of works in which she allowed sexual content to dominate, Bourgeois remembers "a certain glee, awe and fascination" with the possibility of making such explicit artistic statements, finding them an antidote to a generally puritanical, shy, and repressed sensibility. Referring to this as her "erotic period," Bourgeois explains, however, that her own interest in explicit sexuality waned when general interest in this subject became widespread.

In this group, certain sculptures referred to by Bourgeois as "body parts" depict penises or breasts, or the abstract merging of the two. In the striking and highly charged imagery of Trani Episode (pl. 98), Bourgeois uses her familiar bulbous abstract shapes with new realistic features: nipples are indicated at each end of a pillowlike element, which rests on a second form in a limpid, suggestive union. Bourgeois sees the swollen, bulging presence of Trani Episode as signifying a "life force" and a "statement of refusal to death."

The latex Fillette (pl. 107), hanging ominously from a metal hook, is possibly her most explicit piece. It is striking in its raw, funky quality, and although its details can be seen as abstract and within her usual vocabulary of forms, they are totally unidealized here. The size of the piece, its odd repellent material, and its playful title (in English Little Girl) betray an outrageous humor and sense of the ridiculous. When one holds it, Fillette actually seems like a small baby, or at least like the rubber dolls commonly used as children's toys. The urge to rock this scandalous object is almost irresistible.

When Fillette was shown in the exhibition "13 Women Artists" in 1972, one critic described it as "a big, suspended, decaying phallus, definitely on the rough side," and went on to say of Bourgeois: "She has aligned herself with those women artists who paint males as sex objects, reversing the traditional procedure. Sex used like this is still iconography, however, not instinct."[52]

About the same time, Bourgeois made a group of small bronze figural pieces shaped unmistakably like penises, each wearing what looks like a wide-brimmed hat (pl. 97). When grouped together, like so many other of her clustered pieces, these works constitute a rather sweet family and reflect a degree of charm and humor that seems to be a distinct part of Bourgeois's intentions.

In a series of small female figures in plaster, clay, bronze, wax, and marble (pls. 103–06, 108–12), a mixture of aggressiveness and vulnerability characteristic of her "erotic period" reveals itself clearly. The precedent for this series is the plaster Figure of 1960 (pls. 103, 104), done around the same time as her plaster Lairs (pl. 75) and incorporating their clumpish surfaces. The crouching Figure appears to be half-animal and half-human, as it

looks upward from its hind legs in a gesture of innocence and need. The fact that it has no arms and only an abbreviated head adds to its poignancy. In later figures, the innocence of this early plaster evolves into a defensive aggressiveness. An untitled figure in clay (pl. 105) suggests fertility through the use of bulbous, rounded proportions. It verges on toppling over, weighted down and burdened by its sexuality. Bourgeois has said: "Perhaps such features could arouse erotic feelings in men, but actually the poor devil feels ugly and helpless and not at all erotic herself." Yet she also believes that this figure, and others that follow, convey a "deep sense of uselessness" in being women, coupled with a belief that they must protect themselves because others find them "expendable." The thrust of the clay figure's abbreviated head suggests a retaliatory aggressiveness. The whole body can be interpreted as a weapon of self-defense.

The ten-inch-high *Fragile Goddess* (pl. 108) has similar large breasts and the protruding belly of pregnancy. Again she is armless and has a stakelike appendage instead of a head. Now, however, the forms are stylized and balanced rather than ungainly, and the figure, as a result, is purposeful and threatening. According to Bourgeois, the defensiveness of certain of these figures is a result of the condition of pregnancy and its responsibilities. She portrays an attempt to overcome inherent helplessness in order to protect oneself and one's children. She has stated:

> I try to give a representation of a woman who is pregnant and who tries to be frightening....She tries to be frightening but she is frightened. She's frightened for the child she carries. And she's afraid somebody is going to invade her privacy or bother her in some way and that she won't be able to defend what she's responsible for. Now the fact that she's frightening is open to question. Some people might find it very touching. She is frightened herself; she tries to be frightening to others.[53]

These armless and, as Bourgeois refers to them, "harmless" women constitute a group that evolves toward greater aggressiveness in content and greater elegance and sophistication in form. It culminates in the pink marble *Femme Couteau* (Knife Woman; pl. 109). An example of the distance Bourgeois's conception of the female figure has traveled is evident by looking back to her early wood female personages from the late forties (pl. 50). Those silent figures, with

their taut profiles and shy innocence, seemed bound like Egyptian mummies. They even trembled slightly in their original installation because of their tenuous connection with the ground. They barely hinted at their femaleness. *Femme Couteau,* on the other hand, focuses on sexuality, danger, and elegance. Chameleonlike, the woman turns herself into a knife and demonstrates a potential for anger, violence, and cruelty because of her need for self-protection and retaliation. *Femme Couteau* is the abstracted form of a weapon that could be picked up and used, but its elegance and self-containment seem to repel the viewer's touch through a distancing aura.

Bourgeois's figures of this period go far beyond traditional academic studies. She, in fact, explains that the emanation of their vivid content is due to their being representations of the inner self. Their outward appearance grows from feelings about one's body and one's notion (and thus image) of one's self. For Bourgeois, these figures are self-exploratory and self-expressive.

Now, over a decade later, in the early eighties, there is a general resurgence of interest in the abstracted and expressive figure. Bourgeois herself has recently reintroduced her Harmless Women, this time in marble, over three feet in height, She has also reinvestigated her *Femme Couteau* theme, this time in versions that are much more explicitly realistic and that are, in their realism, all the more vulnerable and frightening (pl. 110).

THE SEVENTIES

One of the major thrusts of Bourgeois's work in this decade involved the construction of sculpture that is environmental or architectural as well as symbolic in nature. The first of these is *Number Seventy-two (The No March;* pl. 131), the corner installation of marble facets shown first at the Whitney in early 1973 (called there simply *Number Seventy-two*). This piece, its more than a thousand unconnected entities congregating as if in solidarity, was acquired by the Storm King Art Center in Mountainville, New York, and subsequently installed in a grassy patch beneath a tree (pl. 132). In this new and bucolic setting, political overtones recede and the effect of communal

resistance is diffused. Instead, it calls to mind a natural phenomenon, perhaps a patch of mushrooms, a family of ducklings, or a colony of insects.

Bourgeois's next work of an environmental nature took on architectural proportions. *The Destruction of the Father* (pls. 3, 133–35), first seen in her show at the 112 Greene Street Gallery in 1974, continued her earlier preoccupation with the hidden recesses of the plaster Lairs, which revealed the mysterious workings of strange interior worlds. In *The Destruction of the Father*, however, the proportions of the world have expanded to create a secret chamber. The viewer stands outside as a witness to the imaginary yet life-size enactment within. Bourgeois's bulging, swollen landscapes of the mid-sixties have now overgrown an entire inner sanctum to create a scene that closes in upon itself with the evocation of frightening claustrophobia. A central tablelike structure is enveloped by large globular protuberances in rough latex that suggest decay. An atmosphere of oppression, anger, and violence pervades this installation. It looks as if a ritual had taken place as one notices scattered remains of animal parts, again sinisterly preserved in the omnipresent latex coating. These dismembered limbs lend a realistic and macabre touch to the otherwise abstracted environment, adding a clear level of suggestiveness and thus heightening the atmosphere of churning violence. Bourgeois's alternate title for this work is *The Evening Meal*, and one wonders what kind of ritualistic meal this tableau reveals. One reviewer comments: "The forms themselves are 'disheveled.' The piece has an ad hoc appearance, a kind of nervousness about it, as if the images were created quickly, urgently, like the recounting of a terrifying dream."[54]

Accompanying the 1974 show were the first critical writings emphasizing the antiformal or postmodern aspects of Bourgeois's work. Articles by critics Carl Baldwin and Lucy Lippard were among the first to use this approach so prominently. Toward the end of the seventies, a groundswell of appreciation for Bourgeois's work would be geared to its antiformalist nature, as a major shift occurred in the aesthetic concerns of the art world.

In discussing Bourgeois's 1974 exhibition, Baldwin explores its "iconographic suggestiveness," pointing out:

Such literal readings of work which is as elusive and fundamentally non-referential in appearance as Bourgeois's sculpture is may perturb some observers, but the artist's discussion of her work in these terms is a significant indication of her vehemently anti-formalist conception: "organic shapes" will not suffice by way of description when the artist herself moves from work to work saying, "mother," "father," "child"...[55]

And Lucy Lippard notes:

It is difficult to find a framework vivid enough to incorporate Louise Bourgeois's sculpture. Attempts to bring a coolly evolutionary or art-historical order to her work, or to see it in the context of one art group or another, have proved more or less irrelevant...Rarely has an abstract art been so directly and honestly informed by its maker's psyche.[56]

Summing up, she points out: "While some of her sculpture seems to be the result of random exploration with no immediate point of view, this is not wholly a disadvantage unless one thinks in terms of logical progression, which she certainly does not."[57]

In 1978, after having occupied a somewhat small though unique place in the artistic developments of the New York art world, Bourgeois's work entered its period of widest recognition to date, owing in part to a new appetite for the kind of issues described by Baldwin and Lippard. Her work seemed to fill a distinct aesthetic need that became acute near the end of the seventies: a need for personal content and meaning well beyond what was found in much of the well-known work of the day. New work that emphasized personal, individualized, and even eccentric subject matter began to flourish, and the words most often heard in conjunction with this new art were meaning, content, emotional impact, and expressionism. Bourgeois had worked in this personal, idiosyncratic, and expressionist mode for over forty years. Much of that time described as a loner, outside the mainstream of art developments, she now was at the center of those developments. She became, as a consequence, a "senior figure" for those artists and critics who were exploring this intuitive and emotional direction in the arts. From 1978 to 1981, not only was she to have seven solo shows, but also the critical writing concerning her work proliferated.

In her two 1978 exhibitions, Bourgeois continued her exploration of the architecturally scaled symbolic structures that were first seen earlier in the seventies. At the

Hamilton Gallery of Contemporary Art, she installed the environmental *Confrontation* (pls. 137, 138), filling the all-white gallery to striking effect. This mysterious white piece, experienced as a silent tableau, demonstrated the evolution, on a large scale, of a sculptural conception initiated in the fifties with *Forêt* (*Night Garden;* pl. 63) and *One and Others* (pl. 66), continued in the sixties with the Landscapes and marble pieces, and explored again in 1974 in *The Destruction of the Father* (pl. 133).

Theatrical to its very essence, *Confrontation* obliges the viewer, again, to approach as a witness, in this case with respectful silence, caution, and awe. The white wooden standing boxes that make up the outer ellipse of *Confrontation* serve as guardian figures, keeping watch over a mysterious, solemn, and somewhat frightening ceremonial event. They provide protection, acting as a barrier to the onlooker: this is a private event and the viewer is only a spectator. (This conception of witness or spectator, rather than participant in what appears to be an event, had also been employed in *The Destruction of the Father.*) The arrangement not only restrains the observer from active involvement, but also provides aesthetic distance, enabling him to contemplate the entire structure as a large art object with a discrete shape and internal formal relationships, although the whole is of environmental proportions. This aesthetic distancing acts in combination with the viewer's imaginative involvement in the piece's enigmatic content.

On *Confrontation*'s "stretcher-table," what could be fleshy bits of human anatomy at closer range appear to be food in stages of decay, as if leftovers from some unimaginable feast. Bourgeois's poetic combination of food, death, and sex is stirring and provocative. In fact, the physical presence of this piece gives the impression of being the remains of an event, and the viewer's imagination is prompted to fill in what had taken place. The beautiful, white enclosure, with its subtle changes in height and its roughly painted surfaces, is an immobile geometric foil for the violent, "decaying" protuberances in the center. The order inherent in this outer circle of abstract geometry is brought to the service of emotionally expressive ends.

Aspects of *Confrontation* are reminiscent of Bourgeois's

earlier works. The sliced-off, angled boxes, gathered together side by side, are similar to other unconnected, grouped elements. The latex terrain on the central bier is made up of the familiar soft imaginary Landscape that suggests the surface of the human body as well as the fruits of a still life. The title itself conjures up the dichotomy between isolation and communication, with which Bourgeois had been involved for many years. A quote from 1954, incorporating the concept used in this 1978 title, shows her ongoing involvement with particular themes: "Eighteenth century painters made 'conversation pieces,' my sculptures might be called 'confrontation pieces.'"[58]

The *Confrontation* created an effect that was widely discussed by critics. As Peter Frank conjectured in *The Village Voice:* "Perhaps the boxy forms—whose idiosyncratic construction gives each a distinct personality—are not present at a wake, but [at] a trial or a ritual sacrifice, or even a bout of lovemaking."[59] And John Russell hinted at the ambiguity of the central section when he wrote: "You can think of them as tables heaped with goodies. You can also think of them as human sacrifices, one male, one female."[60]

The spirit of *Confrontation* was dramatically altered, however, when Bourgeois staged a performance in conjunction with the exhibition (pls. 139-43). "A Banquet/ A Fashion Show of Body Parts" was alive with sardonic, witty irreverence. It achieved the ultimate anthropomorphism of a Bourgeois sculpture and the acting-out of the ever-present figural implications of her work. Bourgeois humanized the standing white compartmentlike boxes by having certain members of the audience stand in the tall ones and others sit in the smaller ones. And the fleshlike protuberances laid out on the central table were echoed in outlandish costumes draped on models, who were transformed into outrageous creatures parading capriciously around the previously disquieting bier. A punk musical background and a Surrealist narration accompanying the "models," as well as the general confusion surrounding the event, gave an entirely new level of meaning to the solemn *Confrontation.* It became the setting for a mock fashion show and demonstrated Bourgeois's long-held fascination with fashion and costuming, as well as her pleasure in the fantastic and the ridiculous. Paul

Gardner quotes Bourgeois on this performance: "But, you see, it was all a joke,…a comment on the sexes because they are so mixed today. What more is there to say? The humor is black. Despair is always black."[61]

In the same month as the exhibition of *Confrontation* at the Hamilton Gallery, Bourgeois showed another series of architecturally oriented Structures (pls. 146, 147) in a solo show at Xavier Fourcade, Inc. The five Structures, tiered wooden Figure-Houses standing on steel legs, were based on the *Femme-Maison* theme. They were made up of tiny boxlike wood triangles similar, but on a miniature scale, to the outer white geometric boxes in *Confrontation*. Painted mainly in vivid red, but also with touches of dark green and dark blue, this group of sculptures made a raw and aggressive impact. They occupied the room with a fierceness that seemed to radiate violence. The observer was frightened almost to the point of standing outside the door and peering in at the pieces, again acting as a witness. All the jagged, triangular details were arranged in rows, each one a tableau (so frequently seen thus far) of clustered, geometric open boxes. Together the tiers suggested a voracious jaw or trap with the potential to close quickly on any hand that came close. These constructions created intricate interiors and recalled the convoluted inner workings of Bourgeois's plaster Lair pieces of the early sixties and their motivations of camouflage and protection. Yet here, the angular "heads," the spindly "legs," and the overall shape and personality of each Structure also evoked the house imagery so prevalent in Bourgeois's work. Carter Ratcliff described these works as "sublimely sinister," going on to observe: "Her forms could be—and have been—taken as formal exercises. But the forms themselves, it's tempting to say, are demonstrative. The viewer willing to see—or to feel—their energies of self-revelation risks being overwhelmed."[62]

In her 1978 show at Fourcade's, Bourgeois exhibited, in addition to the wood Structures, two high metal "tables" that conveyed the impression of fragile, teetering, elongated figures, six and seven feet tall. Because of their utter bareness, Bourgeois called these pieces *Empty Houses* (pl. 145). Because of their frail legs and seemingly unsteady posture, she also designated them *Maisons-Fragiles* (Fragile Houses). Their strikingly austere geometric outlines softened somewhat as the two "tables" leaned toward each other in a gesture of communication and need, with a pairing recognizable from Bourgeois's early, slender wood figures.

Bourgeois describes these pieces as a "revelation of the inner woman." The figures appear fragile but in fact are strong. She says it is "in their nature to be trembling and frightened, but they are used to it, and will not fall down or fall apart." For her, this work "confronts and resolves woman's fate, with no embellishments or flourish[es]."[63] She continued her exploration of this theme in 1982, with a wobbly yet ultimately stable version eleven feet tall.

In 1979, at Fourcade's, Bourgeois exhibited yet another piece in her architecturally symbolic mode. *Partial Recall* (pls. 150, 151) embodies the calm, peaceful qualities within Bourgeois's expressive range. Resembling an altar, emerging from an almost mystical glow of white light. *Partial Recall* presents the viewer with a symbol of calm, purity, regularity, and otherworldliness. Its lovely, rhythmic, undulating form is recognizable as one of Bourgeois's dominant motifs. But here, the repetitive oval is put to quite different use from that in the voluminous latex globes of *The Destruction of the Father* (pl. 133), where the effect is that of a frightening scene of inner turmoil; in the crystalline white mounds of the marble Cumuls (pls. 113, 115), where the feeling is one of fecundity and earthliness; or in the many drawings of rhythmic, billowing strokes that Bourgeois made over the years, in what she describes as an endless attempt to overcome "the void of anxiety." One critic has commented on *Partial Recall*: "Looking up at this pristine and ordered assemblage is like beholding some celestial configuration in a place of worship; are these undulating waves of white wood clouds, tombstones, decorative scallops?"[64]

THE EIGHTIES

The wide interest in and new recognition of Bourgeois's work in the late seventies and early eighties were demonstrated by several distinguished awards and a series of four exhibitions that focused on the examination of early periods of her work. Bourgeois received an honorary

degree from Yale University in 1977; an outstanding achievement award from the Women's Caucus for Art in 1980; and a second honorary degree, from Bard College, in 1981. She was commissioned by the General Services Administration of the Federal Government to do a public sculpture in Manchester, New Hampshire, in 1978 (detail, pl. 130). In addition, she had exhibitions of her early wood figures at Xavier Fourcade, Inc. in 1979 (pls. 58, 59); early paintings at Max Hutchinson Gallery and middle-period sculpture at Fourcade's in 1980 (pl. 126); and a small retrospective selection of thirty-one works from all periods at the Renaissance Society of the University of Chicago in 1981.

These exhibitions necessitated that Bourgeois spend a good deal of time with work from her earlier periods. Although she continued making new sculptures throughout, this retrospective involvement allowed her to become reacquainted with some of her earlier imagery and themes. This situation was particularly meaningful for someone whose subjects had been so enduring as Bourgeois's had been. The reintroduction of earlier imagery brought it again to the forefront of her consciousness and thus provided an opportunity for further exploration and interpretation. In her exhibition of the early wood figures at Fourcade's, Bourgeois created a distinctive new installation. Instead of the spare placement around the space of the Peridot Gallery thirty years earlier (pls. 40–43), Bourgeois chose to show her pieces in three communal groupings, combined approximately by color: white and pale blue, stained brown and red, and black. The room as a whole took on the appearance of a large garden with three patches of closely placed figures each "sprouting" from a common "flower bed." While the Peridot Gallery shows had emphasized the isolation of the individual, this new arrangement reflected Bourgeois's long interest in assembling distinct objects into related families, while still maintaining the unique personality of each member. One reviewer took note of the differences, pointing out: "Almost every one of her sculptures has a distinctive human personality. Sometimes they are decked out with navels, knees and necklaces....They are not 'abstract sculptures.' They are portraits, but portraits abstracted from anything that could be called descriptive or anecdotal."[65]

Another critic appreciated the special chance to see this early sculpture thereby gaining a greater understanding of Boureois's work as a whole: "It is a rare opportunity to confirm the idea that a true artist's oeuvre always reveals an indefinable inner consistency no matter how wildly divergent the modes and media over the years."[66]

Bourgeois's exhibition of early paintings and drawings in 1980 was remarkable for its relevance to painting of the current season. Although now between thirty and forty years old, these works employed a mode of symbolic figuration and allegory that corresponded directly to the reversal in recent painting away from the pure abstraction dominant for so many years and toward personal meaning and imagery. Some of the hybrid figures, drawn with light outlines and floating in an open spatial field, could be linked stylistically to such trends as "new wave" and "narrative" art. The expressive content related to "anxious figuration," and to the angst, emotionalism, and "new subjectivity" that were widely discussed.

The exhibition of works from Bourgeois's middle period, held at the same time, focused on her marble sculptures mounted on heavy wood bases. Previously installed directly on the floor (pl. 127), the works were placed on timber bases (pl. 126), giving a strong impact of monumentality. The cold austerity and hardness inherent in the medium, and its traditional overtones of "high art," were impressively combined with Bourgeois's repertoire of organic symbols. One reviewer commented: "Exuberent growth and fecundity, perhaps the life force itself, is their abiding theme."[67]

This exhibition of middle-period marble sculptures served perhaps as an impetus for Bourgeois's trip to Italy in 1981, her first in almost ten years. For over a month, she worked steadily in Carrara, producing a large number of new marbles. In certain of these new works she reintroduced figural themes of earlier years, sometimes on a much larger scale and with a new level of realism, at other times combined with newly discovered abstract elements. She also reinterpreted her clustering Cumul theme. This time Bourgeois chose a four-foot-square piece of black marble for her largest sculpture in this medium to date. Sprouting, connected columns, familiar from such pieces as *Clamart* (pl. 120) and *Colonnata* (pl. 119), overtake the

entire structure rather than emerge from baselike founda-
tions. Its immense size and placement directly on the floor
situate the sculpture firmly in the space of the viewer.
Called *Femme-Maison '81* (pls. 4, 121, 122), the piece is the
powerful embodiment of a theme that previously expressed
fear, withdrawal, and fragility. Here, the appearance of
exterior calm contrasts with the reality of inner turmoil.
The front and sides display articulated elements that appear
to sway together rhythmically and harmoniously, as wheat
might in a field. In the back, however, forms coagulate in a
disruptive, "boiling" turmoil. A house balances precari-
ously on top, an image that goes as far back in Bourgeois's
imagery as her *Femme-Maison* paintings of the late forties.

With all the increased attention to Bourgeois's work
during this period, it is not surprising that she was one of a
group of artists, many a good deal younger than she, who
were chosen for a 1981 *Art News* feature on "Artists the
Critics Are Watching." Critic Kay Larson chose Bourgeois
and stated: "Perhaps Louise Bourgeois is an idiosyncratic
choice for an article on 'emerging' artists. Yet she was the
first to come to mind when considering artists of high
caliber whose work came to my attention during the past
season."[68]

C O N C L U S I O N

The investigation of Bourgeois's work from the late thir-
ties to the present demonstrates that it is not style and the
evolution of style that are fundamental to her character as
an artist. Rather, it is the struggle of an individual actively
attempting to define herself through her art—to under-
stand, control, and express herself through the discovery
and exploration of specific imagery. In this personal ex-
ploration, Bourgeois developed her own idiom within
the sophisticated cultural language of twentieth-century
art. After a basic foundation in abstraction, she awakened
to a more direct expression of her interior world through
the inventions of the imagist branch of Surrealism. Finally,
however, her work became most closely aligned with the
the tradition of Expressionism, as she attempted to encom-
pass in it raw, vulnerable, subjective states of being, involv-
ing elemental aspects of humanity. The vivid expression of

such states are outside the realm of Surrealism, which is
far more intellectual, literary, and ultimately detached.

Bourgeois belongs to the line of twentieth-century
sculptors that includes Brancusi, Arp, Giacometti, Moore,
and Hepworth. In comparison, however, her work does not
seem so generalized, idealized, or otherworldly. Instead,
it is specific, quirky, and individualistic. It provides an
encounter rather than an object to contemplate. Instead
of experiencing an essence or the sublime, we find in it
a strikingly poignant and authentic reminder of our hu-
manity. In fact, the basis of her work may seem modest in
comparison to the aims of those other artists: it involves
her attempts to be responsible for herself, and to under-
stand herself and her needs. Her work, in some way,
takes the form of a strategy for survival. This is a deeply
moving and humanistic aim.

Bourgeois looks to herself for the sources of her art.
What might be considered the conflicts or pathologies of
one's life are seen by Bourgeois as her themes, in fact, the
definition of herself. Consequently, her work expresses a
personal and deeply autobiographical content. It is bound
by life, and her life in particular. Rather than being mysti-
cal or cosmic, it is profoundly human. As a whole, Bour-
geois's work becomes a tangible record of her existence
and, yet, though portraying a single life, it is able to give
form to more general and widespread aspects of humanity.
An encounter with a Bourgeois work reminds one, and
makes one vividly feel, what it is to be human.

> Once there was a girl and she
> loved a man.
> They had a date next to the
> eighth street station of the sixth
> avenue subway.
> She had put on her good clothes
> and a new hat. Somehow he could
> not come. So the purpose of this
> picture is to show how beautiful
> she was. I really mean that she
> was beautiful.
>
> Louise Bourgeois
> **He Disappeared into Complete Silence**

1. Information regarding Bourgeois's views has been obtained through frequent conversations with the artist between 1977 and 1982. Only taped conversations are specifically cited.

2. "French Artists in New York Series" (lecture with slides), Maison Française, Columbia University, New York, Oct. 3, 1979.

3. Taped interview with Louise Bourgeois, July 11, 1981.

4. Taped interview with Louise Bourgeois, Oct. 14, 1981.

5. Louise Bourgeois, "A Memoir," p. 7. Ms. in the artist's possession.

6. Taped interview with Louise Bourgeois, July 2, 1979.

7. J[udith] K. R[eed], [Exhibition Review], *Art Digest* (New York), vol. 19 (June 1945), p. 31.

8. David Porter, Foreword to catalog of the exhibition "Personal Statement: Painting Prophecy 1950," The David Porter Gallery, Washington, D.C., 1945.

9. *Ibid.*

10. Nemecio Antunez, exhibition announcement for "Louise Bourgeois: Paintings," Norlyst Gallery, New York, Oct. 28–Nov. 8, 1947.

11. [Exhibition Review], *Art News* (New York), vol. 46 (Nov. 1947), p. 42.

12. Lucy R. Lippard, *From the Center: Feminist Essays on Women's Art* (New York: Dutton, 1976).

13. "Women in American Architecture: An Historic and Contemporary Perspective," an exhibition organized by the Architectural League of New York and shown at The Brooklyn Museum, New York, 1977.

14. For further information, see Judy Chicago, *Through the Flower: My Struggle as a Woman Artist* (Garden City, N.Y.: Anchor Books, Doubleday, 1977), pp. 104–11, 112–32, and Miriam Schapiro, "The Education of Women as Artists: Project Womanhouse," *Art Journal* (New York), vol. 31 (Spring 1972), pp. 268–70.

15. Marius Bewley, Introduction to *He Disappeared into Complete Silence: Suite of Nine Engravings by Louise Bourgeois* (New York: Text printed by Gemor Press, 1947. Engravings printed on the hand press of Atelier 17).

16. Taped interview, July 2, 1979.

17. *Ibid.*

18. Installation photographs of the early Peridot Gallery exhibitions served to determine which sculptures were shown. An effort was made to match the titles on the early announcements from these shows to individual pieces, but in most cases this was not possible. Titles used here were decided upon in conjunction with the artist.

19. M. G., [Exhibition Review], *Art News* (New York), vol. 48 (Oct. 1949), p. 46.

20. Stuart Preston, [Exhibition Review], *New York Times* (Oct. 9, 1949), Sec. 2, p. 9.

21. [Exhibition Review], *New York Sun* (Oct. 14, 1949).

22. M. G., p. 46.

23. *Ibid.*

24. Susi Bloch, "An Interview with Louise Bourgeois," *Art Journal* (New York), vol. 35 (Summer 1976), p. 373.

25. Stuart Preston, "'Primitive' to Abstraction in Current Shows," *New York Times* (Oct. 8, 1950), Sec. 2, p. 9.

26. Bloch, p. 373.

27. P[esella] L[evy], [Exhibition Review], *Art Digest* (New York), vol. 25 (Oct. 1, 1950), p. 16.

28. M[arynell] S[harp], "Telegraphic Constructions," *Art Digest* (New York), vol. 24 (Oct. 15, 1949), p. 22.

29. Rosalind E. Krauss, "Magician's Game: Decades of Transformation, 1930–1950," in *200 Years of American Sculpture* (Boston: David R. Godine, in association with the Whitney Museum of American Art, New York, 1976), p. 168.

30. Taped interview, July 2, 1979.

31. The Jan. 15, 1951, issue of *Life* published the photo with this caption: "Irascible group of advanced artists led fight against show." The entire event is discussed in B. H. Friedman, "'The Irascibles': A Split Second in Art History," *Arts Magazine* (New York), vol. 53 (Sept. 1978), pp. 96–102.

32. James Fitzsimmons, "Art," *Arts and Architecture* (Los Angeles), vol. 70 (Apr. 1953), p. 35.

33. Preston, *New York Times* (Oct. 9, 1949), Sec. 2, p. 9.

34. P[esella] L[evy], p. 16.

35. S[idney] G[eist], [Exhibition Review], *Art Digest* (New York), vol. 27 (Apr. 1, 1953), p. 17.

36. Louise Bourgeois, statement in Belle Krasne, "10 Artists in the Margin," *Design Quarterly* (Minneapolis), no. 30 (1954), p. 18.

37. Krasne, p. 9.

38. Louise Bourgeois, interview, in Lynn F. Miller and Sally S. Swenson, *Lives and Works: Talks with Women Artists* (Metuchen, N.J., and London: Scarecrow Press, 1981), p. 6.

39. Tom Wolfe, "The Painted Word," *Harper's Magazine* (New York), vol. 250 (Apr. 1975), pp. 57–92.

40. Louise Bourgeois, statement, in Philip Pearlstein, "The Private Myth," *Art News* (New York), vol. 60 (Sept. 1961), p. 45.

41. In the XXVII Salon de la Jeune Sculpture, Paris, 1965.

42. Daniel Robbins, "Sculpture by Louise Bourgeois," *Art International* (Lugano), vol. 8 (Oct. 20, 1964), p. 29.

43. *Ibid.*, p. 31.

44. V. R., [Exhibition Review], *Arts* (New York), vol. 38 (Mar. 1964), p. 63.

45. L[ucy] R. L[ippard], exhibition announcement, "Eccentric Abstraction," Fischbach Gallery, New York, 1966.

46. Taped interview, Oct. 14, 1981.

47. William S. Rubin, "Some Reflections Prompted by the Recent Work of Louise Bourgeois," *Art International* (Lugano), vol. 13 (Apr. 20, 1969), p. 17.

48. Taped interview, Oct. 14, 1981.

49. Quoted in Rubin, p. 20.

50. Louise Bourgeois, statement, in Dorothy Seiberling, "The Female View of Erotica," *New York Magazine*, vol. 7 (Feb. 11, 1974), p. 56.

51. Taped interview, Oct. 14, 1981.

52. Lawrence Alloway, "Art," *The Nation* (Mar. 27, 1972), pp. 413–14.

53. Bourgeois, interview, in Miller and Swenson, p. 8.

54. Alan Sondheim, [Exhibition Review], *Arts Magazine* (New York), vol. 49 (Mar. 1975), p. 23.

55. Carl R. Baldwin, "Louise Bourgeois: An Iconography of Abstraction," *Art in America* (New York), vol. 63 (Mar.–Apr. 1975), p. 82.

56. Lucy R. Lippard, "Louise Bourgeois: From the Inside Out," *Artforum* (New York), vol. 13 (Mar. 1975), p. 27.

57. *Ibid.*, pp. 32–33.

58. Bourgeois, statement, in Krasne, p. 18.

59. Peter Frank, "Prepositional Space," *The Village Voice* (Oct. 2, 1978), p. 121.

60. John Russell, [Exhibition Review], *The New York Daily Metro* (Sept. 22, 1978), p. 20.

61. Louise Bourgeois, quoted in Paul Gardner, "The Discreet Charm of Louise Bourgeois," *Art News* (New York), vol. 79 (Feb. 1980), p. 82.

62. Carter Ratcliff, "Louise Bourgeois," *Art International* (Lugano), vol. 22 (Nov.–Dec. 1978), p. 27.

63. Louise Bourgeois, quoted in Deborah Wye, brochure for the exhibition "Matrix/Berkeley 17," University Art Museum, Berkeley, Calif., 1978.

64. Carrie Rickey, [Exhibition Review], *Artforum* (New York), vol. 18 (Dec. 1979), p. 72.

65. John Russell, "Art: The Sculpture of Louise Bourgeois," *The New York Times* (Oct. 5, 1979), Sec. C.

66. Dore Ashton, [Exhibition Review], *Artscanada* (Toronto), vol. 37 (Apr.–May 1980), p. 43.

67. Hilton Kramer, "Art: Contrasts in Imagery: 2 Views of Louise Bourgeois," *The New York Times* (Oct. 3, 1980), Sec. C, p. 29.

68. Kay Larson, "Louise Bourgeois: Her Reemergence Feels Like a Discovery," in "Artists the Critics are Watching," *Art News* (New York), vol. 80 (May 1981), p. 77.

L O U I S E B O U R G E O I S : P L A T E S

Several years ago I called a sculpture "One and

Others." This might be the title of many since then:

the relation of one person to his surroundings is a

continuing pre-occupation. It can be casual or

close; simple or involved; subtle or blunt. It can

be painful or pleasant. Most of all it can be real or

imaginary. This is the soil from which all my work

grows. The problems of realization — technical, and

even formal and esthetic — are secondary; they

come afterwards and they can be solved.

Louise Bourgeois

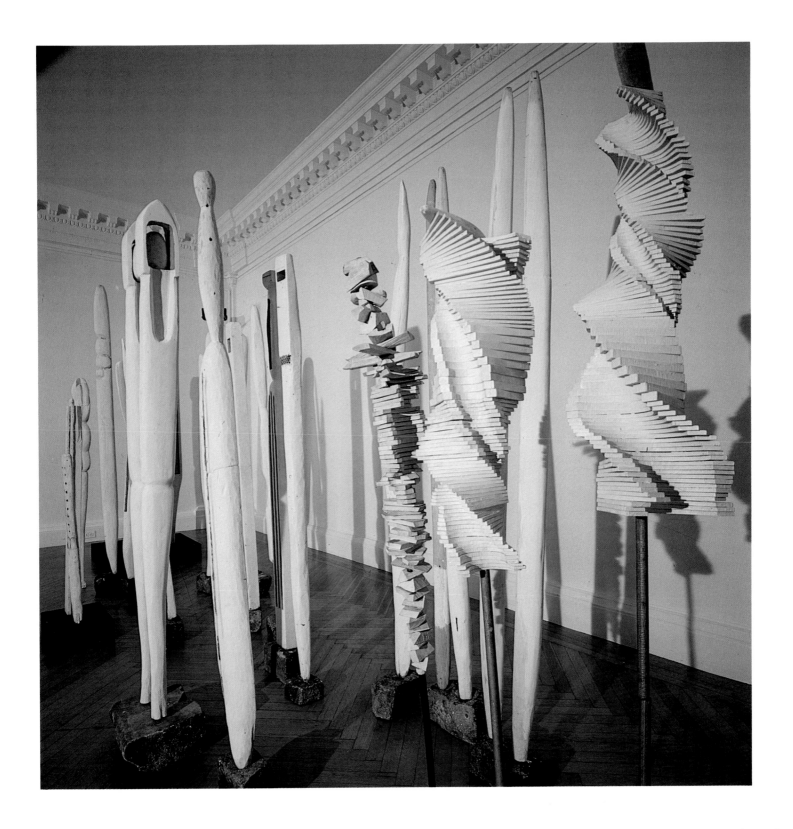

Pl. 1. Figures. ca. 1947–mid-1950s. Painted
wood, each ca. 66″ high. Private collection,
New York. Installation, 1979

38

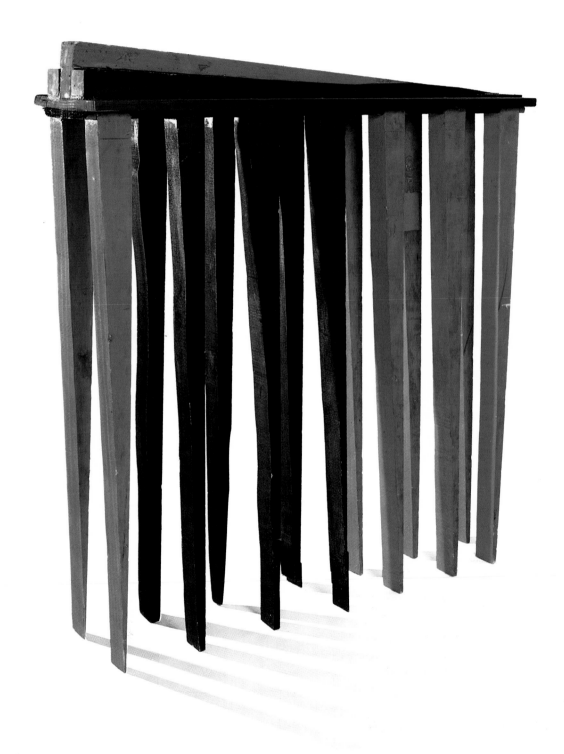

Pl. 2. **The Blind Leading the Blind.** ca. 1947–49.
Painted wood, 67⅛ x 64⅜ x 16¼″. Private
collection, New York

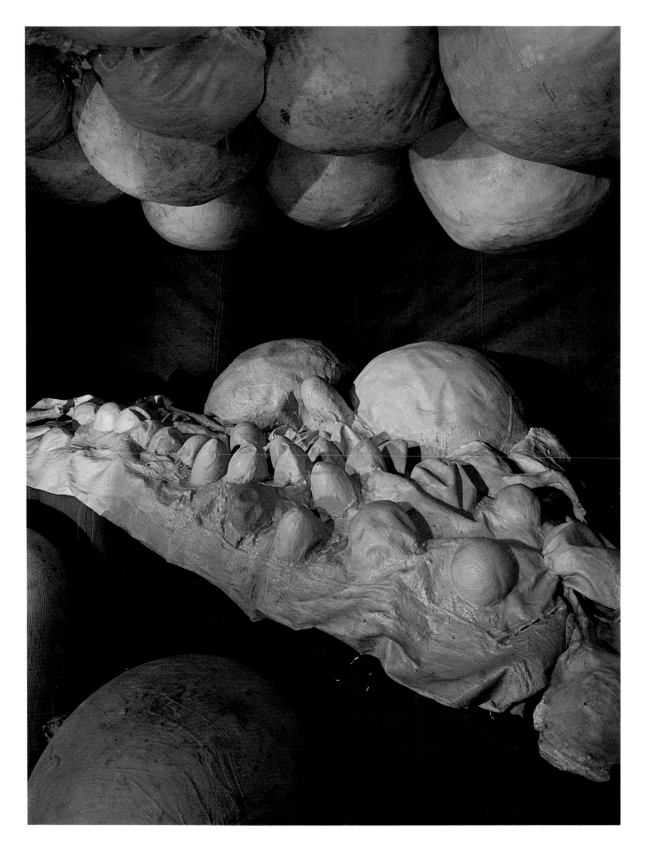

Pl. 3. **The Destruction of the Father,** detail. 1974. Latex, latex over plaster, and mixed media, ca. 9 x 11 x 9′. Private collection, New York

40

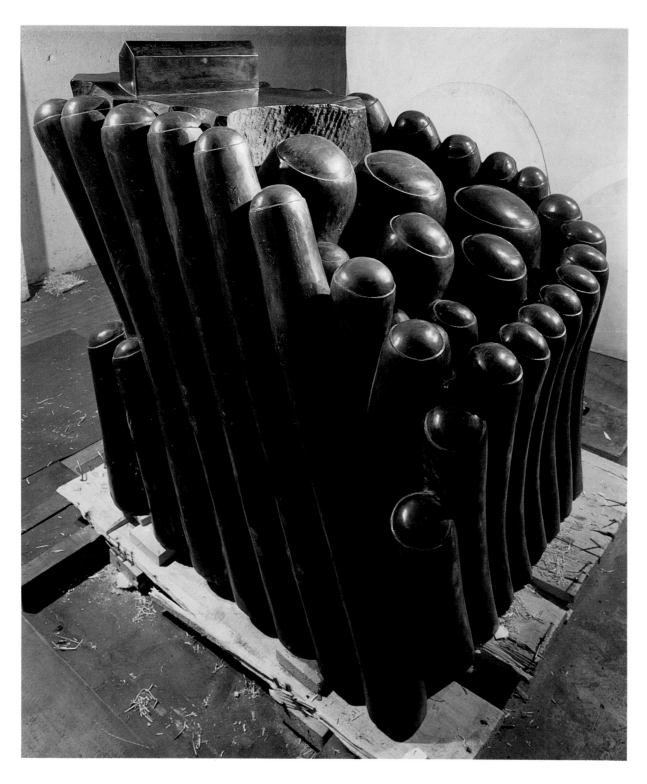

Pl. 4. **Femme-Maison '81** (Woman House '81).
1981. Marble, 48⅛ x 47 x 49⅞″. Private
collection, New York

The grid is a very peaceful thing because nothing can go wrong….everything is complete. There is no room for anxiety…everything has a place…everything is welcome.

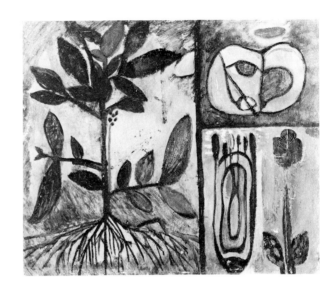

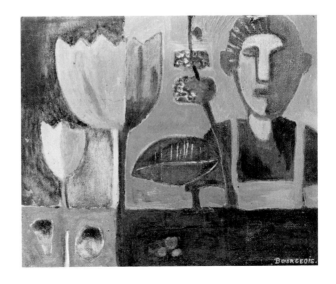

Top right, pl. 5. **Connecticutiana.** ca. 1944–45. Oil on wood, 11 x 42″. Private collection, New York

Right center, pl. 6. **Natural History.** ca. 1944. Oil on canvas, 12 x 18″. Private collection, New York

Bottom left, pl. 7. **Reparation.** ca. 1938–40. Oil on linen, 44 x 26″. Private collection, New York

Bottom right, pl. 8. **Mr. Follet.** ca. 1944–45. Oil on canvas, 12 x 18″. Private collection, New York

44

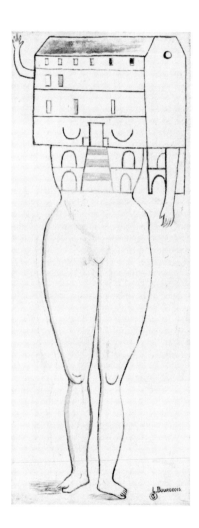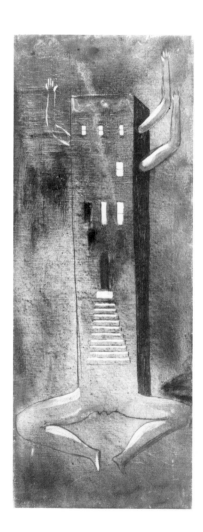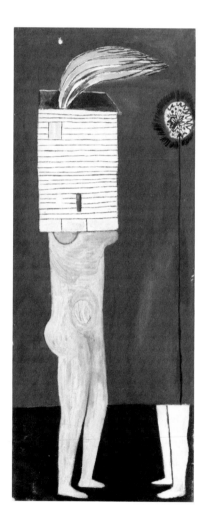

Pl. 9. **Femme-Maison** (Woman House). ca. 1946–47. Ink on linen, 36 x 14″. Collection Ella M. Foshay, New York

Pl. 10. **Femme-Maison** (Woman House). ca. 1946–47. Oil and ink on linen, 36 x 14″. Collection John D. Kahlbetzer, Santa Barbara, California

Pl. 11. **Femme-Maison** (Woman House). ca. 1946–47. Oil and ink on linen, 36 x 14″. The Grenoble Collection of Mr. and Mrs. Eugene P. Gorman, New York

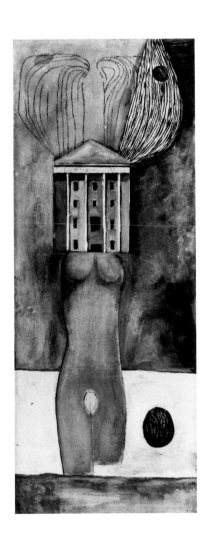

Pl. 12. **Femme-Maison** (Woman House). ca. 1946–47. Oil and ink on linen, 36 x 14". Collection John D. Kahlbetzer, Santa Barbara, California.

Pl. 13. **Fallen Woman.** ca. 1946–47. Oil on linen, 14 x 36". Collection John D. Kahlbetzer, Santa Barbara, California

Pl. 14. Untitled. ca. 1946–47. Oil on linen, 36 x 14". Private collection, New York

Pl. 15. **Red Room.** ca. 1947–48. Oil on linen, 36 x 14". Private collection, New York

Pl. 16. **Abstract Figure.** 1947. Oil on linen,
32 x 24''. Private collection, Westport,
Connecticut

Pl. 17. Untitled. ca. 1947–48. Oil on canvas,
32'' x 8'1''. Private collection, New York

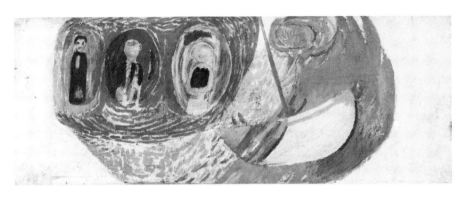

Pl. 18. Untitled. ca. 1946–47. Oil on wood,
14 x 36″. Private collection, New York

Pl. 19. Untitled. ca. 1946–47. Oil on canvas,
11 x 32″. Private collection, New York

Pl. 20. Untitled. ca. 1946–47. Oil on linen, 27 x 45″. Private collection, New York

Pl. 21. **Roof Song.** ca. 1947. Oil on linen, 21 x 31″. The Grenoble Collection of Mr. and Mrs. Eugene P. Gorman, New York

Pl. 22. Drawings on studio wall, 1951. In most cases, India ink on paper

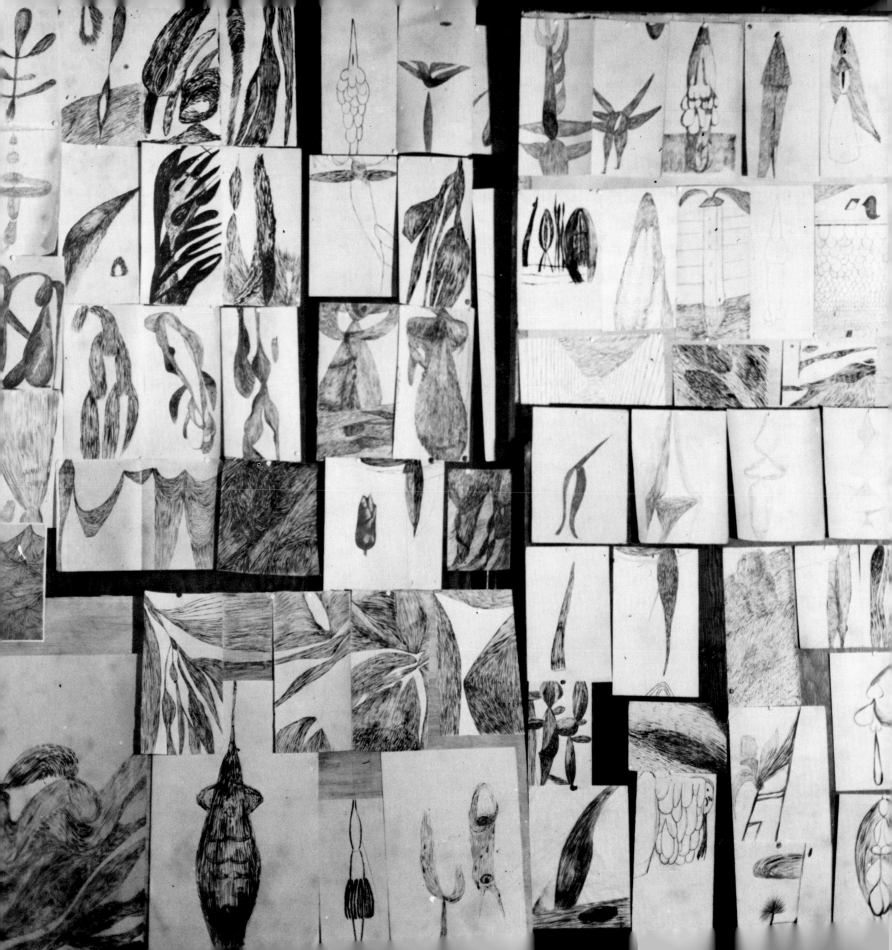

50

Pl. 23. Untitled. ca. 1948–51. Ink on paper, 14¼ x 22½″. Private collection, New York

Pl. 24. Untitled. ca. 1953. Ink on paper, 22 x 14″. Private collection, New York

Pl. 25. Untitled. ca. 1950. Ink and collage on paper, 24 x 30″. Private collection, New York

There are a lot of spirals…but they are not auto-

matic. The spiral is a vacuum….It represents

something….the void, the anxiety void, the void

of anxiety.

Pl. 26. Untitled. ca. 1948–51. Ink and charcoal on paper, 19¾ x 12¾". Private collection, New York

Pl. 27. Untitled. 1953. Ink on paper, 22½ x 14". Private collection, New York

Pl. 28. Untitled. ca. 1968. Colored inks and charcoal on paper, 19¼ x 25". The Metropolitan Museum of Art, New York, Purchase, 1982

52

Plate 1

Once there was a girl and she loved a man.

They had a date next to the eighth street station of the sixth avenue subway.

She had put on her good clothes and a new hat. Somehow he could not come. So the purpose of this picture is to show how beautiful she was. I really mean that she was beautiful.

Plate 2

The solitary death of the Woolworth building.

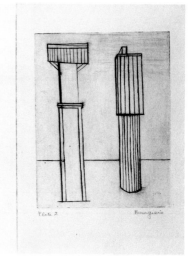

Plate 3

Once a man was telling a story, it was a very good story too, and it made him very happy, but he told it so fast that nobody understood it.

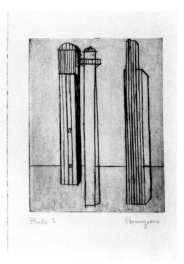

Plate 4

In the mountains of Central France forty years ago, sugar was a rare product.

Children got one piece of it at Christmas time.

A little girl that I knew when she was my mother used to be very fond and very jealous of it.

She made a hole in the ground and hid her sugar in, and she always forgot that the earth is damp.

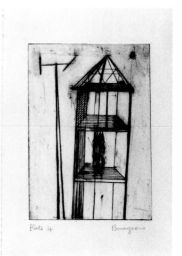

Pls. 29–37. **He Disappeared into Complete Silence.** 1947. Text and engravings, each double-page spread, 10 x 14″. The Museum of Modern Art, New York, Gift of the Junior Council, 1968

Plate 5

Once a man was waving to his friend from the elevator.

He was laughing so much that he stuck his head out and the ceiling cut it off.

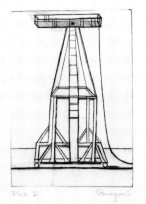

Plate 8

Once an American man who had been in the army for three years became sick in one ear.

His middle ear became almost hard.

Through the bone of the skull back of the said ear a passage was bored.

From then on he heard the voice of his friend twice, first in a high pitch and then in a low pitch.

Later on the middle ear grew completely hard and he became cut off from part of the world.

Plate 6

Leprosarium, Louisiana.

Plate 9

Once there was the mother of a son. She loved him with a complete devotion.

And she protected him because she knew how sad and wicked this world is.

He was of a quiet nature and rather intelligent but he was not interested in being loved or protected because he was interested in something else.

Consequently at an early age he slammed the door and never came back.

Later on she died but he did not know it.

Plate 7

Once a man was angry at his wife, he cut her in small pieces, made a stew of her.

Then he telephoned to his friends and asked them for a cocktail-and-stew party.

They all came and had a good time.

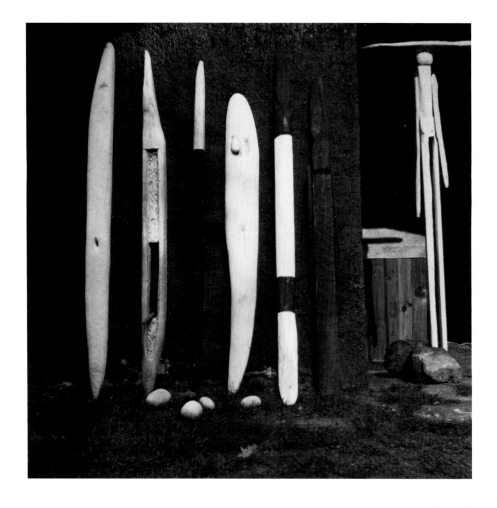

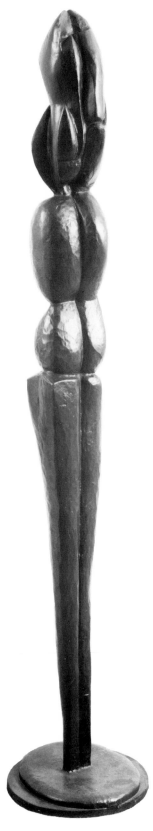

Pl. 38. Country house, Easton, Connecticut, ca. 1947–49

Pl. 39. **Spring.** ca. 1949–50. Bronze (cast ca. 1959), 60″ high. Private collection, New York

Although ultimately each can and does stand alone, the figures can be grouped in various ways and fashions, and each time the tension of their relations makes for a different formal arrangement.

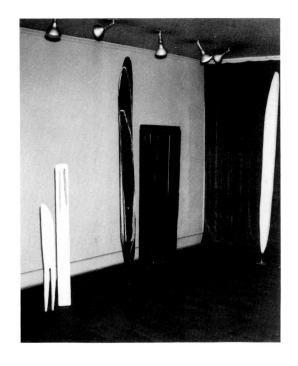

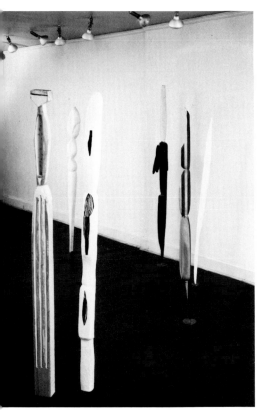

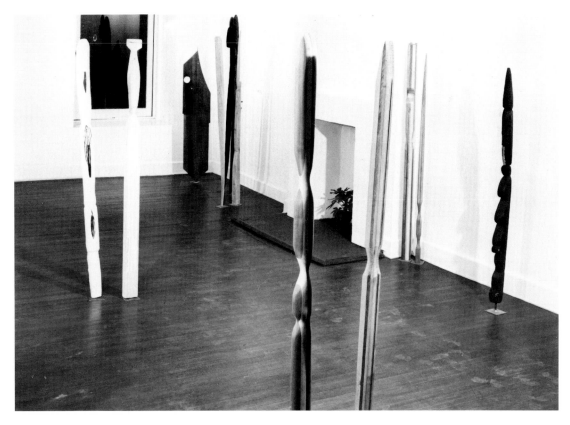

Top, pls. 40–41. Solo exhibition, Peridot Gallery, New York, 1949

Bottom, pls. 42–43. Solo exhibition, Peridot Gallery, New York, 1950

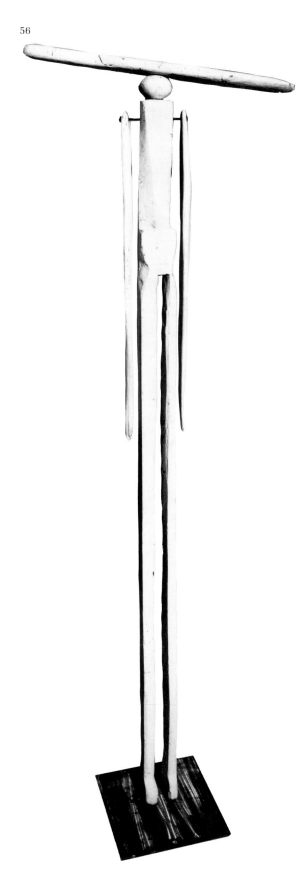

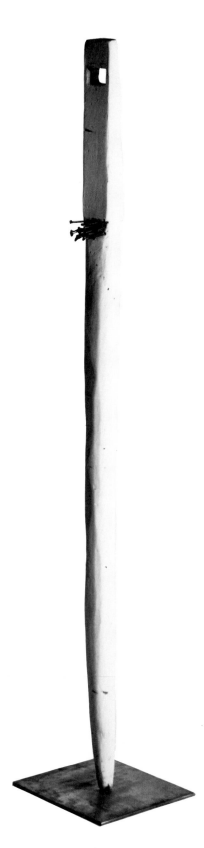

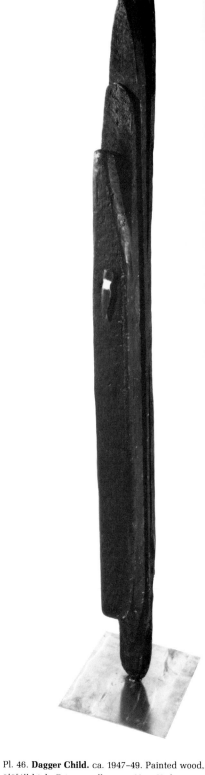

Pl. 44. **Observer.** ca. 1947–49. Painted wood,
6′4½″ high. Private collection, New York

Pl. 45. **Portrait of C.Y.** ca. 1947–49. Painted wood
with nails, 66¾″ high. Private collection,
New York

Pl. 46. **Dagger Child.** ca. 1947–49. Painted wood,
6′3⅜″ high. Private collection, New York

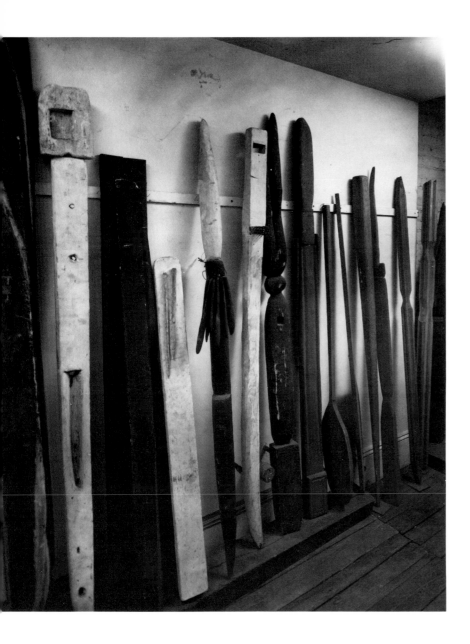

Pl. 47. Bourgeois's studio, 1950s

Pl. 48. **Portrait of Jean-Louis.** ca. 1947–49. Painted wood, 35″ high. Private collection, New York

Pl. 49. **Sleeping Figure.** 1950. Wood, 6′2½″ high. The Museum of Modern Art, New York, Katharine Cornell Fund, 1951

58

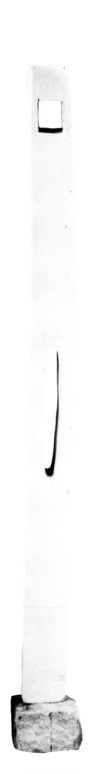

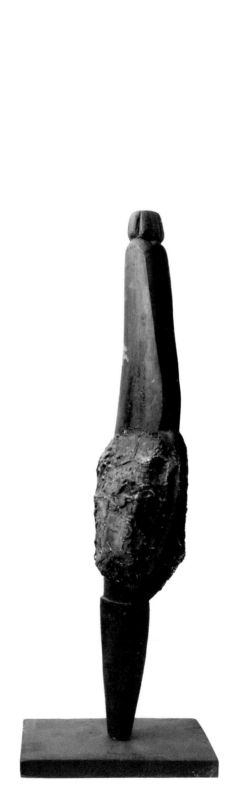

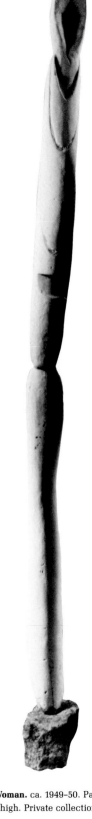

Pl. 50. **Woman in the Shape of a Shuttle.**
ca. 1947–49. Painted wood, ca. 65″ high. Private
collection, New York

Pl. 51. **Pillar.** ca. 1947–49. Painted wood, 61½″
high. Private collection, New York

Pl. 52. **Pregnant Woman.** ca. 1947–49. Painted
wood with plaster, 52″ high. Private collection,
New York

Pl. 53. **Spoon Woman.** ca. 1949–50. Painted
wood, ca. 6′3″ high. Private collection,
New York

59

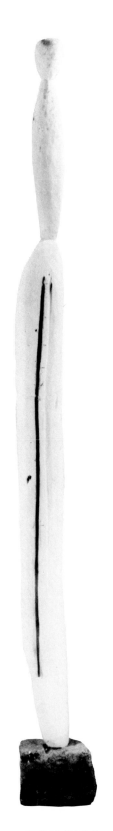

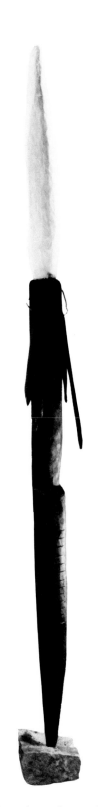

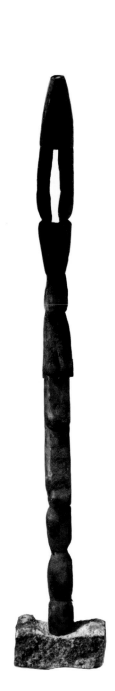

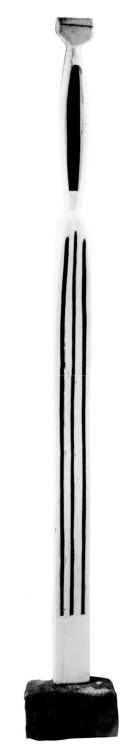

Pl. 54. **Pillar.** ca. 1949–50. Painted wood,
69″ high. Private collection, New York

Pl. 55. **Persistent Antagonism.** ca. 1949–50.
Painted wood, 67⅞″ high. Private collection,
New York

Pl. 56. **Breasted Woman.** ca. 1949–50. Painted
wood, 54″ high. Private collection, New York

Pl. 57. **Pillar.** ca. 1949–50. Painted wood,
64⅜″ high. Private collection, New York

Now even though the shapes are abstract, they represent people. They are delicate as relationships are delicate. They look at each other and they lean on each other.

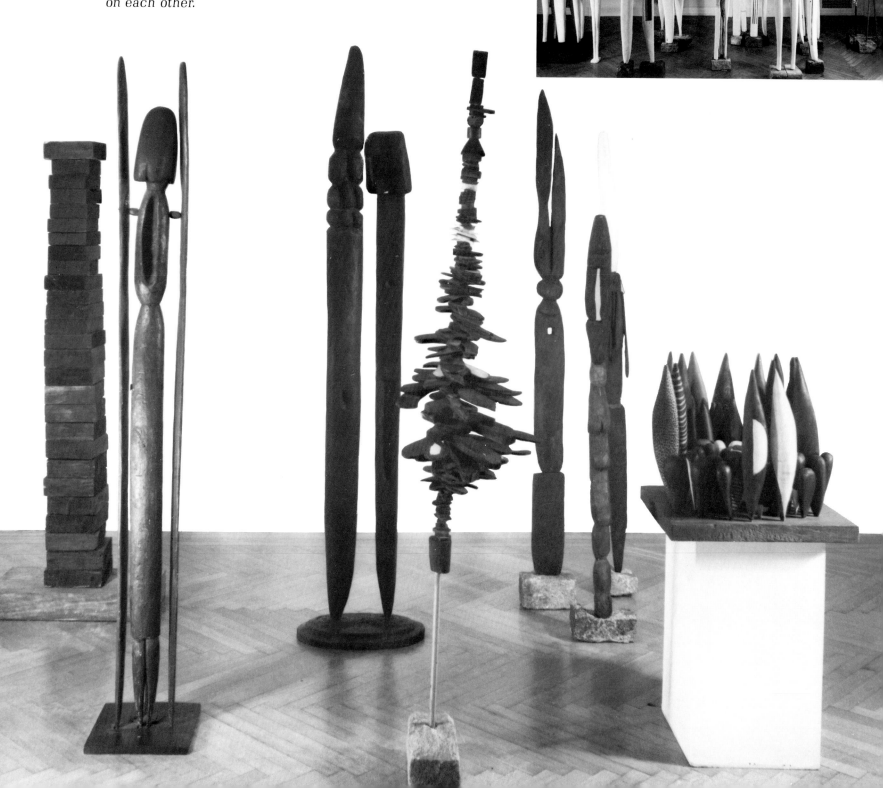

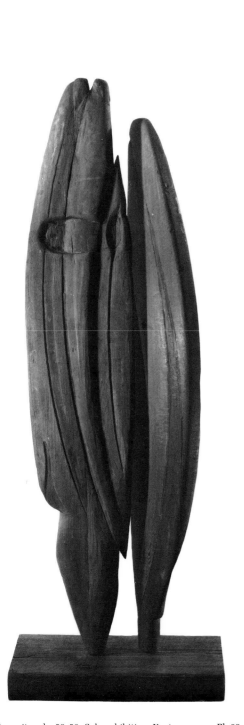

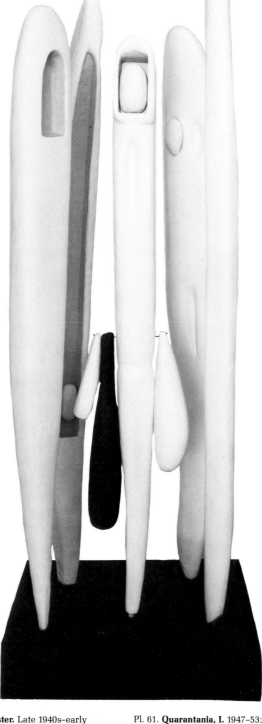

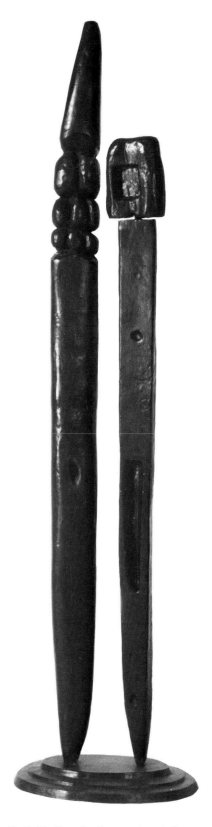

Opposite, pls. 58–59. Solo exhibition, Xavier Fourcade, Inc., New York, 1979

Pl. 60. **Brother and Sister.** Late 1940s–early 1950s. Stained wood, 69″ high. Private collection, New York

Pl. 61. **Quarantania, I.** 1947–53; reassembled 1981. Painted wood on wood base, 6′9¼″ high. The Museum of Modern Art, New York, Gift of Ruth Stephan Franklin, 1969

Pl. 62. **The Listening One.** ca. 1947–49. Bronze (cast 1981), 6′8″ high. American Medical Association, Washington, D.C.

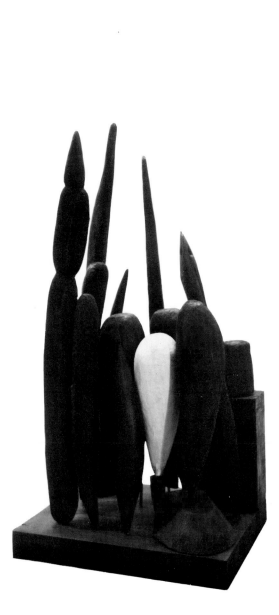

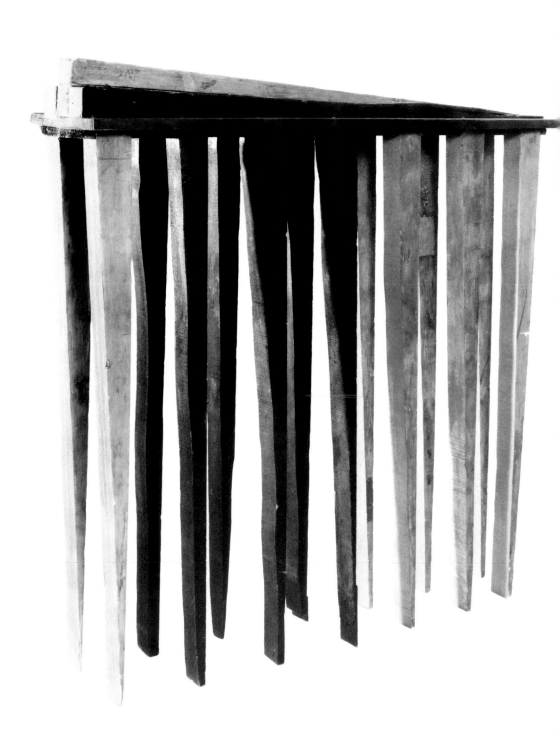

Pl. 63. **Forêt (Night Garden).** 1953. Painted wood,
37 x 18⅞ x 14¾". Greenville County Museum
of Art, Greenville, South Carolina, Gift of
Arnold H. Maremont, 1973

Pl. 64. **The Blind Leading the Blind.** ca. 1947–49.
Painted wood, 67⅛ x 64⅜ x 16¼". Private
collection, New York

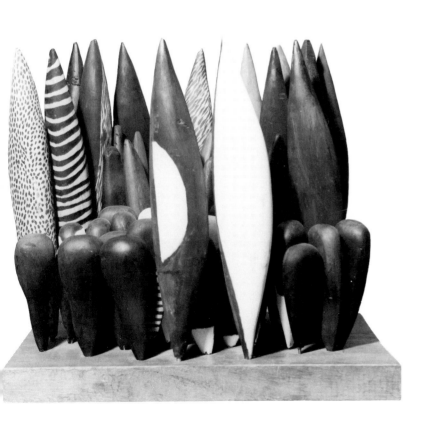

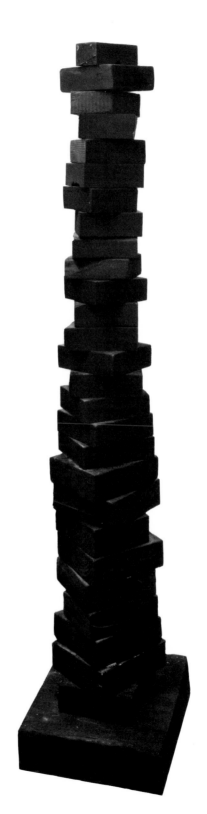

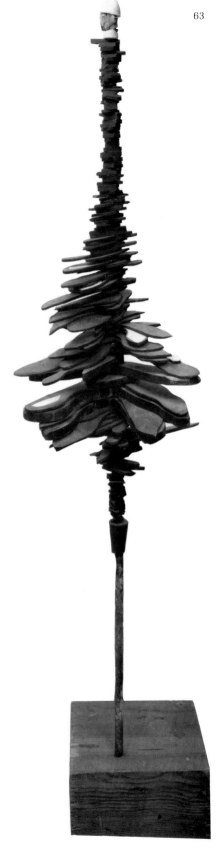

63

Pl. 65. Untitled. ca. 1948–51. Ink on paper, 14 x 11''. Private collection, New York

Pl. 66. **One and Others.** 1955. Painted wood, 18¼ x 20 x 16¾''. Whitney Museum of American Art, New York

Pl. 67. **Memling Dawn.** ca. 1951. Painted wood, 67¼'' high. Private collection, New York

Pl. 68. **Femme Volage** (Fickle Woman). Early–mid-1950s. Painted wood, 6'⅜'' high. Private collection, New York

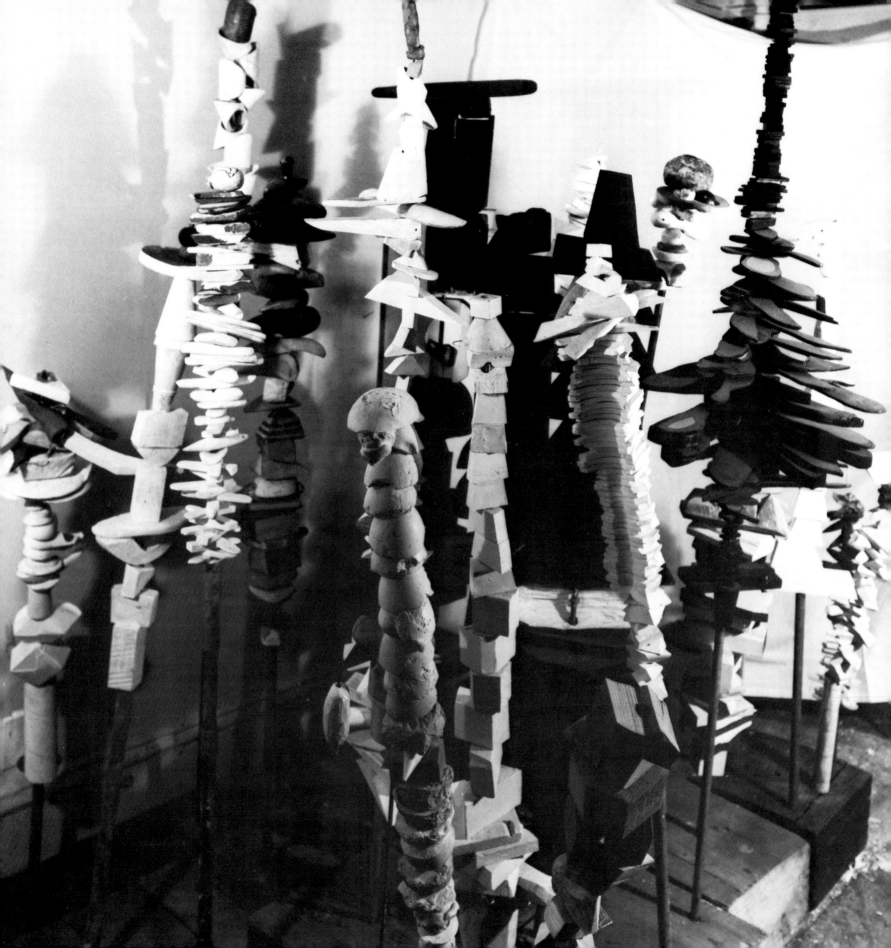

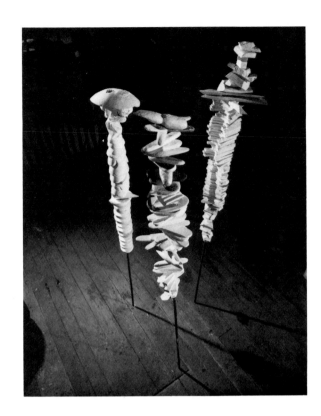

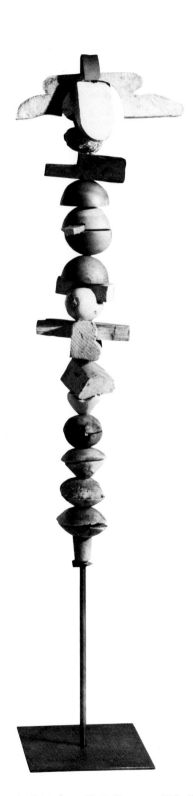

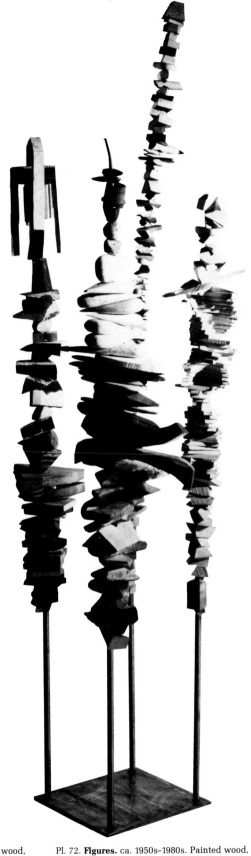

Opposite, pl. 69. Bourgeois's studio, 1960s

Pl. 70. **Spiral Women.** Early–mid-1950s. Painted wood and plaster, ca. 60″ high. Private collection, New York

Pl. 71. **Figure.** ca. 1950s–1980s. Painted wood, 65¼″ high. Private collection, New York

Pl. 72. **Figures.** ca. 1950s–1980s. Painted wood, 6′1″ high. Private collection, New York

66

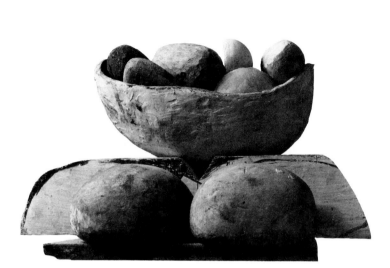

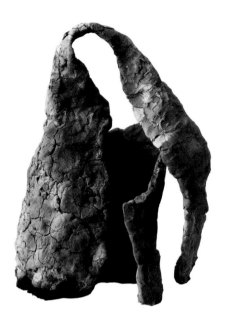

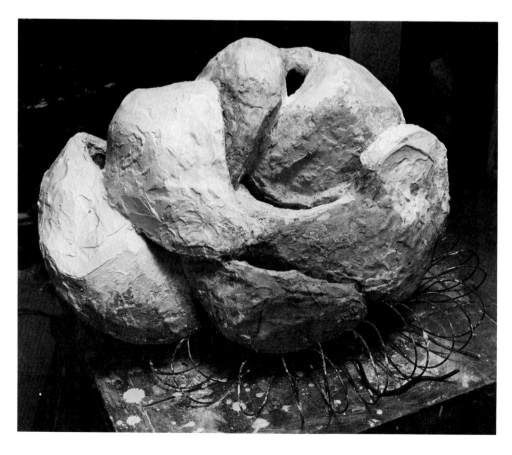

Pl. 73. **Still Life.** ca. 1960–62. Plaster and wood, 11½ x 19⅛ x 18⅛″. Museum of Art, Rhode Island School of Design, Providence

Above right, pl. 74. **Etretat.** 1960. Self-hardening clay, 10 x 7¼ x 5¾″. Private collection, New York

Pl. 75. **Lair.** ca. 1962–63. Plaster, 18⅛ x 29½ x 23½″. Private collection, New York

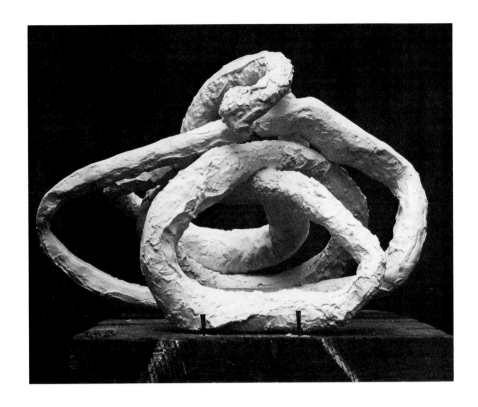

When you experience pain, you can withdraw and protect yourself. But the security of the lair can also be a trap.

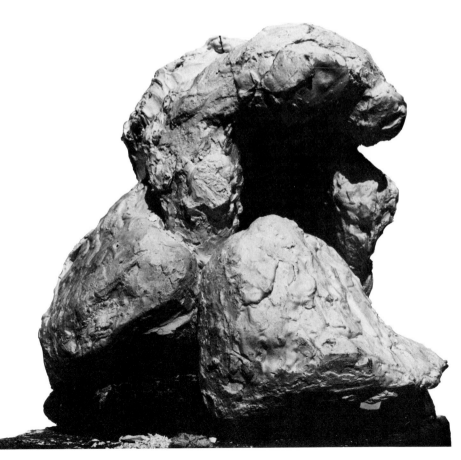

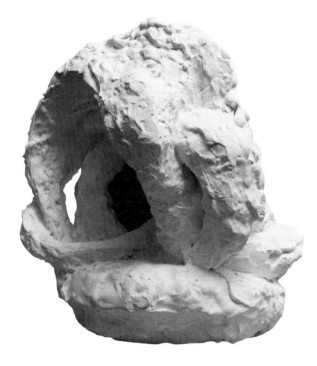

Pl. 76. **Spiral/Summer.** 1960. Plaster, ca. 14 x 21". Private collection, New York

Pl. 77. **Homage to Bernini.** ca. 1967. Bronze, 21½ x 20 x 23". Private collection, New York

Pl. 78. **Rondeau for L.** 1963. Plaster, ca. 11 x 11 x 10½". Private collection, New York

68

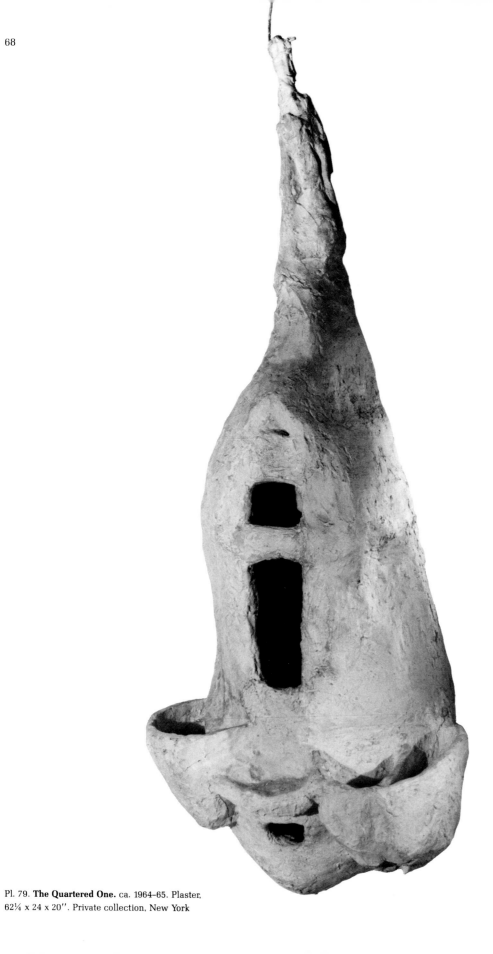

Pl. 79. **The Quartered One.** ca. 1964–65. Plaster,
62¼ x 24 x 20″. Private collection, New York

Pl. 80. Untitled. 1953. Ink on paper, 22 x 14″.
Private collection, New York

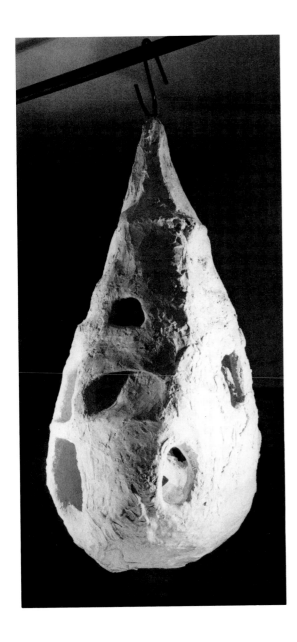

This is the way I experience my torso…somehow with a certain dissatisfaction and regret that one's own body is not as beautiful as one would like it to be. It doesn't seem to measure up by any standard of beauty.

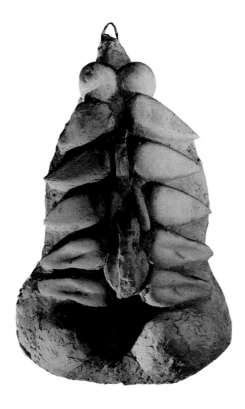

Pl. 81. **Fée Couturière** (Fairy Dressmaker). ca. 1963. Plaster, 39½″ high x 22½″ diam. Private collection, New York

Pl. 82. **Torso/Self-Portrait.** ca. 1963–64. Plaster, 24¾ x 16 x 7⅛″. Private collection, New York

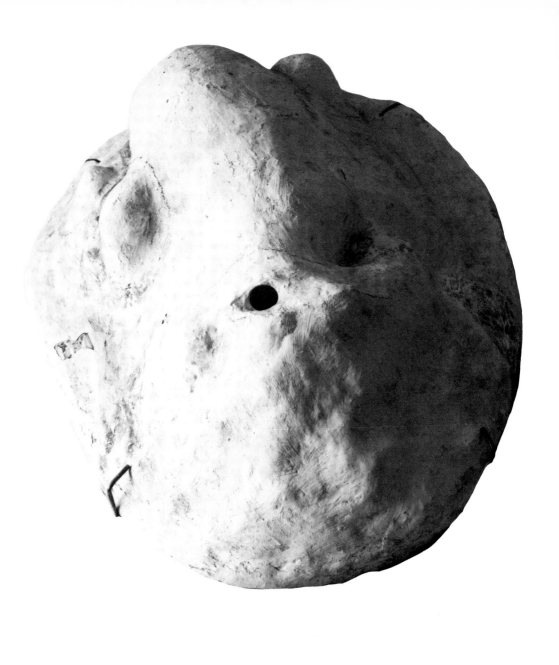

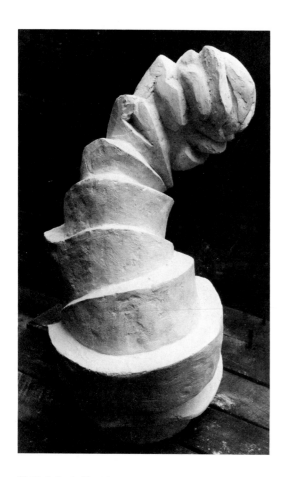

Pl. 83. **Labyrinthine Tower.** ca. 1962. Plaster, 18″ high. Private collection, New York

Pl. 84. **Amoeba.** ca. 1963–65. Plaster, 36 x 29¾ x 12″. Private collection, New York

Opposite, pls. 85 (inset)–86. Solo exhibition, Stable Gallery, New York, 1964

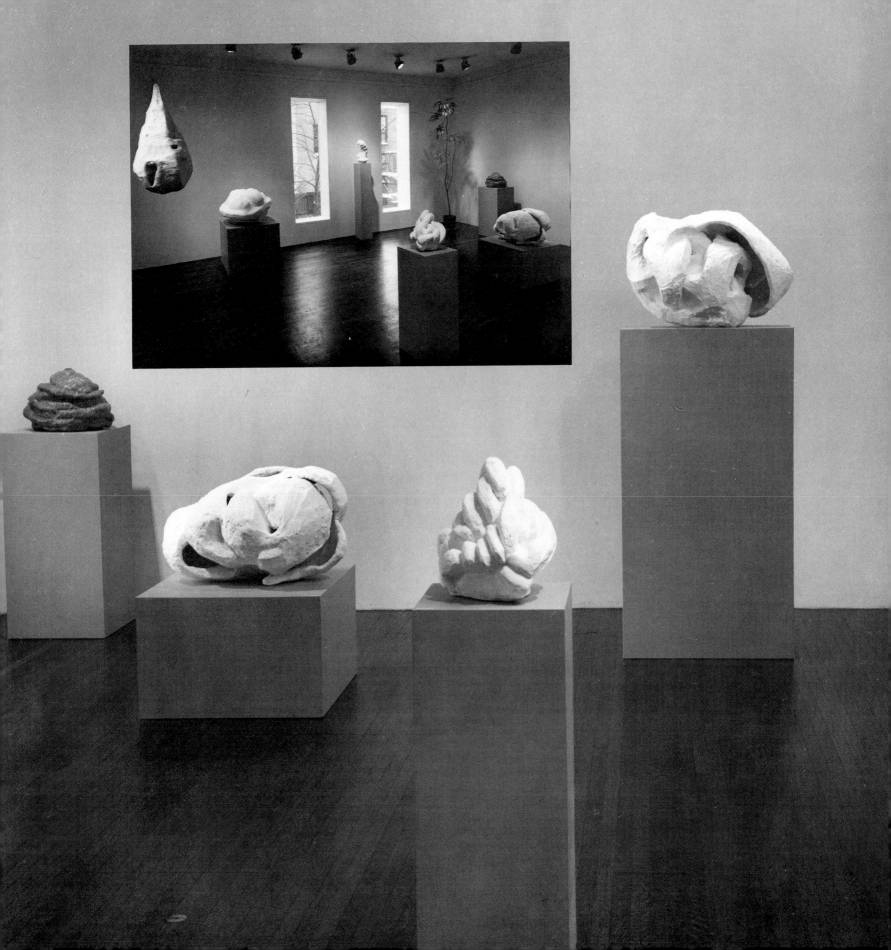

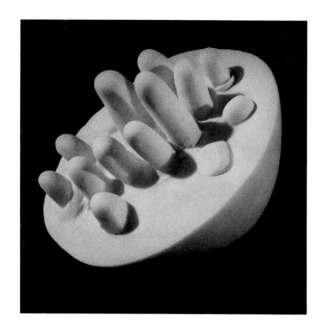

The unconscious is something which is volcanic in tone and yet you cannot do anything about it. You had better be its friend, or accept it, or love it if you can, because it might get the better of you. You never know.

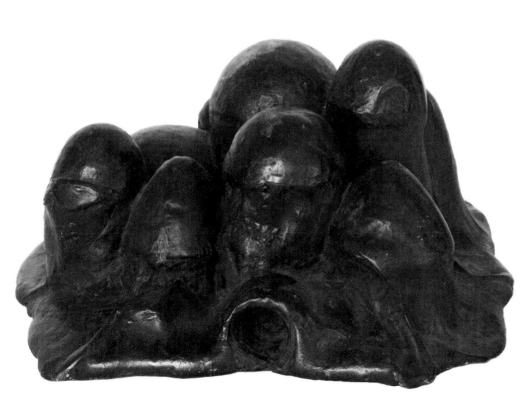

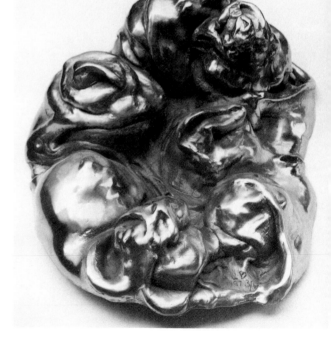

Pl. 87. **Germinal.** 1967. Marble, 5⅜ x 7⅜ x 6¼″. Private collection, New York

Pl. 88. **Unconscious Landscape.** 1967. Bronze (cast 1968), 12 x 22 x 24″. Private collection, New York

Pl. 89. **End of Softness.** 1967. Bronze, 7 x 20⅜ x 15¼″. Private collection, New York

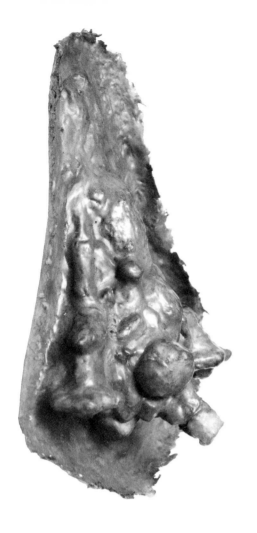

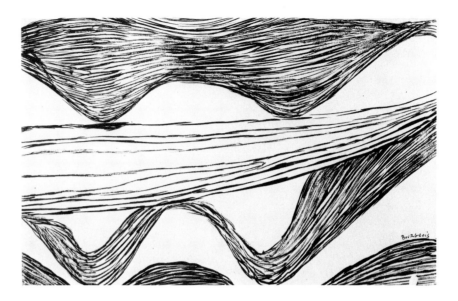

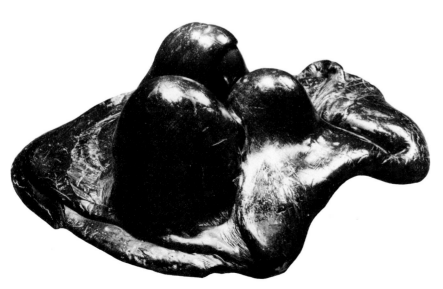

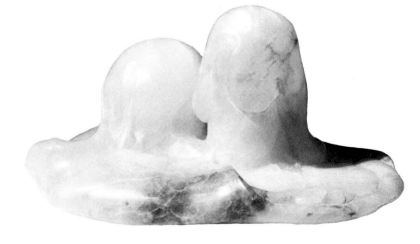

Pl. 90. **Portrait.** 1963. Latex, 15⅜ x 12⅜ x 4⅛″.
Collection Arthur Drexler, New York

Pl. 91. **Soft Landscape, I.** 1967. Plastic,
6¾ x 19¾ x 17¼″. Private collection, New York

Pl. 92. **Soft Landscape, II.** 1967. Alabaster, 6⅞ x
14⅝ x 9⅝″. Private collection, New York

Pl. 93. Untitled. ca. 1948–51. Ink on paper,
9½ x 15″. Private collection, New York

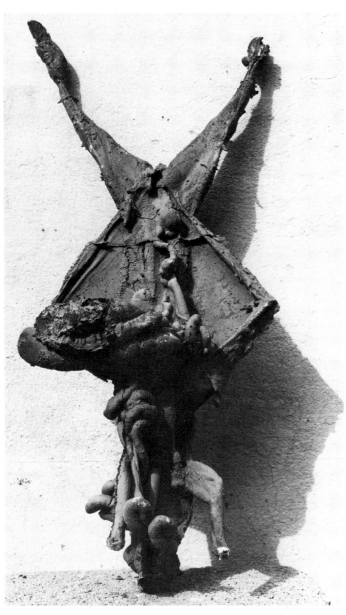

74

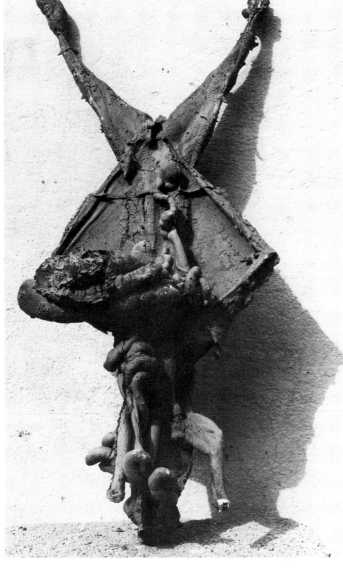

Pl. 94. **Rabbit.** ca. 1970. Bronze, 22½ x 11 x 6″.
Private collection, New York

Pl. 95. **Janus Fleuri** (Janus Blossoming). ca. 1968.
Bronze, 10⅛ x 12½ x 8⅜″. Private collection,
New York

75

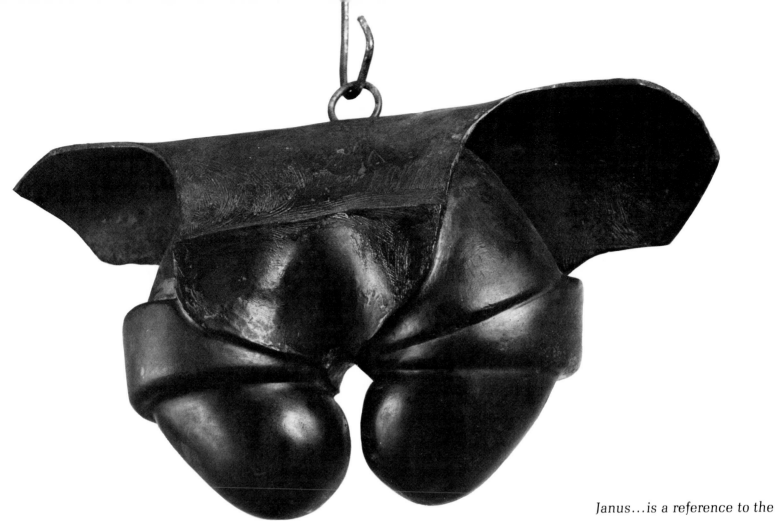

Janus...is a reference to the kind of polarity we represent.... The polarity I experience is a drive toward extreme violence and revolt...and a retiring, I wouldn't say passivity...but a need for peace, a complete peace with the self, with others, and with the environment.

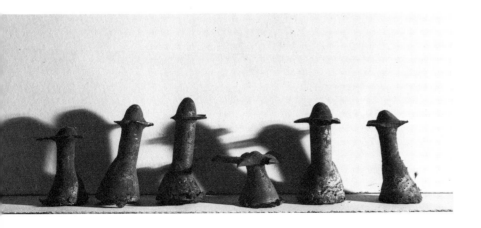

Pl. 96. **Hanging Janus.** ca. 1968–71. Bronze, 10¾ x 21¼ x 6¾". Private collection, New York

Pl. 97. Untitled. ca. 1970–72. Bronze, tallest: 6¼" high x 3⅜" diam. Private collection, New York

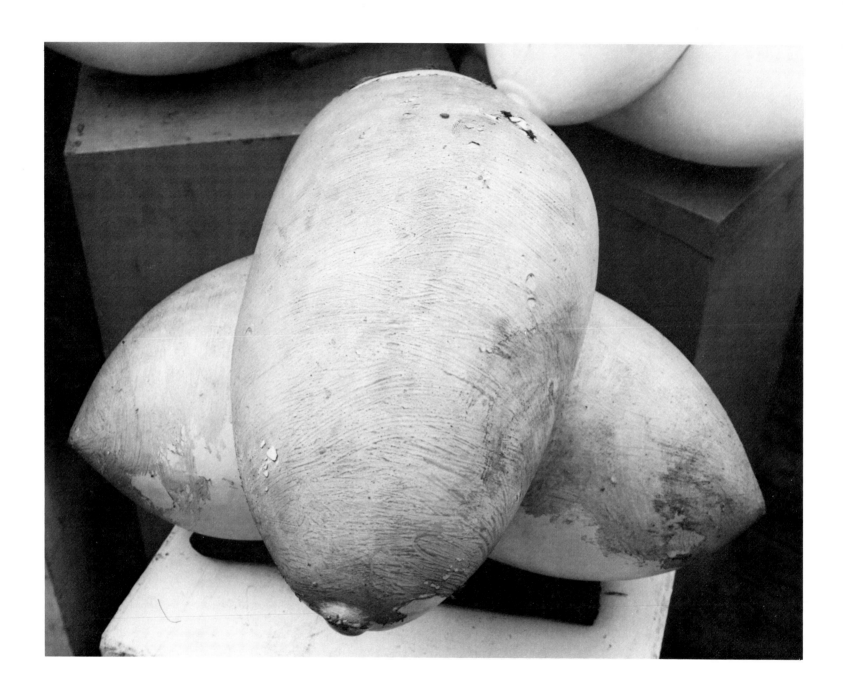

Pl. 98. **Trani Episode.** ca. 1971–72. Hydrocal and latex, 16½ x 23⅛ x 23¼″. Private collection, New York

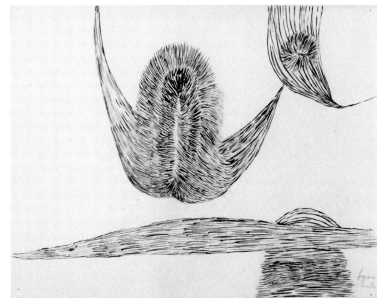

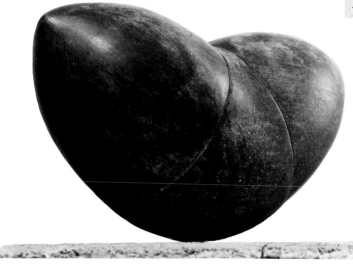

Top, pl. 99. **Point of Contact.** ca. 1967–68. Bronze, 5½ x 10¼ x 3½″. The Metropolitan Museum of Art, New York, Gift of Ruth S. Franklin, 1973

Bottom left, pl. 100. **Molotov Cocktail.** 1968. Bronze, 4½ x 8 x 4¼″. Private collection, New York

Bottom right, pl. 101. **Heart.** ca. 1970. Bronze, 8½ x 8 x 12″. Private collection, New York

Pl. 102. **Figure Voile** (Sail Figure). ca. 1950. Ink on paper, 9¾ x 12¾″. Private collection, New York

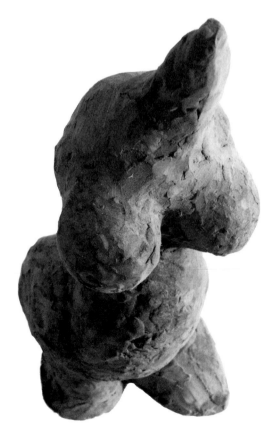

Pl. 103. **Figure.** 1960. Plaster, 15⅛ x 8⅛ x 6⅛".
Private collection, New York

Pl. 104. **Figure,** back view

Pl. 105. Untitled. ca. 1968–69. Self-hardening
clay, 12 x 5 x 3". Private collection, New York

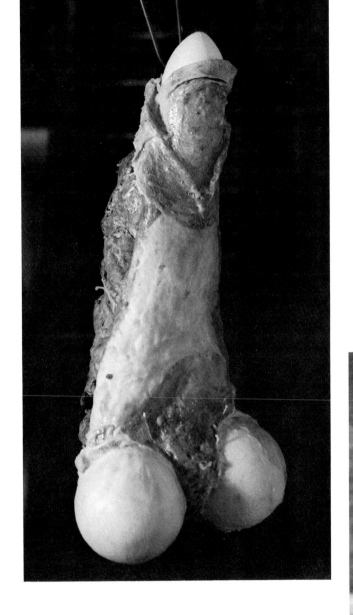

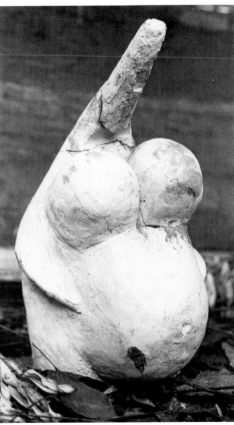

A ferocious desire for independence is present in all the work. It is in all the figures... a determination to survive at whatever fragile level you can achieve.

Pl. 106. **Harmless Woman.** ca. 1969. Bronze, 11⅛ x 4½ x 4½″. Private collection, New York

Pl. 107. **Fillette.** 1968. Latex, 23½ x 10½ x 9¾″. Private collection, New York

Pl. 108. **Fragile Goddess.** ca. 1970. Self-hardening clay, 10¼ x 5⅝ x 5⅜″. Private collection, New York

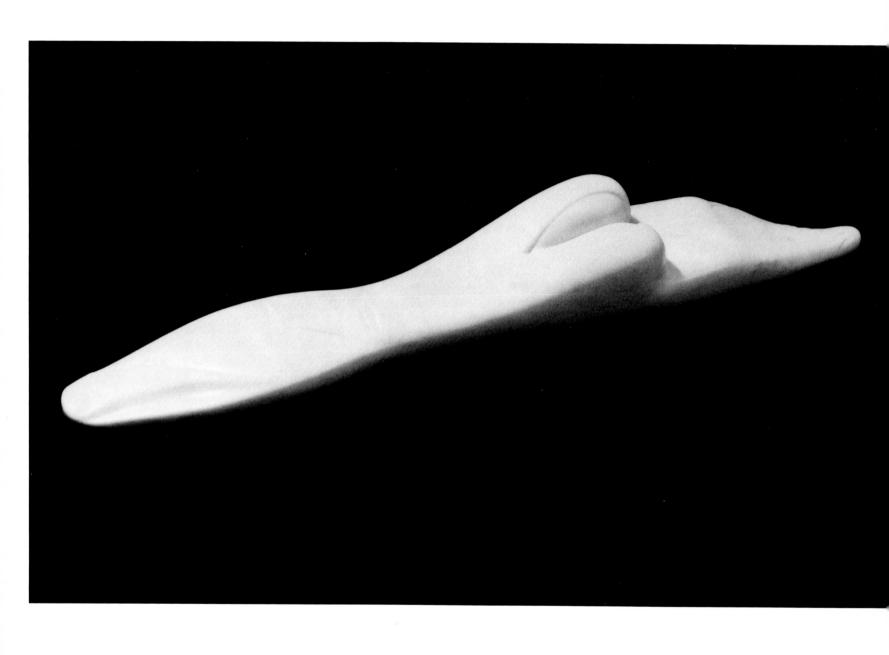

Pl. 109. **Femme Couteau** (Knife Woman).
ca. 1969–70. Marble, 26″ long. Collection Jerry
and Emily Spiegel, Kings Point, New York

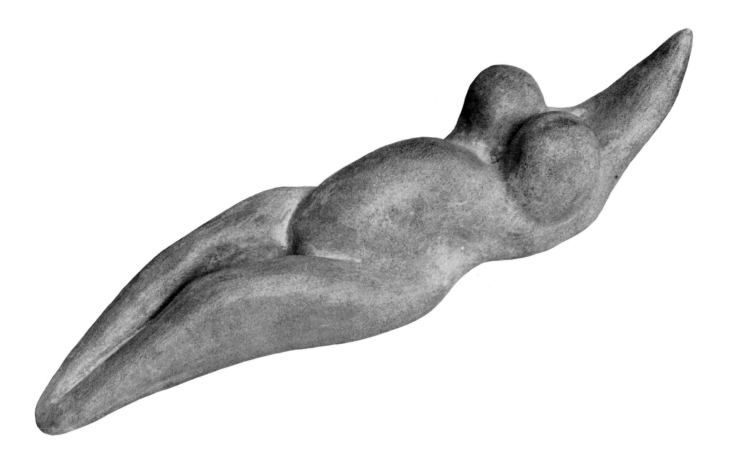

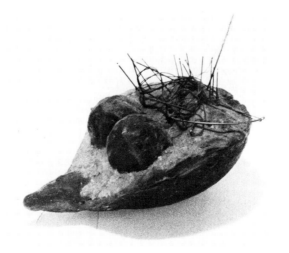

Pl. 110. **Femme Couteau '81** (Knife Woman '81). 1981. Marble, 5 x 24 x 5⅜''. Private collection, New York

Pl. 111. **Femme Pieu** (Stake Woman). ca. 1970. Wax and metal pins, 3½ x 2½ x 6''. Collection Lucy R. Lippard, New York

Pl. 112. Untitled. ca. 1970. Marble, 4½'' high x 3⅛'' diam. Private collection, New York

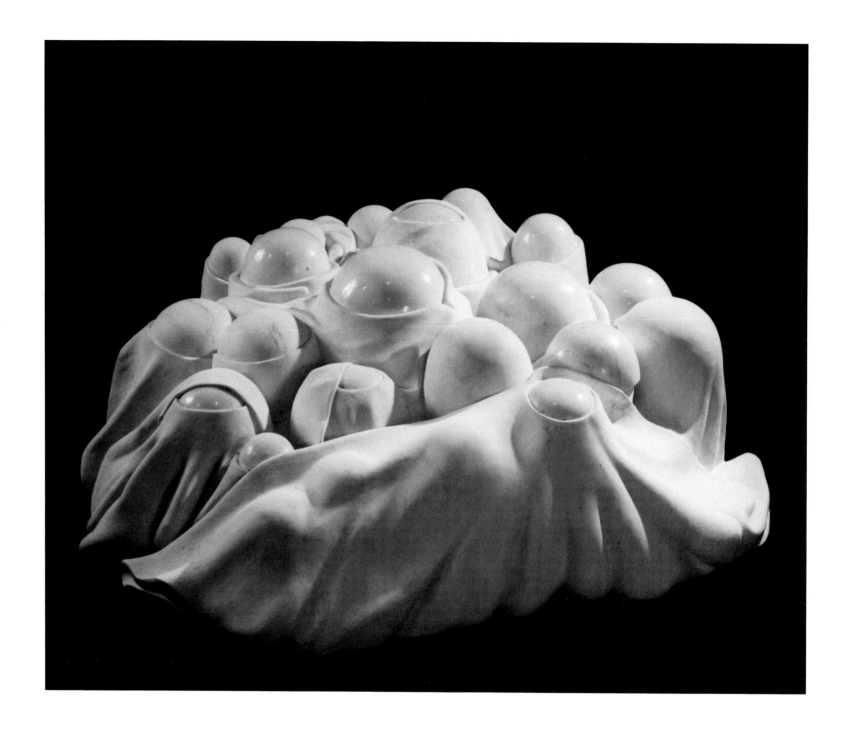

Pl. 113. **Cumul, I.** 1969. Marble, 22⅜ x 50 x
48″. Musée National d'Art Moderne, Centre
Georges Pompidou, Paris

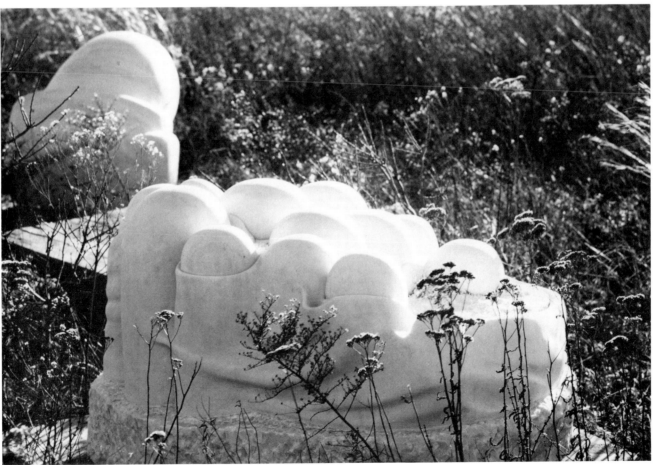

Pl. 114. **Cumuls.** 1970. Sepia and charcoal on paper, 25½ x 39½″. Private collection, New York

Pl. 115. **Cumul, III/Avenza.** 1969. Marble, 23½ x 42½ x 39″. Private collection, New York. Installed at Sam's Creek, Bridgehampton, Long Island, 1970s. In background, *Sleep, II*, pl. 117

The element of Sleep was so important for me. It was like a self-portrait that stayed for many years and was incorporated into other pieces....

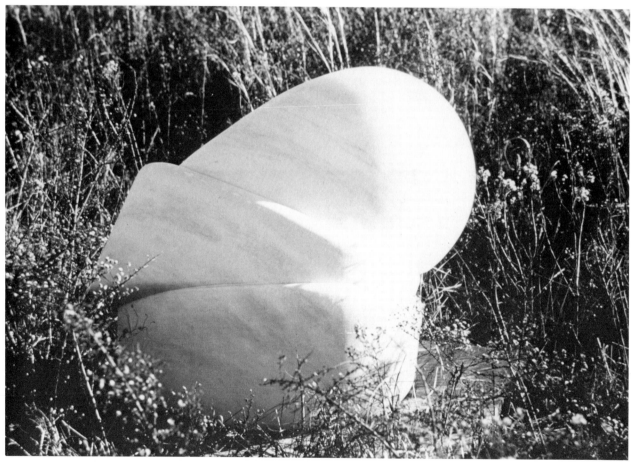

Pl. 116. **Eyes.** ca. 1972. Marble, 44 x 36 x 36″.
Private collection, New York

Pl. 117. **Sleep, II.** 1967. Marble, 23⅜ x 30¼ x
23¾″. Private collection, New York

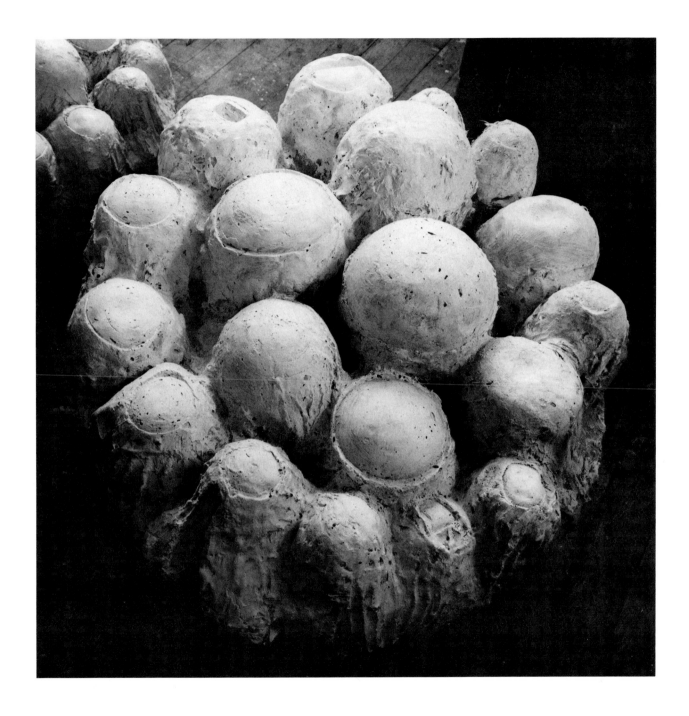

Pl. 118. **Avenza Revisited.** ca. 1972. Plaster and cement, 23½″ high x 41″ diam. Private collection, New York

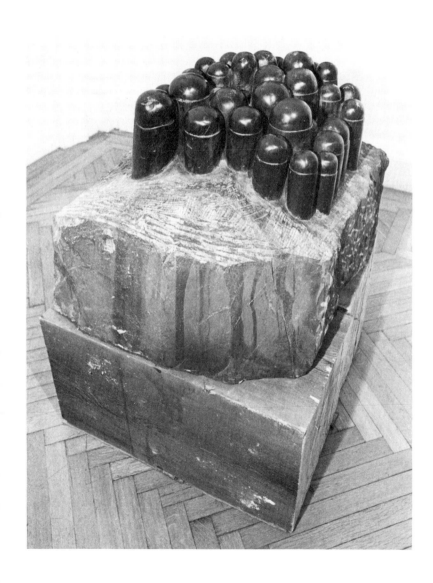

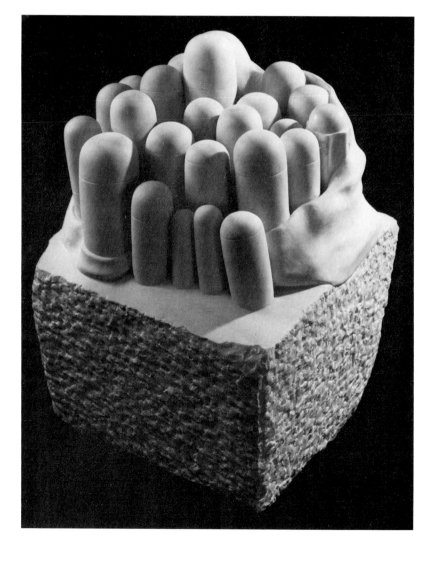

Pl. 119. **Colonnata.** 1968. Marble, 23 x 32¾ x 27¼". Private collection, New York

Pl. 120. **Clamart.** 1968. Marble, 31 x 24 x 27". Collection Mr. and Mrs. Oscar Kolin, New York

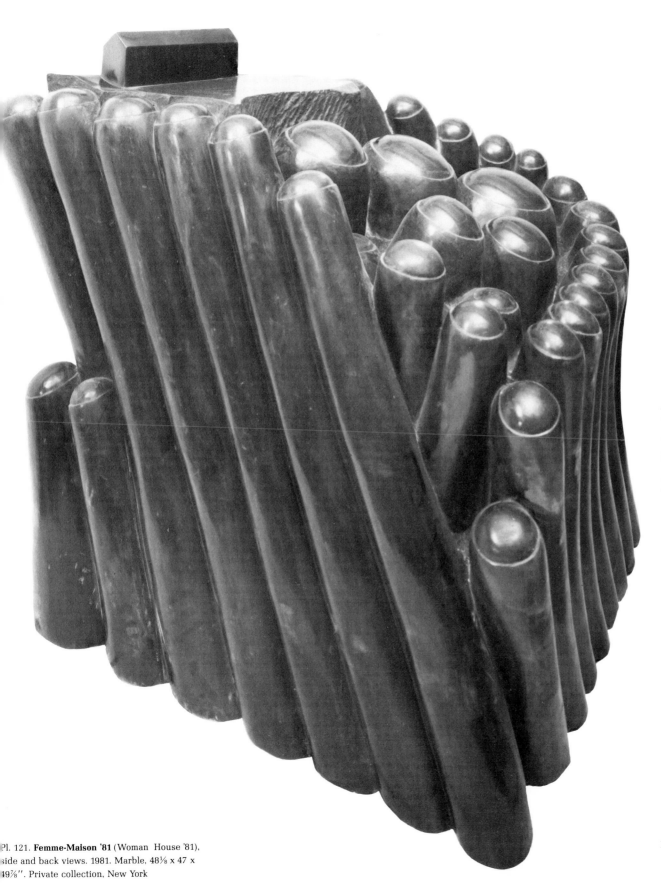

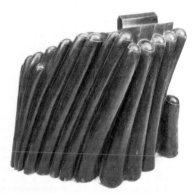

Pl. 121. **Femme-Maison '81** (Woman House '81), side and back views. 1981. Marble, 48⅛ x 47 x 49⅞". Private collection, New York

Pl. 122. **Femme-Maison '81,** front and side views

88

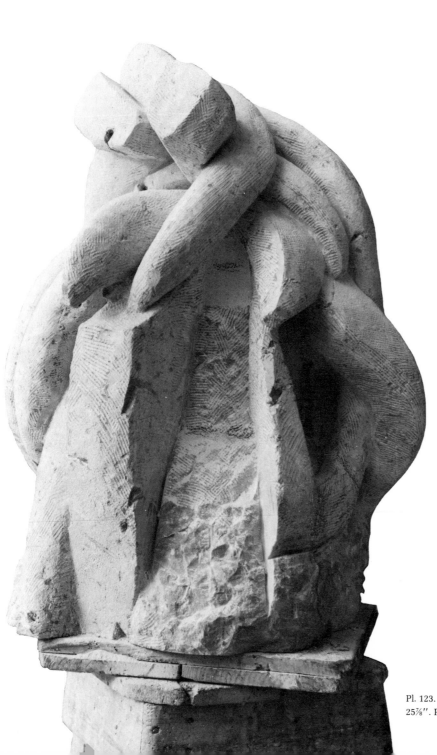

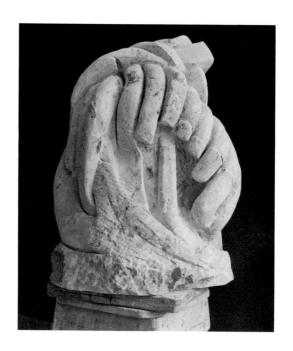

Pl. 123. **Baroque.** ca. 1970. Marble, 37¼ x 25¼ x 25⅞". Private collection, New York

Pl. 124. **Baroque,** back view

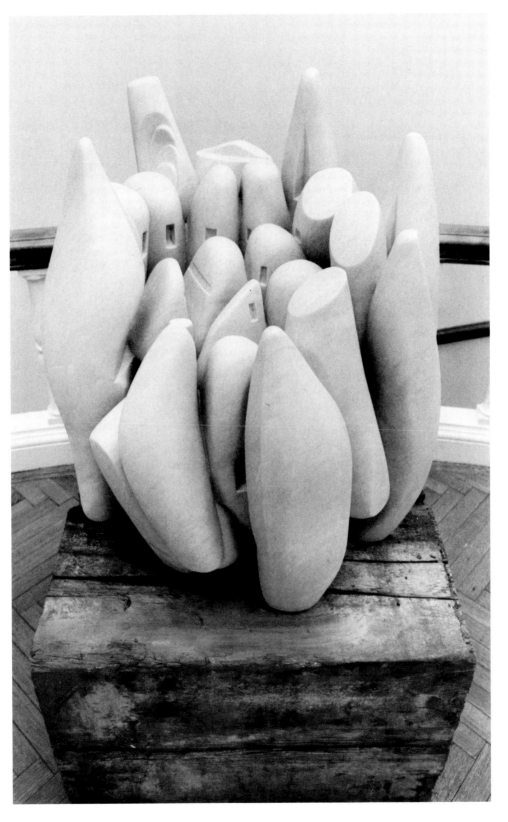

Pl. 125. **Eye to Eye.** ca. 1970. Marble, 31½″ high
x 29⅞″ diam. Private collection, New York

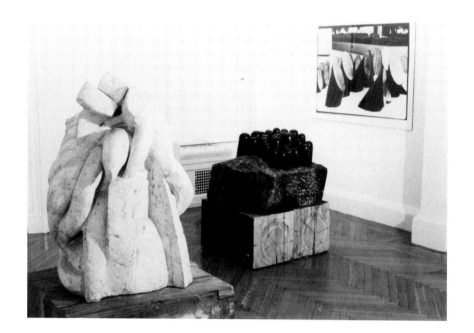

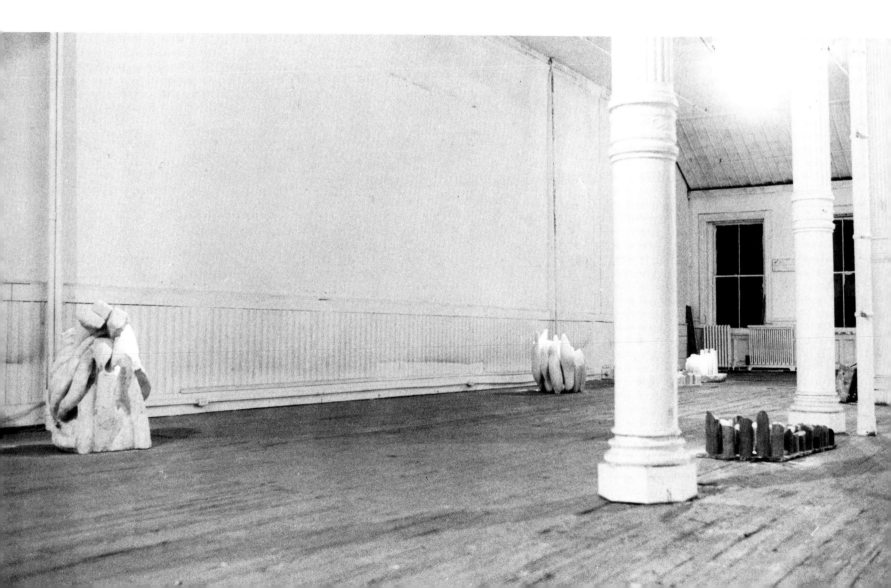

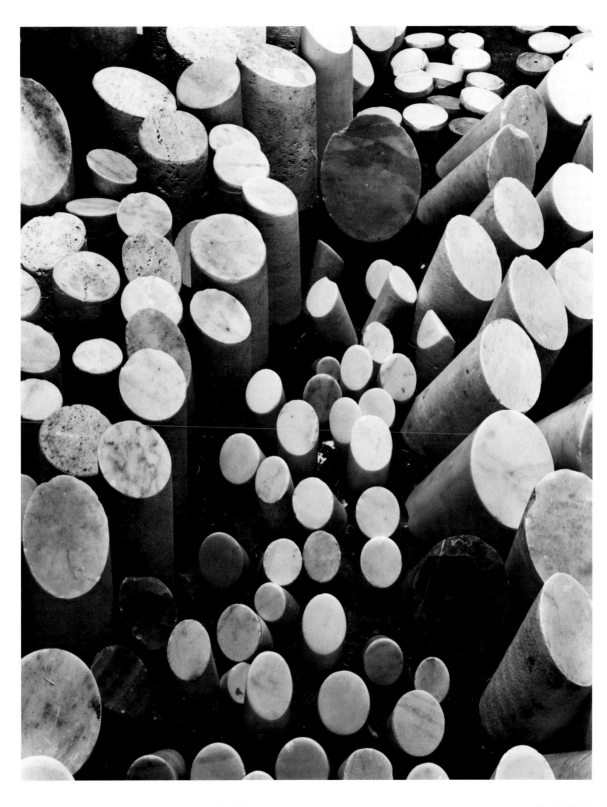

Opposite top, pl. 126. Solo exhibition, Xavier Fourcade, Inc., New York, 1980

Opposite bottom, pl. 127. Solo exhibition, 112 Greene Street Gallery, New York, 1974

Pl. 128. **Number Seventy-two (The No March),** detail. 1972. Marble, 10″ x 17′ x 10′. Storm King Art Center, Mountainville, New York, Purchased with the Aid of Funds from the National Endowment for the Arts

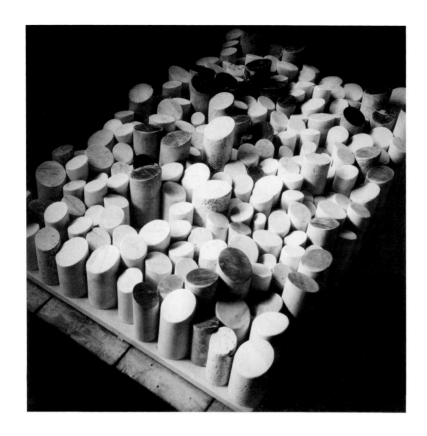

People feel each other, per-

ceive each other, turn toward

or away from each other...

fated to walk together as part

of an ongoing phenomenon...

always perceiving others and

adjusting to them.

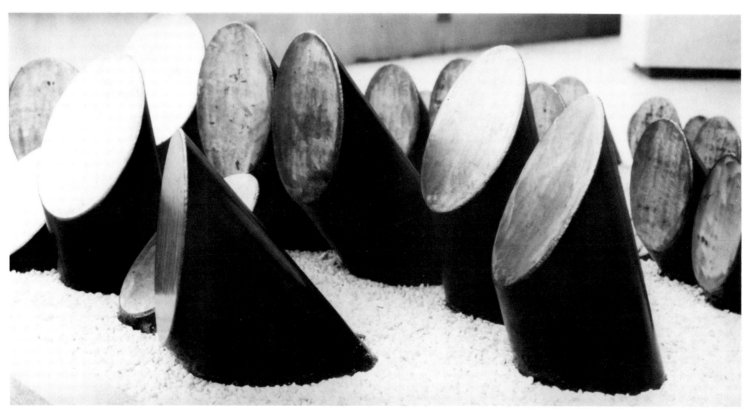

Pl. 129. **Fountain.** ca. 1971. Marble, 11⅛ x 49⅛ x 32¾″. Private collection, New York

Pl. 130. **Facets to the Sun,** detail. 1978. Steel with granite base, ca. 10′ wide x 8′ deep. Norris Cotton Federal Building, Manchester, New Hampshire

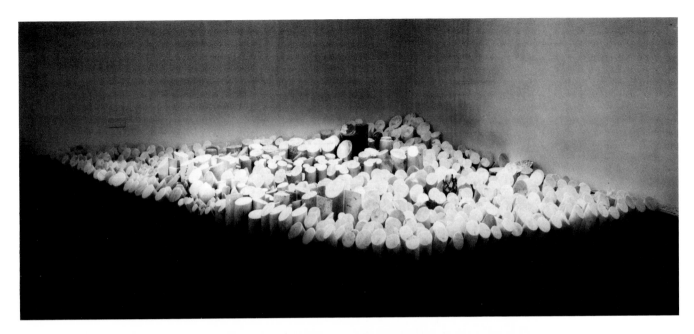

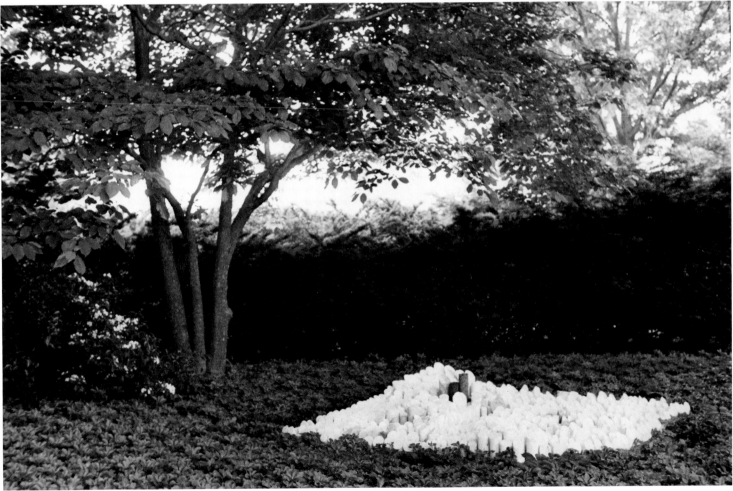

Pl. 131. **Number Seventy-two (The No March),** installed at the Whitney Museum of American Art, 1973

Pl. 132. **Number Seventy-two (The No March),** installed at the Storm King Art Center, Mountainville, New York

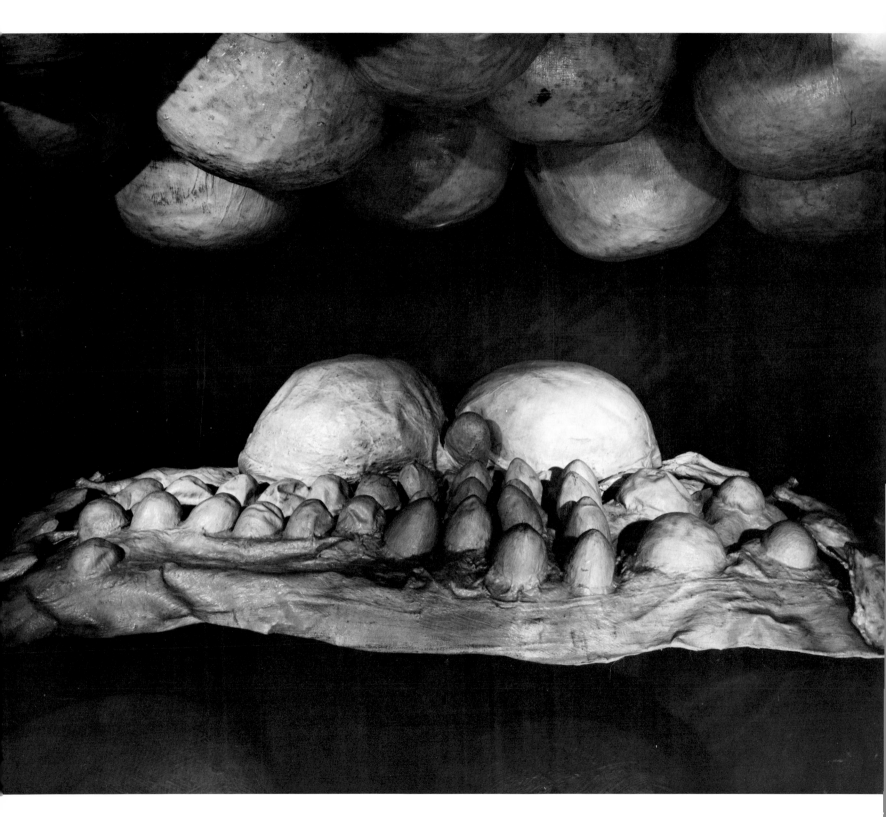

Pl. 133. **The Destruction of the Father,** detail.
Latex, latex over plaster, and mixed media,
ca. 9 x 11 x 9′. Private collection, New York

It is a very murderous piece,

an impulse that comes when

one is under too much stress

and one turns against those

one loves the most.

Pl. 134. **The Quartered Ones** (elements from *The Destruction of the Father*). 1974. Latex over plaster, each 17¾ x 8½ x 2¾″

Pl. 135. Installation of **The Destruction of the Father** in Bourgeois's studio, 1975. Photograph by Peter Moore

Pl. 136. Untitled. 1948–51. Ink on paper, 12¾ x 6¾″. Private collection, New York

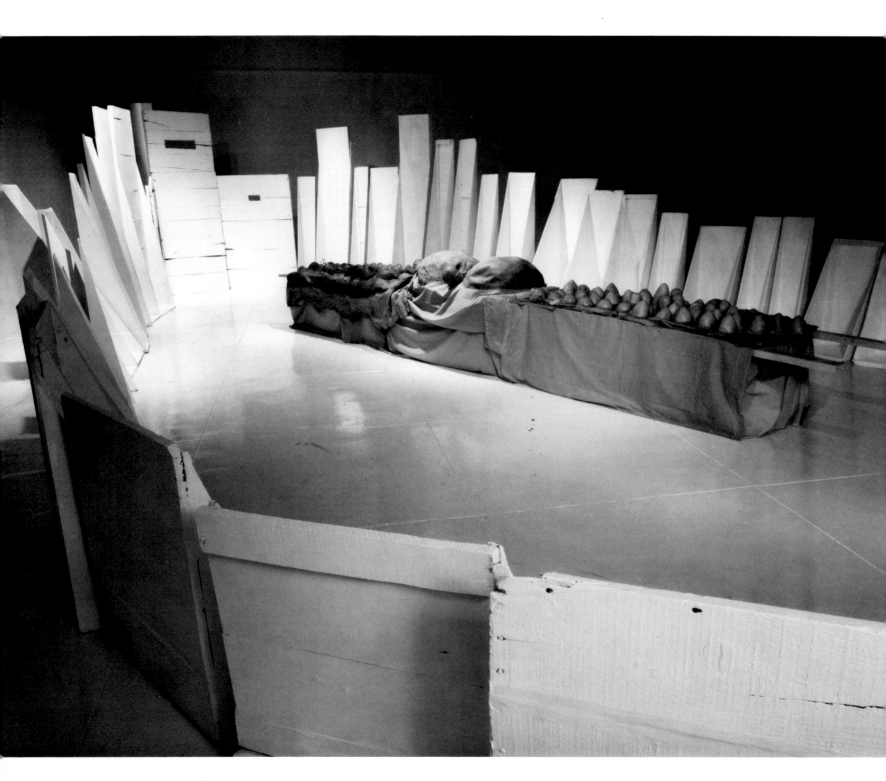

Pl. 137. **Confrontation.** 1978. Painted wood,
latex, and fabric, ca. 37′ long x 20′ wide.
Private collection, New York

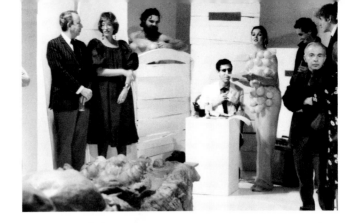

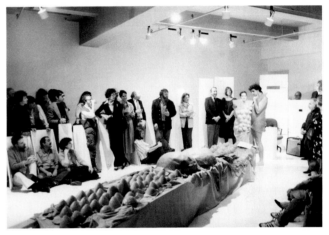

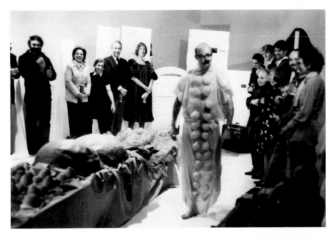

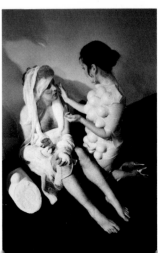

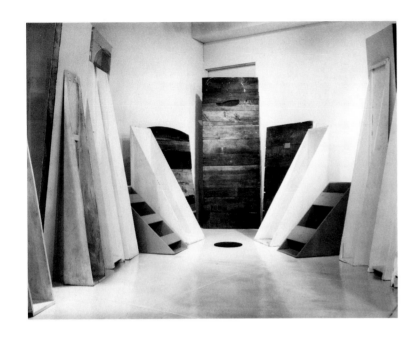

Pl. 138. **Confrontation** in preparation

Pls. 139–43. The performance "A Banquet/A Fashion Show of Body Parts," October 21, 1978, Hamilton Gallery of Contemporary Art, New York. Photographs by Peter Moore

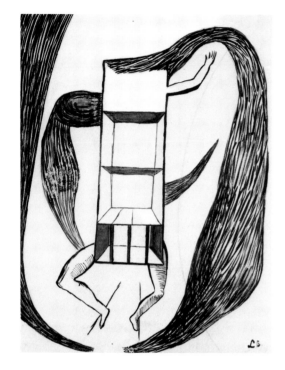

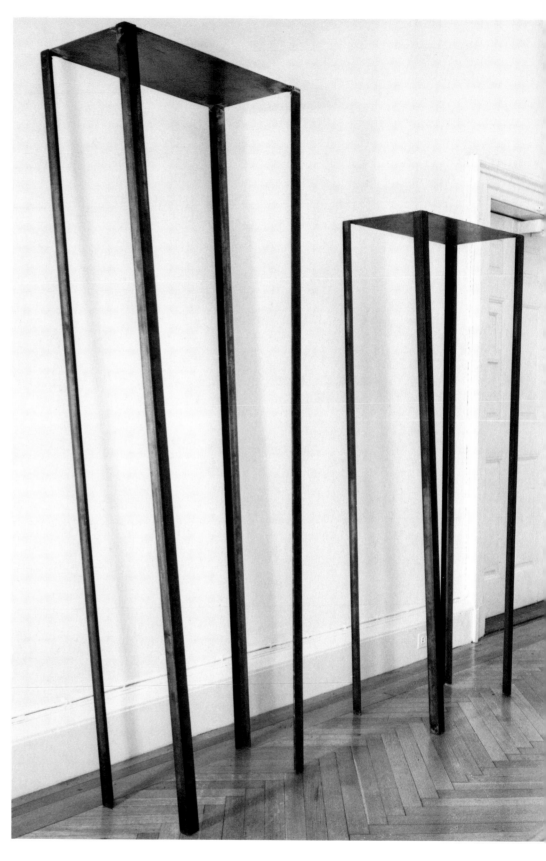

Pl. 144. Untitled. ca. 1947. Ink on paper,
12 x 9½″. Private collection, New York

Pl. 145. **Maisons Fragiles/Empty Houses.** 1978.
Steel, 7 and 6′ high. Private collection,
New York

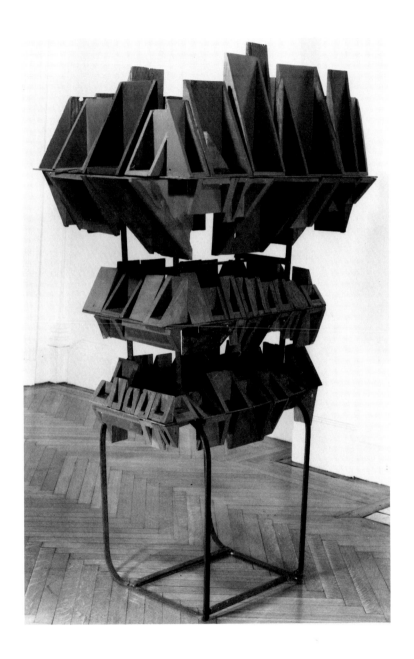

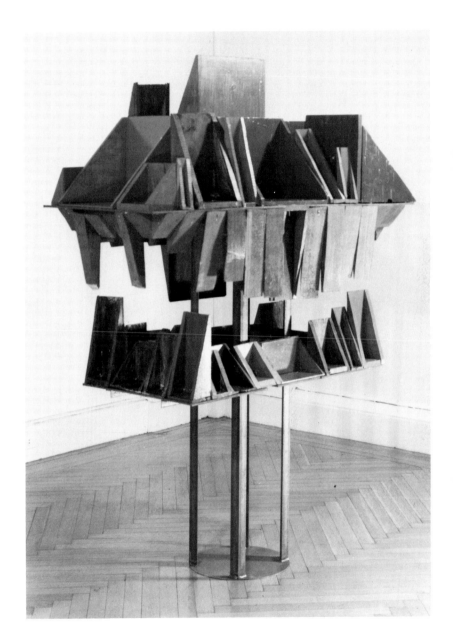

Pl. 146. **Structure, III/Three Floors.** 1978.
Painted wood and steel, 6'2'' x 45'' x 31''.
Private collection, New York

Pl. 147. **Structure, IV/Boat House.** 1978.
Painted wood and steel, 71 x 48 x 25''. Private
collection, New York

Partial Recall *has to do with forgiveness and with*

integration, as aggression has to do with explosion

and disintegration. It is difficult to recall forgive-

ness, one needs to be blessed at that moment.

Aggression is very easy to recall.

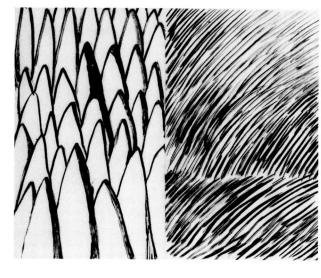

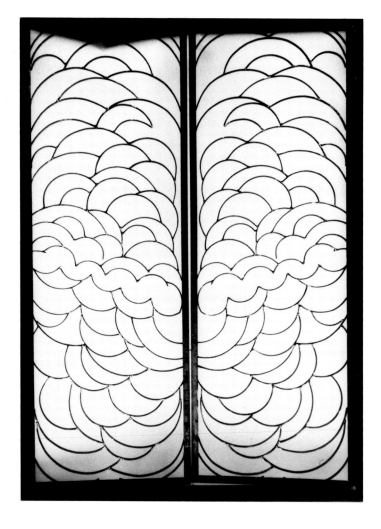

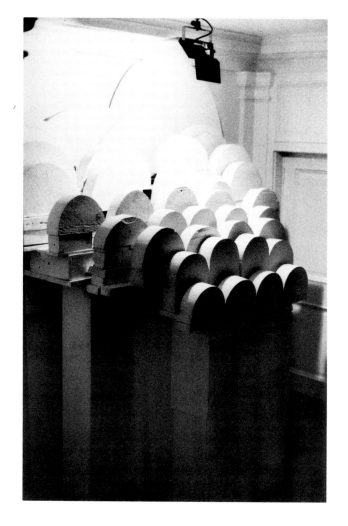

Pl. 148. Entrance gate to Bourgeois's Brooklyn loft, 1982

Pl. 149. Untitled. ca. 1950. Ink on paper, 11 x 14″. Private collection, New York

Pl. 150. **Partial Recall,** detail. 1979. Painted wood, ca. 9′ x 7′6″ x 66½″. Private collection, New York

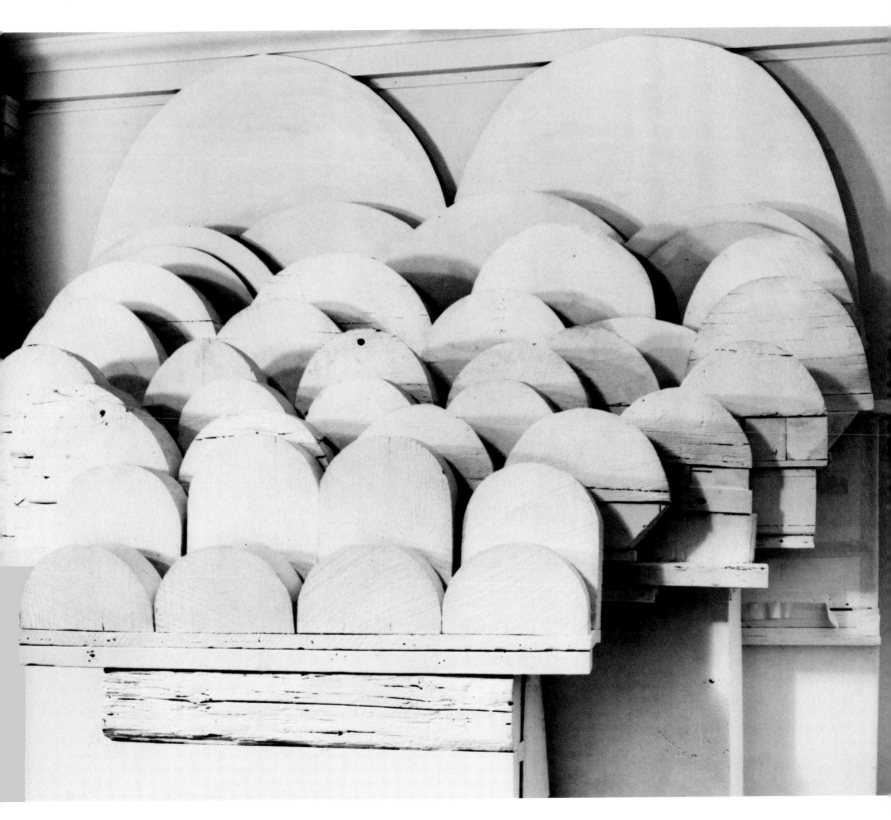

Pl. 151. **Partial Recall,** detail

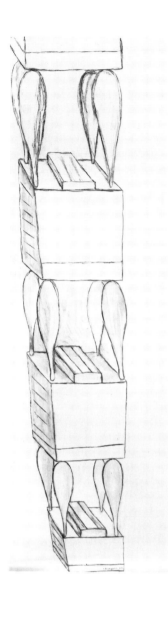

Pl. 152. Untitled. 1953. Charcoal and ink on paper, 40 x 12½″. Collection Helen Herrick and Milton Brutten, Philadelphia

Pl. 153. **"Fences Are Obsolete."** Wood and metal stripping. Backyard, West 20th Street, 1977

104

Fig. 1. Bourgeois at the age of one, Paris, 1913

Fig. 2. Bourgeois with brother Pierre (left) and sister Henriette (center), 172, boulevard Saint Germain, Paris, ca. 1917

Fig. 3. Bourgeois with brother Pierre (right) and cousins Jacques (left) and Maurice (second from right), at grandparents' home, Clamart, France. The cousins lived with the Bourgeois family after their father was killed in the war

Fig. 5. Bourgeois's mother in Cimiez, in the South of France, ca. 1930

Fig. 4. Weavers from family restoration workshop washing tapestries in Bièvre River (upstream from Gobelin workshop), 1920s

Fig. 6. Bourgeois's mother at home, Choisy-le-Roi, near Paris, ca. 1916

Fig. 7. Bourgeois with brother Pierre, the tutor, Sadie, and her father in Nice, ca. 1922

Fig. 8. Bourgeois with tutor, Sadie, on Bièvre River in Antony, early 1920s

Fig. 9. Bourgeois wearing Paul Poiret outfit, with brother Pierre and tutor, Sadie (right), at Deauville, August 1923

Fig. 10. Bourgeois and her father, Trouville, 1930s

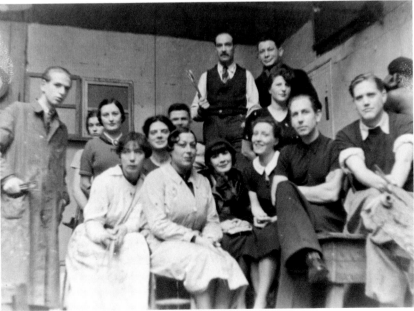

Fig. 11. Bourgeois (third from right) at the Académie de la Grande-Chaumière, Paris, ca. 1937

Information gathered primarily through extensive conversations with the artist and research in her archival materials.

1911

December 25, born in Paris to Josephine Fauriaux and Louis Bourgeois. The middle child, she has sister, Henriette, six years older; brother Pierre born 15 months later. Lives first at 147, boulevard Saint Germain, and later at 172, boulevard Saint Germain, in apartment above parents' gallery, which deals primarily in tapestries.

1912–1919

In 1912, family acquires house in Choisy-le-Roi, outside Paris, where they live until 1918. During war years, with her mother, sister, and brother, spends time in Aubusson with family relatives. Also makes trips with mother to visit father at various military encampments. Father wounded in 1915, brought to hospital in Chartres to recuperate.

1919–1932

In 1919, family buys property in Antony, outside Paris, on banks of Bièvre River, and sets up workshop for restoration of tapestries, taking advantage of special chemical make-up of river for dyeing and other restoration processes. Family also maintains Paris property housing apartment and gallery.

Attends Lycée Fénelon, in Paris, earning baccalauréat in 1932. From her teen years, helps out in tapestry workshop with drawing.

From 1922 to 1932 takes yearly winter trips to South of France, where mother takes cures. Takes summer vacation trips to England to practice English, which her father, experienced in business, regards as important.

Mother dies in 1932.

1932–1938

Enrolls at Sorbonne to study mathematics, eventually leaving to study art. Prepares for entry into Ecole des Beaux-Arts. After acceptance and brief study there, leaves for less academic, freer atmosphere of instruction in ateliers. Studies at Académie Ranson, Académie Julian, and Académie de la Grande-Chaumière (where she works as studio assistant). Also studies art history at Ecole du Louvre and works as docent at Louvre, using knowledge of English.

1938

September, marries an American, Robert Goldwater, and in October, moves to New York, living first in apartment at Park Avenue and East 38 Street. Has three sons, Michel, Jean-Louis, and Alain, and a marriage of more than 30 years.

Enrolls at Art Students League. Studies painting there for two years with Vaclav Vytlacil.

1939

Moves to East 41 Street, remaining there for two years.

Exhibits for first time in U.S., in print exhibition at The Brooklyn Museum. During early years exhibits prints there and at Philadelphia Print Club, Library of Congress, and Pennsylvania Academy of the Fine Arts.

Soon after arrival in U.S., meets and establishes close friendship with Gertrude and Balcomb Greene, active members of American Abstract Artists group.

1941

Moves to apartment, known as Stuyvesant's Folly, on East 18 Street, where she lives until 1958. Will experiment with large-scale wood sculpture on roof of apartment house. Family purchases country home in Easton, Conn., where she and children spend long stretches of time during war years.

1942-1945

Takes part in art-world activities involving war effort, including exhibitions organized under auspices of the Artists for Victory. Receives Honorary Award, along with Alexander Calder and André Masson, for tapestry entered in The Museum of Modern Art's "The Arts in Therapy" exhibition, "designed to encourage and broaden the use of the various arts and crafts in therapeutic work among disabled and convalescent members of the armed forces." June 1945, organizes "Documents France 1940-1944: Art-Literature-Press of the French Underground," at Norlyst Gallery.

June 1945, first solo exhibition, "Paintings by Louise Bourgeois," at Bertha Schaefer Gallery. Exhibits 12 paintings, including *Natural History*, *Mr. Follet*, and *Connecticutiana*.

In 1945, begins exhibiting paintings in many group shows, as she will throughout the forties, often with artists of Abstract Expressionist generation.

Fig. 12. Bourgeois in New York studio, 1940s, with two paintings (pls. 19, 20)

Fig. 13. Bourgeois with son Alain, Easton, Connecticut, early 1950s

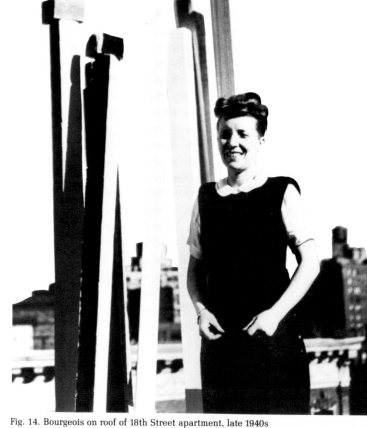

Fig. 14. Bourgeois on roof of 18th Street apartment, late 1940s

Fig. 15. Bourgeois with her sons Alain, Jean-Louis, and Michel; in background, husband Robert Goldwater (right) and Charles Prendergast, Easton, Connecticut, July 1945

Fig. 16. Bourgeois (top center) with Joan Miró (left), his wife (lower center), and his daughter (right), New York, 1947

Fig. 17. Bourgeois with Robert Rauschenberg at exhibition of American Abstract Artists, Riverside Museum, New York, mid-1950s

Fig. 18. Bourgeois at work on Sleep, II (pl. 117), Pietrasanta, Italy, 1967

Exhibits for first time in Whitney Museum of American Art Annual of Painting. Begins working at Atelier 17, where she will make prints through latter part of decade. Becomes friendly there with artists such as Nemecio Antunez, Le Corbusier, Joan Miró, Yves Tanguy, and Ruthven Todd.

1947

September, second solo show, at Norlyst Gallery. Exhibits 17 paintings, including *Conversation Piece, Jeffersonian Courthouse, Regrettable Incident in the Louvre Palace, Roof Song.*

Publishes *He Disappeared into Complete Silence,* suite of engravings and parables made at Atelier 17.

1949

October, makes debut as sculptor at Peridot Gallery, at invitation of Louis Pollock, gallery director, and his friend and collaborator, Arthur Drexler, who also helps install exhibition. Shows 17 pieces, including *Portrait of C.Y., Woman in the Shape of a Shuttle, Dagger Child,* and *Observer.* Marynell Sharp, in *Art Digest* (October 15), observes: "Though Miss Bourgeois has changed her medium certainly she has not deviated from her 'swan song' theme…to convey through…severity of treatment the tragedy of isolation."

1950-1951

April 1950, takes part in three-day session for advanced artists at Studio 35 (35 East Eighth Street).

May 1950, joins group of artists, who become known as "Irascibles," in protest against planned American painting exhibition at The Metropolitan Museum of Art.

October 1950, second show of sculpture, at Peridot Gallery. Exhibits 15 pieces, including *Sleeping Figure, Breasted Woman, Persistent Antagonism,* and *Spring.*

The Museum of Modern Art acquires *Sleeping Figure* in 1951.

Father dies.

In 1951, becomes U.S. citizen. Interrogated extensively at naturalization hearings about art-world associations, perhaps thought to be Left Wing by Cold-War era immigration officials.

1952

January 19, performance of Erick Hawkins's dance, "The Bridegroom of the Moon," for which Bourgeois has designed set. Takes place at Hunter Playhouse, New York.

1953-1958

April 1953, third solo show at Peridot Gallery. Exhibits either two or three sculptures, featuring *Forêt* (later known as *Night Garden*), and series of India ink drawings. Marks debut of organic multiform sculptures, which metaphorically relate to nature as much as to figures.

Takes part in many group shows, at galleries such as Stable and Poindexter and with organizations such as American Abstract Artists (of which she becomes a member in 1954) and Federation of Modern Painters and Sculptors. Exhibits in Annuals of Whitney Museum of American Art from 1953 through 1957. Whitney Museum acquires *One and Others* in 1956.

In 1958, moves from "Stuyvesant's Folly," on East 18 Street, to West 22 Street, where she will remain for four years.

1959

Participates in Festival of Contemporary Arts at The Andrew Dickson White Art Museum, Cornell University, Ithaca, N.Y. Exhibits 11 wood figural sculptures, including *Memling Dawn, Sleeping Figure, Figures for a Niche,* and *One and Others.* Alan Solomon, director of museum, is curator of exhibition.

1960-1965

Continues to take part in various group exhibitions at galleries such as Frumkin, Stable, Tanager, Great Jones, A. M. Sachs, and Noah Goldowsky. Exhibits regularly with Sculptors Guild.

Begins to teach regularly, first adults and children at Great Neck, Long Island, N.Y., public schools, in 1960, and then at college level at Brooklyn College, in 1963 and 1968, and at Pratt Institute, Brooklyn, in 1964 and from 1965 to 1967.

In 1962, moves from West 22 Street to West 20 Street, where she still lives.

January 1964, solo show at Stable Gallery. Exhibits approximately 12 plaster pieces, including *Lair, Rondeau for L, Labyrinthine Tower, Fée Couturière,* and *Still Life;* some latex pieces, including *Portrait;* and *Night Garden* (formerly called *Forêt*) from earlier wood period. In concurrent solo show at Rose Fried Gallery, exhibits drawings and watercolors. Daniel Robbins writes in bro-

chure accompanying show: "These drawings are not specifically preparatory to works of art in another medium. Instead, they are the active signs of an extraordinary inner life and rich vision."

Robbins surveys Bourgeois's career to date for *Art International* (October); includes six illustrations, among them *One and Others, Fée Couturière,* and *Still Life.* Describes historical context of work, discusses connections to both France and America, and explores recent sculptural activities in plaster (including detailed technical descriptions).

In 1965, participates in Waldorf Panels for Sculpture; published in *It Is* magazine late that year.

1966
September, takes part in group exhibition "Eccentric Abstraction," organized by Lucy R. Lippard at Fischbach Gallery. In defining an individualistic, antiformalist tendency in sculpture, Lippard states in announcement text: "Eccentric means off-center, idiosyncratic, perverse. These artists are eccentric because they refuse to forego imagination and the expansion of sensuous experience."

Becomes actively involved in political and feminist events in latter part of decade.

1967
Wayne Andersen discusses Bourgeois's place in the artistic developments of the fifties in "American Sculpture: The Situation in the Fifties," *Artforum* (Summer).

First trip to marble works at Pietrasanta, Italy. Travels there regularly until 1972, usually in summer but sometimes twice in one year. Produces at least 13 major marble pieces there, including *Sleep, II,* 1967; *Colonnata* and *Clamart,* 1968; *Femme Couteau,* 1969-70; *Baroque,* 1970; *Fountain,* 1971; and *Number Seventy-two (The No March),* 1972, as well as many smaller pieces. Also works in bronze foundries there.

1969
William Rubin discusses Bourgeois's place in contemporary painting and sculpture in *Art International* (April). Includes six illustrations, among them *Still Life, Soft Landscape, I,* and *Molotov Cocktail.* He observes: "There is a quality, integrity, and immediacy of feeling in Miss Bourgeois'

work that we never feel in those occasional essays we see in painting where an attempt has been made to keep the language of organic forms alive. The implications of this seem to me to go beyond Miss Bourgeois' own work and to raise questions about the historicity of post-World War II sculpture, as over and against painting."

1970
Continues to take part in demonstrations, benefits, panels, and exhibitions connected with feminism in the arts and does so throughout decade.

1971
J. Patrice Marandel writes in *Art International* (December) on Bourgeois's recent activities in Italy. Reproduces six marble pieces, including *Colonnata* and *Baroque.*

1973
Receives Artist's Grant from National Endowment for the Arts.

Designs sets, costumes, and poster for Women's Interart Center production of Tennessee Williams's *This Property Is Condemned* and August Strindberg's *The Stronger;* produced and directed by Alice Rubinstein, lighting by Laura Lowrie.

January, shows environmental-scale marble floor piece *Number Seventy-two* (later known as *The No March*) at Whitney Museum of American Art Biennial.

Musée National d'Art Moderne, Paris, acquires *Cumul, I.* Transfers sculpture to Centre Georges Pompidou in 1976.

Husband dies in March.

1974
December, solo show at 112 Greene Street Gallery. Exhibits several marbles, including *Eye to Eye, Colonnata, Baroque, Systems,* and *Fountain;* several bronzes, including the Hanging Janus series; several plasters (and hydrocal), including *Trani Episode;* and the environmental work, *The Destruction of the Father.*

Participates in Seminars with Artists and Critics program of Whitney Museum of American Art, returning for another seminar in 1976.

Begins teaching at The School of Visual Arts, continuing to do so through 1977. Holds other teaching positions in seventies at Columbia University, Cooper Union, and

Fig. 19. Bourgeois (lower left) with other honorary degree recipients, Commencement, Yale University, New Haven, Connecticut, 1977

Fig. 20. Bourgeois in backyard, West 20th Street, 1970s

Fig. 21. Feminist dinner party in honor of Bourgeois, March 14, 1979. From left, top row: Gloria MacDonald, Barbara Moore, Judith Bernstein, Joyce Kozloff, Mary Beth Edelson, Phyllis Krim, Poppy Johnson; middle row: Edit de Ak, Anne Sharp, Pat Hamilton, Bourgeois, Suzan Cooper, Hannah Wilke, Barbara Zucker; front row: Ana Mendieta, Michelle Stuart

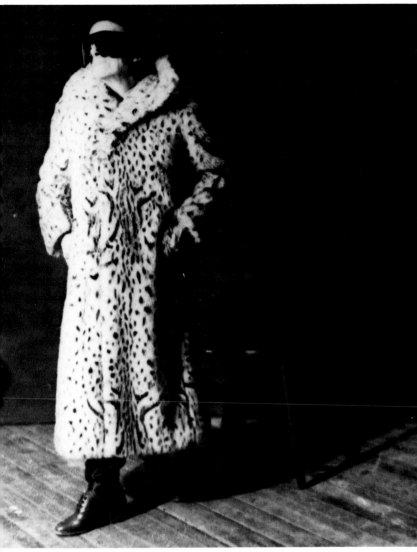

Fig. 22. Bourgeois at The Mudd Club, New York, 1980

Fig. 23. Bourgeois and assistant Jerry Gorovoy, Carrara, Italy, Fall 1981, with two versions of *Femme Couteau* (one, pl. 110)

Fig. 24. Assistant Mark Setteducati reconstructing *Partial Recall* (cover, pls. 150, 151), August 1982

Goddard College (Plainfield, Vt.); has Visiting Artist assignments at Pratt Institute, Philadelphia College of Art, Woodstock Artists Association, Rutgers University (New Brunswick, N.J.), New York Studio School, and Yale University.

Acts as juror for New York State's CAPS awards, and does so again in 1975. Also serves on juries for Massachusetts State Council Awards, 1976; Brandeis University Creative Arts Awards, 1978; and Yaddo, throughout seventies and into eighties.

1975

Lucy Lippard writes on Bourgeois in *Artforum* (March), reproducing *The Destruction of the Father* (cover) and 14 other works from forties to present, including *The Blind Leading the Blind*, *Trani Episode*, *Fillette*, and *Femme Couteau*. Lippard sums up her essay as follows: "Despite her apparent fragility, Bourgeois is an artist, and a woman artist, who has survived almost 40 years of discrimination, struggle, intermittent success and neglect, in New York's gladiatorial art arenas. The tensions which make her work unique are forged between just those poles of tenacity and vulnerability."

Interviewed on videotape by Lynn Blumenthal and Kate Horsfield for their Video Data Bank. Discusses family background and student years in France, as well as working methods and motivations for specific pieces.

1975

Takes part in tribute to former teacher, Vaclav Vytlacil, an exhibition of his work and that of some of his students, at Montclair Art Museum, Montclair, N.J. Other exhibitions in which her participation arises from past associations are the retrospective of Atelier 17, at Elvehjem Art Center, Madison, Wis., in 1977, and Brooklyn College Art Department's faculty show, "Past and Present 1942–1977," in 1977.

Wayne Andersen represents her in book surveying *American Sculpture in Process: 1930/1970*.

1976

Susi Bloch focuses on work of late forties and early fifties for *Art Journal* (Summer) interview with Bourgeois.

Prominent place in Whitney Museum of American Art's Bicentennial exhibition, "200 Years of American Sculpture."

1977

Participates in panel "Women Artists of the '50s," along with Anne Arnold, Gretna Campbell, Marisol, Marcia Marcus, and Pat Passloff.

Receives Honorary Doctor of Fine Arts degree from Yale University. Citation reads: "You have reminded us through your sculpture that art speaks to the human condition. You have offered us powerful symbols of our experience and of the relations between men and women. You have not been afraid to disturb our complacency. The precision of your craftsmanship, the range of your imagination, and your fearless independence have been exemplary. Yale takes pleasure in bestowing upon you the degree of Doctor of Fine Arts."

1978

Three solo exhibitions: at Hamilton Gallery of Contemporary Art and Xavier Fourcade, Inc., in September; and at University Art Gallery, Berkeley, Calif., in December.

At Hamilton Gallery, features environmental sculpture *Confrontation* and exhibits nine small sculptures, including two Germinals, *Tamed Confrontation*, and pottery version of Hanging Janus. Stages performance in conjunction with *Confrontation*, entitled "A Banquet/A Fashion Show of Body Parts"; people stand and sit in outer boxes, while friends and students, dressed in costumes by Bourgeois, parade to script and music suggesting worlds of fashion and punk.

At Fourcade's, exhibits series of wood pieces, Structures I–V, the steel sculpture *Maisons Fragiles*, two other recent sculptures, and a group of recent drawings.

In Berkeley exhibition, part of ongoing Matrix/Berkeley program of small exhibitions of contemporary art at University museum, includes *Maison Fragiles*, *Lair of Five*, and *Radar*. In catalog/brochure, Deborah Wye points out: "The four works which comprise this Matrix unit are from 1978, but reflect artistic concerns and personal preoccupations that have been Bourgeois's themes for many years."

In response to commission from General Services Administration, makes outdoor public sculpture *Facets to the Sun* for

Norris Cotton Federal Building in Manchester, N.H.

Detroit Institute of Arts acquires version of *The Blind Leading the Blind*. Storm King Art Center, Mountainville, N.Y., acquires *Number Seventy-two (The No March)*.

1979

September, solo show at Xavier Fourcade, Inc. Exhibits 33 wood figures and the recent *Partial Recall*.

Eleanor Munro includes extensive essay in her book *Originals: American Women Artists*. Includes five illustrations, among them *The Blind Leading the Blind* and *Confrontation*, and discusses "memories leading back to early days in France and also thoughts leading to some programs for future work."

Marsha Pels interview appears in *Art International* (October). Include 14 illustrations, among them *The Blind Leading the Blind, Brother and Sister, Femme Volage*, and several installation views.

1980

Paul Gardner writes "The Discreet Charm of Louise Bourgeois," chatty, personal discussion of artist, her work and her life, for *Art News* (February). Includes nine illustrations of her and her work. Gardner states: "Within the last two years Louise Bourgeois, long considered a bit special, has entered the mainstream of American art."

September, two solo shows, at Max Hutchinson Gallery and Xavier Fourcade, Inc. Both focus on early work, demonstrating her rediscovery in current artistic milieu.

At Hutchinson Gallery, exhibits over 30 early paintings, including *Reparation, Connecticutiana*, the four *Femmes-Maisons, Fallen Woman, Red Room*, and *Roof Song*; over 35 drawings, from 1942 to 1974; and 12 prints, from late forties. Catalog contains 31 reproductions and essay by Jerry Gorovoy, who, observing the new interest in figuration by younger artists, states: "Because of this shift, which has resulted in a move towards the 'personal,' the art of Louise Bourgeois is being accorded a renewed sense of significance...."

At Fourcade's, exhibits 10 marbles, including *Clamart, Eye to Eye, Colonnata, Baroque*, and *Sleep, II*; three bronzes, including *Torso/Self-Portrait*; and granite version of *Trani Episode*, all from period of 1955 to 1970.

Posing in costume created for 1978 performance at Hamilton Gallery, is photographed for *Vogue* (October). Accompanies article by Carter Ratcliff tracing development and exploring psychological motivations.

Purchases large loft space in Brooklyn for both work and storage.

Australian National Gallery at Canberra acquires *C.O.Y.O.T.E.*

Receives Award for Outstanding Achievement in the Visual Arts from Women's Caucus for Art at conference in New Orleans. Award reads in part: "You say in form what most of us are afraid to say in any way. Your sculpture defies styles and movements and returns to the sources of art—to the cultural expression of communal belief and emotion."

1981

May, solo show at The Renaissance Society, University of Chicago. Exhibits 31 pieces from the forties to the seventies, among them five early paintings; 15 early wood figures; three marbles, including *Clamart*; seven metal pieces, including *End of Softness* and *Janus Fleuri*; and suite of engravings, *He Disappeared into Complete Silence*. Catalog contains six reproductions and essay by J. Patrice Marandel, who says: "*Femme Maison* is the generic title given this exhibition, a cut across Bourgeois' work from the '40s until the present, suggesting the continuity of a theme throughout the work and [presenting] an oeuvre whose coherence often hides behind its diverse manifestations."

Chosen by critic Kay Larson for feature "Artists the Critics Are Watching" in *Art News* (May).

Receives Honorary Doctor of Fine Arts degree from Bard College, Annandale-on-Hudson, N.Y.

Elected Fellow of American Academy of Arts and Sciences.

Spends over month in Italy, first trip since 1972, working in Carrara rather than Pietrasanta. Produces more than 20 new marbles, including several on the Harmless Woman and *Femme Couteau* themes; produces largest marble to date, *Femme-Maison '81*.

Fig. 25. Bourgeois with Dominique Bozo at foundry, New York, 1978, with working stage of *Facets to the Sun* (pl. 130)

Fig. 26. Bourgeois at group exhibition, CDS Gallery, New York, May 1982

An attempt has been made to provide a listing for every exhibition in which the artist participated, but a few references found in dictionaries, the artist's records, and exhibition lists from earlier catalogs could not be fully documented, and thus have been omitted. Where a catalog, brochure, or checklist accompanied a show, it is so noted, except in the case of annual or biennial exhibitions. Significant catalogs are fully documented in the bibliography. In certain group shows some of the participating artists are mentioned, if it serves to document a period or trend.

S O L O E X H I B I T I O N S

1945
New York. Bertha Schaefer Gallery. "Paintings by Louise Bourgeois." Opened June 4, 1945. Announcement with checklist.

1947
New York. Norlyst Gallery. "Paintings." October 28-November 8, 1947. Announcement with checklist.

1949
New York. Peridot Gallery. "Late Work 1947 to 1949: 17 Standing Figures." October 4-29, 1949. Announcement with checklist.

1950
New York. Peridot Gallery. "Sculptures." October 2-28, 1950. Announcement with checklist.

1953
New York. Peridot Gallery. "Louise Bourgeois: Drawings for Sculpture, and Sculpture." March 30-April 25, 1953.

1959
Ithaca, N.Y. Andrew D. White Art Museum, Cornell University. "Sculpture by Louise Bourgeois." April 9-25, 1959. One of five exhibitions that were part of a "Festival of Contemporary Arts."

1964
New York. Stable Gallery. "Louise Bourgeois: Recent Sculpture." January 7-February 1, 1964.

New York. Rose Fried Gallery. "Recent Drawings by Louise Bourgeois." January 14-February 29, 1964. Brochure with text.

1974
New York. 112 Greene Street Gallery. "Sculpture 1970-1974." December 14-26, 1974.

1978
New York. Hamilton Gallery of Contemporary Art. "New Work." September 16-October 21, 1978.

New York. Xavier Fourcade, Inc. "Triangles: New Sculpture and Drawings, 1978." September 26-October 21, 1978.

Berkeley, Calif. University Art Museum. "Louise Bourgeois: Matrix/Berkeley 17." December 1978-February 1979. Brochure with text.

1979
New York. Xavier Fourcade, Inc. "Louise Bourgeois, Sculpture 1941-1953, Plus One New Piece." September 18-October 13, 1979.

1980
New York. Max Hutchinson Gallery. "The Iconography of Louise Bourgeois." September 6-October 11, 1980. Catalog.

New York. Xavier Fourcade, Inc. "Louise Bourgeois Sculpture: The Middle Years 1955-1970." September 20-October 25, 1980.

1981
Chicago. The Renaissance Society at the University of Chicago. "Louise Bourgeois: Femme Maison." May 3-June 6, 1981. Catalog.

G R O U P E X H I B I T I O N S

1936
Paris. Galerie de Paris. "Exposition de l'Atelier de la Grande-Chaumière." June 23-30, 1936.

1938
Paris. 7, rue Joseph-Bara. "La Groupe 1938-1939 de l'Académie Ranson." July 7-20, 1938.

1939
New York. The Brooklyn Museum. "Fine Prints for Mass Production." May 19-September 1939.

1942
New York. The Metropolitan Museum of Art. "Artists for Victory: An Exhibition of Painting, Sculpture and Graphic Arts." Held under the auspices of Artists for Victory, Inc. December 7, 1942-February 22, 1943. Catalog/brochure with checklist.

1943
Philadelphia. The Print Club. "15th Annual Exhibition of American Lithography." January 22-February 12, 1943.

New York. The Museum of Modern Art. "The Arts in Therapy: A Competition and Exhibition Sponsored by The Museum of Modern Art in Collaboration with Artists for Victory, Inc." February 1943. Received Honorary Award.

1944
New York. The Museum of Modern Art. "Modern Drawings." February 16-May 10, 1944. Omitted from published checklist.

Washington, D.C. Library of Congress. "National Exhibition of Prints Made during the Current Year ('The Pennell Show')." May 1-July 1, 1944. Catalog/brochure with checklist.

1945
Washington, D.C. David Porter Gallery. "Personal Statement: Painting Prophecy 1950." February 1945. Also shown at the Memorial Art Gallery, University of Rochester, New York, October 1945. Catalog includes 21 artists, among them Baziotes, Ferren, Gottlieb, Motherwell, Pereira, Pollock, Pousette-Dart, Rothko, and Salemme.

Los Angeles. Los Angeles County Museum. "The First Biennial Exhibition of Drawings by American Artists." February 18-April 22, 1945. Catalog/brochure with checklist.

New York. Art of This Century Gallery. "The Women." June 12-July 7, 1945. Leaflet listing 14 artists, including Blaine, Carrington, G. Greene, Krasner, Pereira, Sage, and Sterne.

New York. The Museum of Modern Art. "Textile Design." August 29-September 23, 1945. Tour through May 1949.

New York. Whitney Museum of American Art. "Annual Exhibition of Contemporary American Painting." November 27, 1945-January 10, 1946.

New York. Buchholz Gallery. "Contemporary Prints." December 4-29, 1945. Leaflet listing 29 European printmakers, including Braque, Chagall, Matisse, and Picasso, and 15 American printmakers, including Albers, Feininger, Lasansky, and Schanker.

1946
New York. Bertha Schaefer Gallery. "Directions in Abstraction." January 8-February 2, 1946. Announcement with checklist includes 12 painters, among them de Kooning, B. Greene, Gottlieb, and Rothko.

New York. Whitney Museum of American Art. "Annual Exhibition of Contemporary American Sculpture, Watercolors and Drawings." February 5-March 13, 1946.

New York. Bertha Schaefer Gallery. "Flowers by Moderns." April 15-May 10, 1946.

New York. Bertha Schaefer Gallery. "Watercolors, Temperas, Gouaches." May 20-June 8, 1946. Press release lists 13 artists, among them Avery, Barnet, Gottlieb, Maurer, Rothko, and Solman.

New York. Bertha Schaefer Gallery. "The Horse (in Painting and Sculpture)." November 4-23, 1946. Included 13 painters and five sculptors, among them Avery, Lipton, Schanker, Solman, and Trajan.

1947
New York. Bertha Schaefer Gallery. "Fact and Fantasy." June 2-28, 1947.

New York. Wildenstein and Co. "7th Annual Exhibition of Paintings and Sculpture by Guest Members of the Federation of Modern Painters and Sculptors." September 8-27, 1947. Leaflet listing artists, invited guests, and works exhibited. Gertrude Greene invited Bourgeois.

New York. Norlyst Gallery. "Seaboard and Midland Moderns." September 29-October 25, 1947. National tour. Annual exhibition of painters residing in New York City and the Middle West. Included 26 painters, among them Antunez, G. McNeil, and Slobodkina.

Philadelphia. Pennsylvania Academy of the Fine Arts and the Philadelphia Watercolor Club. "45th Annual Watercolor and Print Exhibition." November 9-December 14, 1947.

New York. Whitney Museum of American Art. "Annual Exhibition of Contemporary American Painting." December 6, 1947-January 25, 1948.

1948
New York. The Brooklyn Museum. "Second Annual National Print Exhibition." March 23-May 24, 1948.

New York. Whitney Museum of American Art. "Annual Exhibition of Contemporary American Painting." November 13, 1948-January 2, 1949.

1949
New York. Laurel Gallery and Kende Galleries. "Collection of Modern Art and Manuscripts Contributed to International Rescue, Inc." Exhibition: Laurel Gallery, March 1-12, 1949. Public auction sale: Kende Galleries, March 18, 1949. Announcement lists over 100 artists.

New York. The Brooklyn Museum. "Third Annual National Print Exhibition." March 23-May 22, 1949.

New York. Riverside Museum. "13th Annual Exhibition of the American Abstract Artists." March 27-April 17, 1949. Guest exhibitor.

New York. Peridot Gallery. Group Show. April 4-30, 1949. Included nine painters, among them A. Drexler, de Kooning, Hofmann, and Tomlin, and sculptor Leonard.

New York. The Museum of Modern Art. "Master Prints from the Museum Collection." May 10-July 10, 1949. Catalog with checklist.

1950

New York. Peridot Gallery. "The Year's Work." June 19-July 21, 1950. Included paintings by Brooks, Franks, Kees, R. Pollack, and Russell, and sculpture by Bourgeois and Negret.

1951

New York. The Museum of Modern Art. "Recent Acquisitions." February 13-May 13, 1951.

New York. Whitney Museum of American Art. "Annual Exhibition of Contemporary American Sculpture, Watercolors and Drawings." March 17-May 6, 1951.

1952

New York. Peridot Gallery. Group Show. February 25-March 22, 1952.

New York. Peridot Gallery. "Recent Painting and Sculpture." April 21-May 17, 1952. Included eight painters, among them Brooks, Crampton, Guston, R. Pollack, and Vicente, and two sculptors, Bourgeois and Rosati.

1953

New York. Stable Gallery. "Second Annual Exhibition of Paintings and Sculpture." January 11-February 7, 1953. Announcement includes essay by Clement Greenberg designating exhibition as follow-up of "Ninth Street Show" of 1951. Included approximately 100 artists, among them de Kooning, DeNiro, Ferren, Frankenthaler, Goldberg, Kline, Leslie, Lippold, Rivers, Tworkov, and Zogbaum.

Chicago. Allan Frumkin Gallery. "Two Sculptors: Louise Bourgeois, Jeremy Anderson." February 13-March 11, 1953.

New York. Peridot Gallery. "Watercolors, Collages, Drawings." March 2-28, 1953.

Boston. Institute of Contemporary Art. "40 Pictures from the Lee Ault Collection." March 4-29, 1953.

New York. Whitney Museum of American Art. "Annual Exhibition of Contemporary American Sculpture, Watercolors and Drawings." April 9-May 29, 1953.

New York. Peridot Gallery. "Watercolors and Drawings." May 21-June 1953. Included 10 artists, among them Brooks, A. Drexler, Guston, Kees, and Vicente.

New York. Peridot Gallery. Group Show. October 27-November 14, 1953. Included 11 artists, among them Beck, Tal Coat, Leonard, Russell, and K. Smith.

1954

New York. Stable Gallery. "Third Annual Exhibition of Painting and Sculpture." January 27-February 20, 1954. Included approximately 150 artists, among them Blaine, Corbett, Donati, Fine, Frankenthaler, Gordin, Hartigan, Lassaw, Okada, and de Rivera.

New York. Riverside Museum. "18th Annual Exhibition of American Abstract Artists, 1954." March 7-28, 1954.

New York. Whitney Museum of American Art. "Annual Exhibition of Contemporary American Sculpture, Watercolors and Drawings." March 17-April 18, 1954.

New York. Private residence, 48 West 10th Street. "Sculpture in a Garden." May 3-26, 1954.

Minneapolis. Walker Art Center. "Reality and Fantasy 1900-1954." May 23-July 2, 1954.

1955

New York. Whitney Museum of American Art. "Annual Exhibition: Paintings, Sculpture, Watercolors, Drawings." January 12-February 20, 1955.

Champaign, Ill. Krannert Art Museum, University of Illinois. "Contemporary American Painting and Sculpture." February 27-April 3, 1955.

New York. Poindexter Gallery. "Drawings, Watercolors and Small Oils." December 19, 1955-January 7, 1956. Included 51 artists, among them W. and E. de Kooning, Diebenkorn, Goldberg, Kline, Rauschenberg, Stefanelli, and Twombly.

New York. Tanager Gallery. "Sculpture

Group." December 1955-January 12, 1956. Among artists included were Geist, Marisol, and Rosati.

1956

New York. Riverside Museum. "20th Annual Exhibition of the American Abstract Artists." April 8-May 20, 1956.

New York. Whitney Museum of American Art. "Annual Exhibition of Contemporary American Sculpture, Watercolors and Drawings." April 18-June 10, 1956.

New York. Stable Gallery. "Fifth Annual Exhibition of Painting and Sculpture." May 22-June 16, 1956. Included approximately 130 artists, among them Beauchamp, Bolotowsky, Ferren, Finkelstein, Kline, Loew, Longo, Motherwell, Reinhardt, and Yunkers.

New York. Riverside Museum. "16th Annual Exhibition of the Federation of Modern Painters and Sculptors." November 4-25, 1956.

New York. Whitney Museum of American Art. "Annual Exhibition: Sculpture, Paintings, Watercolors, Drawings." November 14, 1956-January 6, 1957.

New York. Stable Gallery. "Black and White." December 4-31, 1956.

1957

Boston. Boston Public Garden. "American Painting and Sculpture: A National Invitational Exhibition" (Boston Arts Festival). June 4-30, 1957.

New York. Whitney Museum of American Art. "Annual Exhibition: Sculpture, Paintings, Watercolors." November 20, 1957-January 12, 1958.

1958

New York. Whitney Museum of American Art. "Nature in Abstraction." January 14-March 16, 1958.

Oberlin, Ohio. Allen Memorial Art Museum. "Sculpture 1950-1958." February 14-March 17, 1958. *Oberlin College Bulletin*, vol. 15, no. 2, Winter 1958, p. 66, describes and illustrates exhibition.

1960

Dallas. Dallas Museum for Contemporary Arts. "To be Continued: An Exhibition of the Museum Collection, Now and in Prospect." March 23-April 24, 1960. Catalog/brochure with checklist.

New York. Allan Frumkin Gallery. "An

Invitational Exhibition." May 16-June 4 1960. Included 18 artists, among them Blaine, Diebenkorn, Kerkam, Kohn, Marisol and Pearlstein.

New York. Stable Gallery. "5th Exhibition of the New Sculpture Group: Guests and Members." September 27-October 15, 1960 Included approximately 43 artists, among them Agostini, Follett, Geist, Mallary, Marisol, Rosati, Seley, and Sugarman.

New York. The Sculptors Guild, Inc. "Sculpture 1960." Held at Lever House. October 18-November 6, 1960.

Paris. Claude Bernard Gallery. "Aspects de la Sculpture Américaine." October 1960 Included approximately 60 artists, among them Chamberlain, Grippe, Hunt, Kipp Lassaw, Spaventa, Stankiewicz, and Sugarman.

New York. Whitney Museum of American Art. "Annual Exhibition 1960: Contemporary Sculpture and Drawings." December 7 1960-January 22, 1961.

1961

New York. Tanager Gallery. "The Private Myth." October 6-26, 1961. Brochure with statements by 21 of 28 exhibiting artists among them P. Adams, Donati, Geist, A Jensen, Lewitin, Marsicano, Ortman, and Pearlstein.

New York. The Museum of Modern Art "Recent Acquisitions." November 20 1961-January 13, 1962.

1962

South Hadley, Mass. Mount Holyoke College. "Women Artists in America Today." April 10-30, 1962. Catalog.

New York. Tanager Gallery. "The Closing Show: 1952-1962." May 25-June 14, 1962 Included approximately 160 artists, among them Arnold, Bladen, Boutis, Briggs Grooms, Hazelet, Ippolito, Katz, Johns Mitchell, Oldenburg, Stout, Welliver Wesselmann, and Zogbaum.

New York. Whitney Museum of American Art. "Annual Exhibition 1962: Sculpture and Drawings." December 12, 1962-February 3 1963.

1963

East Hampton, N.Y. East Hampton Gallery. "Sculptors Choice." December 3-21, 1963 Included 24 artists, among them Agostini, Dehner, Higgins, Lassaw, Slivka, and Stankiewicz.

Washington, D.C. Washington Gallery of Modern Art. "Treasures of 20th Century Art from the Maremont Collection." April 1-May 5, 1963. Catalog.

1964

New York. St. Peter's Church. "First Chelsea Art Festival." May 9-24, 1964.

New York. The Sculptors Guild, Inc. "Sculpture 1964." Held at Lever House. October 8-November 26, 1964.

Houston. University of St. Thomas. "Constant Companions: An Exhibition of Mythological Animals, Demons and Monsters, Phantasmal Creatures and Various Anatomical Assemblages." October 28, 1964–February 7, 1965. Catalog.

New York. Noah Goldowsky Gallery. "Quantum I." December 1964. Included 13 artists, among them Agostini, Hinman, and Pereira.

1965

New York. Noah Goldowsky Gallery and A. M. Sachs Gallery. "Quantum II." January 5-26, 1965.

Paris. Musée Rodin. "Les Etats-Unis: Sculpture du XX Siècle." Organized under the auspices of The International Council of The Museum of Modern Art, New York. June 22-October 10, 1965. Catalog.

New York. Great Jones Gallery. "Drawings." September 29-October 23, 1965. Included 11 artists, among them Guston, Kadish, Lekakis, Pavia, and Stout.

New York. The Sculptors Guild, Inc. "Sculpture 1965." Held at Lever House. October 31-November 21, 1965.

Paris. "XXVIIe Salon de la Jeune Sculpture." 1965.

1966

Providence, R.I. Museum of Art, Rhode Island School of Design. "Recent Still-Life." February 23-April 4, 1966. Catalog.

New York. Fischbach Gallery. "Eccentric Abstraction." September 20-October 8, 1966. Announcement with text. Included A. Adams, Hesse, Kuehn, Nauman, Potts, Sonnier, and Viner.

New York. The Sculptors Guild, Inc. "Annual Exhibition." Held at Lever House. October 23-November 20, 1966.

1967

New York. The Museum of Modern Art.

"Jewelry by Contemporary Sculptors." Limited showing in New York for Museum members, October 3-6, then national tour.

New York. The Sculptors Guild, Inc. "Thirtieth Anniversary Exhibition." Held at Lever House. October 23-November 19, 1967. Tour.

New York. The Sculptors Guild, Inc. "Recent Sculpture." Held at 797 Madison Avenue. December 12, 1967-January 6, 1968.

1968

New York. The Sculptors Guild, Inc. "Wood and Stone." Held at 797 Madison Avenue. March 2-31, 1968.

New York. Bertha Schaefer Gallery. "Faculty, Alumni and Students of Pratt Institute Honor the Memory of Jeffrey Lundstedt." June 17-22, 1968. Benefit.

New York. "Soft Sculpture." Touring exhibition sponsored by The American Federation of Arts and organized by Lucy R. Lippard. October 1968-May 1969. Included 14 artists, among them Hesse, Nauman, Oldenburg, Serra, and Sonnier.

New York. The Sculptors Guild, Inc. "Salute to New York City." Held at Bryant Park. October 3-November 3, 1968.

New York. Whitney Museum of American Art. "Annual Exhibition: Sculpture." December 17, 1968-February 9, 1969.

1969

New York. The Museum of Modern Art. "The New American Painting and Sculpture: The First Generation." June 18-October 5, 1969. Checklist.

Baltimore. Baltimore Museum of Art. "The Partial Figure in Modern Sculpture." December 2, 1969-February 1, 1970. Catalog.

Carrara, Italy. 6th Biennale Internazionale di Scultura. August 1969.

1970

New York. M. Knoedler and Co., Inc. Group Show. January 6-31, 1970. Among artists included were Moore, Newman, Rosenthal, and T. Smith.

Providence, R. I. Museum of Art, Rhode Island School of Design. "Governor's Arts Awards Exhibition." June 24-July 12, 1970. Catalog.

St. Paul de Vence, France. Fondation Maeght. "L'Art Vivant aux Etats-Unis." July 16-September 30, 1970. Catalog.

Lincoln, Neb. Sheldon Sculpture Garden at the University of Nebraska. "American Sculpture." September 11-November 15, 1970. Catalog.

New York. Whitney Museum of American Art. "Annual Exhibition: Contemporary American Sculpture." December 12, 1970-February 7, 1971.

Philadelphia. Philadelphia Art Alliance. "Sculpture 1970."

1971

New York. M. Knoedler and Co., Inc. "Exhibition of Gallery Artists." September 14-October 16, 1971.

1972

New York. Women's Ad Hoc Committee at 117-119 Prince Street. "13 Women Artists." March 4-31, 1972. Included A. Adams, Dunkelman, Hemenway, Hui, Kazuko, Lasch, Marshall, Miss, Norvell, Robins, Tavins, and Waterman.

Hamburg, Germany. Kunsthaus. "American Women Artists Show." April 1972. In cooperation with Gedok, the feminist organization of German artists. Included 46 artists.

Peoria, Ill. Lakeview Center for the Arts and Sciences. "American Women: 20th Century." September 15–October 29, 1972. Catalog.

Stony Brook, N.Y. Suffolk Museum and Carriage House. "Unmanly Art." October 7-November 17, 1972. Catalog.

New York. Landmark Gallery. "118 Artists." December 9-30, 1972. Among the artists were Aach, Boutis, Briggs, Cavallon, Fromboluti, Georges, Kaldis, Kriesberg, Marsicano, Passloff, Resika, and Resnick.

New York. "Soho Arts Festival for McGovern."

1973

New York. Whitney Museum of American Art. "Biennial Exhibition: Contemporary American Art." January 10-March 18, 1973.

New York. School of Visual Arts. "American Type Sculpture: Part 1." March 20-April 13, 1973. Included Ferber, Hare, Lassaw, Lipton, Noguchi, and D. Smith.

Mountainville, N.Y. Storm King Art Center. "Sculpture in the Fields." 1973-April 7, 1976.

New York. Landmark Gallery. "118 Artists." December 22, 1973-January 10, 1974.

1974

New York. The Erotic Art Gallery. Group Show. February 8-March 30, 1974. Catalog.

East Lansing, Mich. Kresge Art Center Gallery, Michigan State University. "Works by Women from the Ciba-Geigy Collection." March 2-24, 1974. Catalog.

New York. South Houston Gallery. "American International Sculptors Symposiums, Inc." April 6-29, 1974. Included Graves, Greenleaf, Halahmy, Hatcher, Katzen, Lindner, Slivka, Stoltz, and Witkin.

Philadelphia. Museum of the Philadelphia Civic Center. "East Coast Women's Invitational Exhibition." April 27-May 26, 1974.

New York. Women's Interart Center, Inc. "Color, Light and Image." November 13, 1974-January 30, 1975.

New York. Sculpture Now, Inc. "Group Show." November 16, 1974-January 1975. Included Buchman, Chamberlain, Ginnever, Helman, Kirschenbaum, R. Murray, Myers, and Wilmarth.

New York. The Museum of Modern Art. "American Prints 1913-1963: An Exhibition Commemorating the 25th Anniversary of the Founding of The Abby Aldrich Rockefeller Print Room." December 3, 1974-March 3, 1975. Brochure with checklist.

New York. Landmark Gallery. "118 Artists." December 20, 1974-January 8, 1975. Included Baranik, Blaustein, Cajori, G. Campbell, Drexler, Finkelstein, Geist, Ippolito, Mumford, Pearlstein, Semmel, and Speyer.

1975

New Brunswick, N. J. Mabel Smith Douglass Library, Douglass College. "Women Artists Year 4." April 21-May 9, 1975. Included Abish, Graupe-Pillard, Reder, Rusak, Schapiro, Sirkis, Sleigh, and Stevens. Catalog.

New York. Michael Walls Gallery. "Thirty Artists in America, Part 1." June 7-July 3, 1975. Included Abish, Bontecou, Celmens, Hesse, Korman, Kurt, Lenkowsky, A. Martin, E. Murray, K. Porter, Snyder, and Yankowitz.

Portland, Ore. Portland Art Museum. "20th Century Masterworks in Wood." September 17-October 19, 1975. Catalog.

Washington, D.C. National Collection of Fine Arts, Smithsonian Institution. "Sculpture:

American Directions." October 3-November 30, 1975. Checklist.

New York. New York University. "Inaugural Exhibition: Selections from the N.Y.U. Art Collection." Autumn 1975. Catalog with checklist.

Montclair, N. J. Montclair Art Museum. "Vaclav Vytlacil." November 16, 1975-January 25, 1976. Catalog. Included work by his students: Boris, Boxer, Day, Garel, Hess, Krushenick, Leiber, Minewski, Moy, Ponce de Leon, Rauschenberg, Rosenquist, T. Smith, Stapleton, Stefanelli, Tania, and Twombly.

New York. The Museum of Modern Art. "American Art since 1945 from the Collection of The Museum of Modern Art." Tour 1975-77. Catalog.

New York. Sculpture Now, Inc. Group Show. Included Buchman, Fishman, Ginnever, Grossberg, Kirschenbaum, Meadmore, Myers, and Reginato.

1976
New York. Whitney Museum of American Art. "200 Years of American Sculpture." March 16-September 26, 1976. Catalog.

Roslyn, N.Y. Nassau County Museum of Fine Art. "Nine Sculptors: On the Ground, In the Water, Off the Wall." May 2-July 25, 1976. Included Benglis, Bladen, di Suvero, Ginnever, Hagan, Singer, Stone, and von Schlegell.

New York. The Museum of Modern Art. "Narrative Prints." May 14-August 8, 1976.

New York. Landmark Gallery. "118 Artists." December 18, 1976-January 6, 1977.

1977
Greenwich, Conn. Hurlbutt Gallery. "Contact: Women and Nature." January 7-29, 1977. Checklist.

New York. Xavier Fourcade, Inc. "Works on Paper, Small Format, Objects." February 15-March 19, 1977.

New York. Whitney Museum of American Art. "30 Years of American Art 1945-1975: Selections from the Permanent Collection." March 24-October 23, 1977.

New York. Women's Interart Center, Inc. "Space/Matter 1977." April 12-May 26, 1977.

New York. Cayman Gallery. "Solidarity with

Chilean Democracy: Memorial to Orlando Letelier." April 30-May 7, 1977. Benefit.

New York. Grace Borgenicht Gallery, Leo Castelli Gallery, Xavier Fourcade, Inc. "300 Artists to the Support of the New York Studio School." April 1977. Benefit.

Waltham, Mass. Rose Art Museum, Brandeis University. "From Women's Eyes." May 1-June 12, 1977. Catalog.

New York. Davis and Long Co. and Robert Schoelkopf Gallery. "Brooklyn College Art Department: Past and Present 1942-1977." September 13-October 8, 1977. Catalog.

New York. Brooklyn Museum Art School. "Contemporary Women: Consciousness and Content." October 1-27, 1977. Catalog. Included 31 artists, among them Bernstein, Carlson, Edelson, Kozloff, Morton, Semmel, Steir, Stevens, and Wilke.

Madison, Wis. Elvehjem Art Center of The University of Wisconsin. "Retrospective Exhibition of Atelier 17." In honor of the workshop's 50th Anniversary. October 9-December 4, 1977. Catalog.

New York. Bronx Museum of the Arts. "Images of Horror and Fantasy." November 15-December 30, 1977. Book published in 1978.

1978
New York. Julian Pretto Gallery. "Atypical Works." January 1978.

New York. O. K. Harris. "Living Sculpture: Benefit for Public Arts Council of the Municipal Art Society." May 22, 1978.

New York. Roy G. Biv Gallery. "Prints by Sculptors." June 27-July 29, 1978.

Reading, Pa. Freedman Gallery, Albright College. "Perspective 1978: Works by Women." October 8-November 15, 1978. Catalog. Included 27 artists, among them Flack, Frank, Haerer, Katzen, J. Mitchell, Pepper, Rockburne, and Sleigh.

New York. Hamilton Gallery of Contemporary Art. "In Small Scale: Maquettes for Larger Works." December 1978.

New York. Landmark Gallery. "118 Artists." December 16, 1978-January 4, 1979.

1979
Philadelphia. Marion Locks Gallery. "In Small Scale, Phase II." April 14-May 11,

1979. Coordinated by Hamilton Gallery, New York.

New York. Hamilton Gallery of Contemporary Art. "Gallery Group." Summer 1979. Included Dusenbery, Gorchov, Hall, Hare, Meadmore, R. Murray, Remington, Snyder, Stayton, Willenbecher, and Witkin.

New York. Hamilton Gallery of Contemporary Art. "Gallery Artists." December 20, 1979-January 5, 1980.

New York. 112 Greene Street Gallery. "Artists against Nuclear Power Plants." Benefit.

1980
New York. Xavier Fourcade, Inc. "Small Scale." January-March 1980.

New York. Graham Gallery. "Originals." January 15-February 20, 1980. Based on book by Eleanor Munro, *Originals: American Women Artists*, 1979.

New Orleans, La. E. Lorenze Borenstein Gallery. "Women's Caucus for Art Honors: Albers, Bourgeois, Durieux, Kohlmeyer, Krasner." January 31-February 16, 1980. Organized in conjunction with National Women's Caucus for Art Conference. Catalog.

New York. Helen Serger, La Boetie, Inc. "Pioneering Women Artists 1900 to 1940." February 15-May 15, 1980.

New York. Art Expo 1980. "Sculpture at the Coliseum." March 6-19, 1980. Organized by The Institute for Art and Urban Resources. Included di Suvero, Ferrara, Nonas, Rosenthal, Saret, Stockwell, and Yasudo.

Purchase, N.Y. Neuberger Museum of The State University of New York at Purchase. "Hidden Desires." March 9-June 15, 1980.

New York. Max Hutchinson Gallery. "10 Abstract Sculptures: American and European 1940-1980." March 18-April 19, 1980. Catalog.

New York. Frank Marino Gallery. "Heresies Benefit Exhibition." May 1980.

New York. Henry Street Settlement. "Exchanges II." May 8-June 21, 1980. Organized to combine established and emerging artists. Included Bertoldi, dePirro, Dolberg, Highstein, Katz, Murphy, Nelson, Noguchi, Obuck, Rossiter, and von der Lippe.

Washington, D.C. National Collection of Fine Arts. "Across the Nation: Fine Art for Fed-

eral Buildings 1972-79." June 4-September 1, 1980.

New York. Grey Art Gallery and Study Center, New York University. "Perceiving Modern Sculpture: Selections for the Sighted and the Non-Sighted." July 8-August 22, 1980. Catalog.

New York. Xavier Fourcade, Inc. "One Major New Work Each." November 4-December 31, 1980. Included 11 artists, among them Berlant, de Kooning, Hague, Heizer, Mitchell, Morley, C. Murphy, and Westermann.

1981
New York. Max Hutchinson Gallery. "Sculptors and their Drawings." February 1981.

New York. Westbeth Gallery. "Voices Expressing What Is: Exhibition against Racism in the Arts." February 1981.

New York. Grey Art Gallery and Study Center, New York University. "Permanent Collection Exhibition: Small Sculpture." March-April 1981.

New York. Marisa del Re Gallery. "Sculptures and their Related Drawings." March 3-31, 1981.

New York. The Drawing Center. "Sculptors' Drawings over Six Centuries 1400-1950." March 21-June 20, 1981. Catalog. National tour.

New York. Whitney Museum of American Art. "Decade of Transition: 1940-1950." April 30-July 12, 1981.

New York. Grey Art Gallery and Study Center, New York University. "Heresies Benefit Exhibition." June 1981.

New York. Robert Miller Gallery. "Summer Exhibition 1981." June 9-July 31, 1981. Included Brice, Chase, Resnick, Sugarman, and Zakanitch.

Stamford, Conn. Stamford Museum and Nature Center. "Classic Americans: XX Century Painters and Sculptors." June 14-September 7, 1981. Checklist.

New York. Xavier Fourcade, Inc. "Sculpture." June 30-September 11, 1981.

Edinburgh, Scotland. City Art Centre, Fruitmarket Gallery. Edinburgh International Festival 1981: "American Abstract Expressionists." August 13-September 12, 1981.

Organized under the auspices of The International Council of The Museum of Modern Art, New York. Brochure with checklist.

New York. Oscarsson Hood Gallery. "The New Spiritualism: Transcendent Images in Painting and Sculpture." September 9–27, 1981. Catalog. Included 16 artists, among them Brookner, Highstein, D. Martin, Puryear, Reinhardt, Stout, Torreano, and Westerlund.

New York, Forum Gallery. "Sculpture in Wood and Stone." September 19–October 10, 1981.

New York. The Institute for Art and Urban Resources, P.S. 1. "Figuratively Sculpting."

October 18–December 13, 1981. Checklist. Included 43 artists, among them Ahearn, Borofsky, Garet, Neri, Otterness, Rupp, J. Shea, Thek, F. Young, and Youngblood.

New York. Zabriskie Gallery. "Art for E.R.A." November 19–21, 1981. Benefit.

New York. Terry Dintenfass Gallery and Allan Frumkin Gallery. "Art Sale for C.A.P.S." December 5–6, 1981. Benefit.

1982

New York. Ronald Feldman Gallery. "Sweet Art Sale: Benefit for Franklin Furnace." February 17–20, 1982.

New York. Greene Space Gallery. "Nature

as Image and Metaphor: Works by Contemporary Women Artists." Sponsored by the New York Chapter of the Women's Caucus for Art. February 23–March 13, 1982. Catalog. Included 28 artists, among them Benglis, Chase, Edelson, Graves, Pfaff, Slavin, Stuart, and Weil.

Fort Myers, Fla. Gallery of Fine Arts, Edison Community College. "National Women in Art." March 6–April 18, 1982.

New York. Marisa del Re Gallery. "Selected Works on Paper II." April 6–May 1, 1982.

New York. CDS Gallery. "Artists Choose Artists." April 16–June 12, 1982. Catalog. Bourgeois chose N. Antunez.

Boston. Harcus Krakow Gallery. "Major Works of the 1960s." May 8–June 9, 1982.

Montclair, N. J. College Art Gallery, Montclair State College. "Visiting Artist Invitational." May 10–June 18, 1982.

Cambridge, Mass. Hayden Corridor Gallery, Massachusetts Institute of Technology. "Clothing by Artists." May 15–June 27, 1982.

New York. Robert Miller Gallery. "Landscapes." June 9–July 31, 1982.

San Francisco. San Francisco Museum of Modern Art. "20 American Artists: 1982 Sculpture." July 22–September 15, 1982.

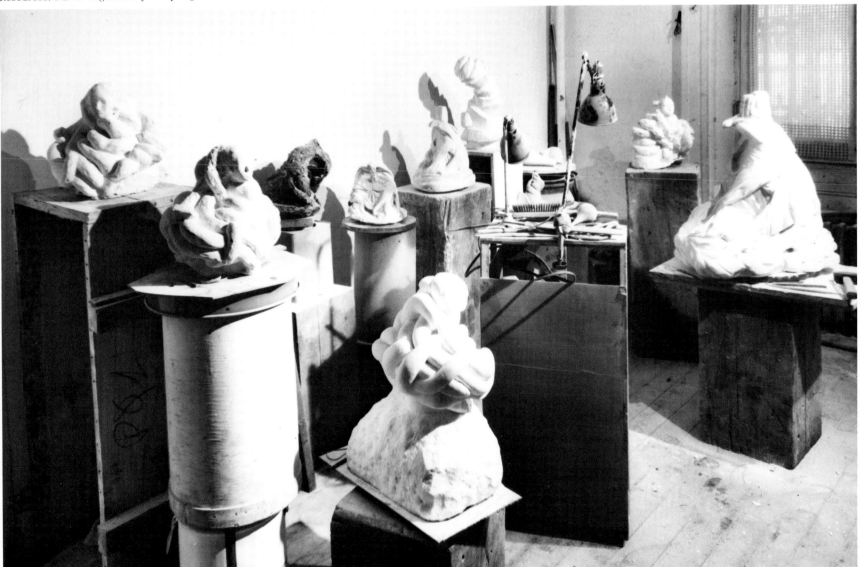

Fig. 27. Studio, West 20th Street, August 1982

BIBLIOGRAPHY

The publications that follow are arranged chronologically by year, alphabetically within the year. Materials containing statements or writings by the artist are indicated by an asterisk. Although the exhibitions list takes note of the existence of a catalog, brochure, checklist, or announcement accompanying a show, significant exhibition catalogs are also cited here. Reviews of group exhibitions have been included selectively, as have newspaper reviews of New York solo exhibitions. A few books or magazines that illustrate the artist's work but do not discuss it have also been cited. Only general reference works with extended entries on the artist are included.

Materials available at the Archives of American Art, Smithsonian Institution, Washington, D.C., are as follows:

*Roll N48, frame 460: Personal statement.

*Roll 54: Papers, 1936–70, including correspondence, drawings; 1947–63, portraits, prints, catalogs, clippings (ca. 265 items)

Roll N49, frames 744–45: Exhibition announcement and reproduction.

Roll 90, frames 1–247: Sketches (drawings, studies), and miscellany, ca. 1939–70 (ca. 430 items)

*Interview with Colette Roberts.

1945

*Bourgeois, Louise. "Natural History." In [exhibition catalog] Personal Statement: Painting Prophecy 1950, edited by David Porter. Washington, D.C.: David Porter Gallery, 1945, p. 9.

Devree, Howard. [Exhibition review, Bertha Schaefer Gallery.] New York Times (June 10, 1945), Sec. II, p. 2.

[Exhibition review, Bertha Schaefer Gallery.] Art News (New York), vol. 44 (June 1945), pp. 30, 37.

[Exhibition review, Bertha Schaefer Gallery.] New York Herald Tribune (June 10, 1945).

R[eed], J[udith] K. [Exhibition review, Bertha Schaefer Gallery.] Art Digest (New York), vol. 19 (June 1945), p. 31.

1947

[Exhibition review, Norlyst Gallery.] Art News (New York), vol. 46 (Nov. 1947), p. 42.

[Exhibition review, Norlyst Gallery.] New York Sun (Oct. 31, 1947).

[Exhibition review, Norlyst Gallery.] New York Times (Nov. 2, 1947).

1948

"Artists." Magazine of Art (New York), vol. 41 (Dec. 1948), p. 307 (2 illus.).

1949

Bewley, Marius. "An Introduction to Louise Bourgeois." The Tiger's Eye (New York), vol. 1, no. 7 (Mar. 15, 1949), pp. 89–92 (1 illus.).

[Exhibition review, Peridot Gallery.] New York Times (Oct. 9, 1949).

[Exhibition review, Peridot Gallery.] New York Sun (Oct. 14, 1949).

G., M. "Debut as Sculptor at Peridot." Art News (New York), vol. 48 (Oct. 1949), p. 46.

Preston, Stuart. [Exhibition review, Peridot Gallery.] New York Times (Oct. 9, 1949), Sec. II, p. 9.

S[harp], M[arynell]. "Telegraphic Constructions." Art Digest (New York), vol. 24 (Oct. 15, 1949), p. 22.

The Tiger's Eye (New York), no. 9 (Oct. 15, 1949), p. 52 (illus. only).

1950

G., R. [Exhibition review, Peridot Gallery.] Art News (New York), vol. 49 (Oct. 1950), p. 48.

L[evy], P[esella]. [Exhibition review, Peridot Gallery.] Art Digest (New York), vol. 25 (Oct. 1, 1950), p. 16 (1 illus.).

Preston, Stuart. "'Primitive' to Abstraction in Current Shows." New York Times (Oct. 8, 1950), Sec. II, p. 9.

1951

Motherwell, Robert, and Reinhardt, Ad. Modern Artists in America. New York: Wittenborn Schultz, 1951, pp. 8–22, 86, 100, 133 (1 illus.).

1952

Fitzsimmons, James. [Exhibition review, "Recent Painting and Sculpture," Peridot Gallery.] Art Digest (New York), vol. 26, no. 15 (May 1, 1952).

1953

Fitzsimmons, James. [Exhibition review, Peridot Gallery.] Arts and Architecture (Los Angeles), vol. 70 (Apr. 1953), p. 35.

G[eist], S[idney]. "Louise Bourgeois." Art Digest (New York), vol. 27 (Apr. 1, 1953), p. 17.

P[orter], F[airfield]. [Exhibition review, Peridot Gallery.] Art News (New York), vol. 52 (Apr. 1953).

1954

*Krasne, Belle. "10 Artists in the Margin." Design Quarterly (Minneapolis), no. 30 (1954), pp. 9–22 (2 illus.).

Walker Art Center. [Exhibition catalog.] Reality and Fantasy, 1900–1954. Introduction by H.H. Arnason. Minneapolis: 1954 (1 illus.).

1956

Goldwater, Robert. "La Sculpture Actuelle à New York." Cimaise (Paris), vol. 4 (Nov.–Dec. 1956), pp. 24–28 (1 illus.).

Hess, Thomas B. "Mutt Furioso." Art News (New York), vol. 55 (Dec. 1956), pp. 22–25, 64–65 (1 illus.).

Munro, Eleanor. "Explorations in Form." Perspectives USA (New York), no. 16 (Summer 1956), pp. 160–72 (1 illus.).

M., J.R. "Whitney Annual." Arts (New York), vol. 31 (Dec. 1956), p. 52 (1 illus.).

1957

American Abstract Artists, ed. The World of Abstract Art. New York: Wittenborn, 1957, p. 155 (1 illus.).

1958

*Baur, John I. H. Nature in Abstraction. New York: Whitney Museum of American Art, 1958, pp. 8, 9, 30, 61 (1 illus.).

Hess, Thomas B. "Inside Nature." Art News (New York), vol. 56 (Feb. 1958), p. 63 (illus. only).

"Sculpture 1950–1958." Oberlin College Bulletin (Oberlin, Ohio), vol. 15, no. 2 (Winter 1958), p. 66 (1 illus.).

1959

Berckelaers, F. L. [Michael Seuphor]. "Le Choix d'un critique." Oeil (Paris), no. 49 (Jan. 1959), pp. 28, 30 (1 illus.).

Berckelaers, F. L. The Sculpture of This Century. Translated from the French. New York: Braziller, 1959 (1 illus.).

Ragon, Michel. "L'Art actuel aux États-Unis: Art Today in the United States." Cimaise (Paris), vol. 6 (Jan.–Mar. 1959), pp. 6–35.

1960

Giedion-Welcker, Carola. Contemporary Sculpture: An Evolution in Volume and Space. Rev. ed. New York: Wittenborn, 1960, pp. 288, 325, 326, 327 (1 illus.).

1961

"Artists on the Current Scene." In Arts Yearbook 4. New York: Art Digest, 1961, p. 154 (2 illus.).

*Pearlstein, Philip. "The Private Myth." Art News (New York), vol. 60 (Sept. 1961), pp. 42–45, 62.

*Tanager Gallery. [Exhibition catalog.] The Private Myth: An Exhibition and Statements. New York: 1961.

Whitney Museum of American Art. [Exhibition catalog.] American Art of our Century. Organized by Lloyd Goodrich and John Baur. New York: Praeger, 1961, p. 234 (1 illus.).

1962

Mount Holyoke Friends of Art. [Exhibition catalog.] Woman Artists in America Today. South Hadley, Mass.: 1962 (1 illus.).

Oeri, Georgine. "A Propos of 'The Figure.'" Quadrum: Revue Internationale d'Art Moderne (Brussels), vol. 13 (1962), pp. 49–60 (1 illus.).

1963

Washington Gallery of Modern Art. [Exhibition catalog.] Maremont Collection of Twentieth Century Art. Washington, D.C.: 1963 (illus. only).

1964

E[dgar], N[atalie]. [Exhibition review, Stable Gallery.] Art News (New York), vol. 62 (Jan. 1964), p. 10 (1 illus.).

E[dgar], N[atalie]. [Exhibition review, Fried Gallery.] Art News (New York), vol. 62 (Feb. 1964), p. 9.

[Exhibition review, Stable Gallery.] New York Herald-Tribune (Jan. 11, 1964).

[Exhibition review, Stable and Fried Galleries.] New York Post (Jan. 26, 1964).

Oeri, Georgine. "The Object of Art." Quadrum: Revue Internationale d'Art Moderne (Brussels), vol. 16 (1964), pp. 14–15 (1 illus.).

Preston, Stuart. [Exhibition review, Stable Gallery.] New York Times (Jan. 19, 1964), p. 23.

R., V. [Exhibition review, Stable Gallery.] Arts (New York), vol. 38 (Mar. 1964), p. 63 (1 illus.).

Read, Herbert. *Concise History of Modern Sculpture.* New York: Praeger, 1964, p. 203 (illus. only.).

Robbins, Daniel. "Sculpture by Louise Bourgeois." *Art International* (Lugano), vol. 8 (Oct. 20, 1964), pp. 29-31 (6 illus.).

Rose Fried Gallery. [Exhibition catalog.] *Drawings by Louise Bourgeois.* Text by Daniel Robbins. New York: 1964 (1 illus.).

University of St. Thomas. [Exhibition catalog.] *Constant Companions: An Exhibition of Mythological Animals, Demons and Monsters, Phantasmal Creatures and Various Anatomical Assemblages.* Houston: 1964.

1965

Arts Yearbook 8: Contemporary Sculpture. Introduction by William Seitz. New York: Art Digest, 1965, pp. 24-25 (1 illus.).

Musée Rodin. [Exhibition catalog.] *Les Etats-Unis: Sculpture du XX Siècle.* Exhibition organized under the auspices of The International Council of The Museum of Modern Art, New York. Paris: 1965 (1 illus.).

*"Waldorf Panels 1 and 2 on Sculpture." *It Is* (New York), vol. 6 (Autumn 1965), pp. 12-13, 30, 54, 71, 123 (4 illus.).

1966

Antin, David. "Another Category: 'Eccentric Abstraction.'" *Artforum* (Los Angeles), vol. 5 (Nov. 1966), pp. 56, 57.

Ashton, Dore. "Marketing Techniques in the Promotion of Art." *Studio International* (London), vol. 172, no. 883 (Nov. 1966), pp. 270-73.

B[ochner], M[el]. "Eccentric Abstraction." *Arts* (New York), vol. 41 (Nov. 1966), p. 58.

Fischbach Gallery. [Exhibition catalog.] *Eccentric Abstraction.* Introduction by Lucy R. Lippard. New York: 1966.

Lippard, Lucy R. "Eccentric Abstraction." *Art International* (Lugano), vol. 10 (Nov. 20, 1966), pp. 28, 34-40 (2 illus.).

Museum of Art, Rhode Island School of Design. [Exhibition catalog.] *Recent Still Life.* Introduction by Daniel Robbins. Providence: 1966 (2 illus.).

Robbins, Daniel. "Recent Still Life." *Art in America* (New York), vol. 54 (Jan.-Feb. 1966), pp. 57-60 (1 illus.).

1967

Andersen, Wayne. "American Sculpture: The Situation in the Fifties." *Artforum* (New York), vol. 5 (Summer 1967), pp. 60-67 (2 illus.).

1968

Ashton, Dore. *Modern American Sculpture.* New York: Abrams, 1968, pp. 36, 39 (1 illus.).

Trier, Eduard. *Form and Space: Sculpture in the 20th Century.* New York: Praeger, 1968 (1 illus.).

1969

Baltimore Museum of Art. [Exhibition catalog.] *The Partial Figure in Modern Sculpture.* Introduction by Albert Elsen. Baltimore: 1969, pp. 72-73, 95, 98 (3 illus.).

*Bourgeois, Louise. *Art Now: New York,* vol. 1, no. 7 (Sept. 1969) (1 illus.).

*Bourgeois, Louise. "Fabric of Construction at MOMA." *Craft Horizons* (New York), vol. 29 (Mar.-Apr. 1969), pp. 30-35.

Elsen, Albert. "Notes on the Partial Figure." *Artforum* (New York), vol. 8 (Nov. 1969), pp. 58-63 (1 illus.).

Goldwater, Robert. *What Is Modern Sculpture?* New York: The Museum of Modern Art, 1969, p. 96 (1 illus.).

Hammacher, A. M. *The Evolution of Modern Sculpture.* New York: Abrams, 1969, pp. 323, 326.

Rubin, William. "Some Reflections Prompted by the Recent Work of Louise Bourgeois." *Art International* (Lugano), vol. 8 (Apr. 20, 1969), pp. 17-20 (6 illus.).

1970

Art International (Lugano), vol. 14 (Feb. 1970) cover.

Fondation Maeght, St. Paul de Vence, France. *L'Art vivant aux États-Unis.* Introduction by Dore Ashton. Paris: 1970, pp. 118-19 (1 illus.).

*Glueck, Grace. "Women Artists Demonstrate at Whitney." *New York Times* (Dec. 12, 1970). (Reprinted in *A Documentary Herstory.* New York: Women Artists in Revolution, 1971.)

Maillard, Robert, ed. *New Dictionary of Modern Sculpture.* Translated from the French. New York: Tudor, 1970, pp. 40-41 (1 illus.).

Museum of Art, Rhode Island School of Design. [Exhibition catalog.] *Governor's Arts Awards Exhibition.* Providence: 1970 (1 illus.).

Nebraska Art Association. [Exhibition catalog.] *American Sculpture.* Introduction by Norman A. Geske. Lincoln: 1970 (1 illus.).

1971

Marandel, J. Patrice. "Louise Bourgeois." *Art International* (Lugano), vol. 15 (Dec. 20, 1971), pp. 46-47, 72 (6 illus.).

*Nemser, Cindy. "Forum: Women in Art." *Arts Magazine* (New York), vol. 45 (Feb. 1971), p. 18. (Reprinted in *A Documentary Herstory.* New York: Women Artists in Revolution, 1971.)

Nochlin, Linda. "Why Have There Been No Great Women Artists?" *Art News* (New York), vol. 69 (Jan. 1971), p. 37 (illus. only).

1972

Alloway, Lawrence. "Art." *The Nation* (New York), vol. 214 (Mar. 27, 1972), pp. 413-14.

*Bourgeois, Louise. "Letter to the Editor." *Art in America* (New York), vol. 60 (Jan.-Feb. 1972), p. 123.

Lakeview Center for the Arts and Sciences. [Exhibition catalog.] *American Women: 20th Century.* Introduction by Ida Kohlmeyer. Peoria: 1972, pp. 28-29, 70-71 (3 illus.).

Suffolk Museum. [Exhibition catalog.] *Unmanly Art.* Introduction by June Blum. Stony Brook, N.Y.: 1972, p. 31 (1 illus.).

1973

Ashton, Dore. "Louise Bourgeois." In *The Britannica Encyclopedia of American Art.* Chicago: Encyclopedia Britannica Educational Corporation, 1973, p. 79.

Brumer, Miriam. "Organic Image: Women's Image?" *The Feminist Art Journal* (Brooklyn, N.Y.), vol. 2 (Spring 1973), pp. 12-13 (1 illus.).

Hunter, Sam. *American Art of the Twentieth Century: Painting, Sculpture, Architecture.* New York: Abrams, 1973, p. 518 (1 illus.).

1974

The Erotic Art Gallery. [Exhibition catalog.] *Group Show.* Introduction by Lee Revens. New York: 1974 (2 illus.).

Kresge Art Center Gallery. [Exhibition catalog.] *Works by Women from the Ciba-Geigy Collection.* East Lansing: Michigan State University, 1974 (1 illus.).

*Seiberling, Dorothy. "The Female View of Erotica." *New York Magazine,* vol. 7 (Feb. 11, 1974) (1 illus.).

1975

Andersen, Wayne. *American Sculpture in Process: 1930/1970.* Boston: New York Graphic Society, 1975, pp. 92-95 (4 illus.).

Andre, Michael. [Exhibition review, 112 Greene Street Gallery.] *Art News* (New York), vol. 74 (Feb. 1975), p. 100.

"Artists Talk on Art." *Women in the Arts Newsletter* (New York, Feb. 1975).

Baldwin, Carl R. "Louise Bourgeois: An Iconography of Abstraction." *Art in America* (New York), vol. 63 (Mar.-Apr. 1975), pp. 82-83 (2 illus.).

Lippard, Lucy R. "Louise Bourgeois: From the Inside Out." *Artforum* (New York), vol. 13 (Mar. 1975), pp. 26-33 (14 illus. and cover). (Reprinted in *From the Center: Feminist Essays on Art.* New York: Dutton, 1976.)

*"Louise Bourgeois." Videotaped interview conducted by Lynn Blumenthal and Kate Horsfield, Sept. 1975. 30 min., b/w. Video Data Bank, School of the Art Institute of Chicago. Also available for rent in program entitled *Sculpture A.*

Mabel Smith Douglass Library, Douglass College. [Exhibition catalog.] *Women Artists Year 4.* Introduction by Linda Nochlin. New Brunswick, N.J.: 1975, pp. 12, 15 (1 illus.).

Montclair Art Museum. [Exhibition catalog.] *Vaclav Vytlacil.* Montclair, N.J.: 1975, p. 48 (1 illus.).

*The Museum of Modern Art. [Exhibition catalog.] *American Art since 1945 from the Collection of The Museum of Modern Art.* Exhibition organized by Alicia Legg. New York: 1975, p. 45 (1 illus.).

Petersen, Karen, and Wilson, J.J. *Women Artists: Themes and Dreams.* New York: Harper & Row, 1975 (1 slide).

Portland Art Museum. [Exhibition catalog.] *20th Century Masterworks in Wood.* Portland, Ore.: 1975 (1 illus.).

Sondheim, Alan. [Exhibition review, 112 Greene Street Gallery.] *Arts Magazine* (New York), vol. 49 (Mar. 1975), p. 23 (1 illus.).

1976

Alloway, Lawrence. "Women's Art in the '70s." *Art in America* (New York), vol. 64 (May-June 1976), pp. 64-72 (1 illus.).

*Bloch, Susi. "An Interview with Louise Bourgeois." *The Art Journal* (New York), vol. 35, no. 4 (Summer 1976), pp. 370-73 (5 illus.).

*Henry, Gerrit. "Views from the Studio." *Art News* (New York), vol. 75, no. 5 (May 1976), pp. 32-36 (1 illus.).

Krauss, Rosalind E. "Magician's Game: Decades of Transformation, 1930-1950." In [exhibition catalog] *200 Years of American Sculpture.* Boston: David R. Godine, and New York: Whitney Museum of American Art, 1976, pp. 168, 173, 176, 191 (2 illus.).

Lippard, Lucy R. "Louise Bourgeois: From the Inside Out." In *From the Center: Feminist Essays on Women's Art.* New York: Dutton, 1976, pp. 238-249 (cover and 3 illus.).

Ratcliff, Carter. [Exhibition review, Nassau County Museum of Fine Arts.] *Artforum* (New York), vol. 15 (Oct. 1976), p. 63.

Robins, Corinne. "Louise Bourgeois: Primordial Environments." *Arts Magazine* (New York), vol. 50 (June 1976), pp. 81-83 (3 illus.).

1977

Arnason, H. H. *History of Modern Art: Painting, Sculpture, Architecture.* 2d ed. New York: Abrams, 1977, pp. 605-607 (3 illus.).

Conway, Madeleine, and Kirk, Nancy. "Louise Bourgeois." In *Artists' Cookbook.* New York: The Museum of Modern Art, 1977 (1 illus.).

Duncan, Carol. "The Esthetics of Power in Modern Erotic Art." *Heresies* (New York), vol. 1 (Jan. 1977), pp. 46-53 (1 illus.).

Ekdahl, Janis. *American Sculpture: A Guide to Information Sources.* Detroit: Gale Research, 1977.

Elvehjem Art Center, University of Wisconsin. [Exhibition catalog.] *Atelier 17: A 50th Anniversary Retrospective Exhibition.* Introduction by Joann Moser. Madison, Wis.: 1977, p. 84.

Hadler, Mona, and Viola, Jerome. [Exhibition catalog.] *Brooklyn College Art Department: Past and Present 1942-1977.* New York:

Brooklyn College Art Department, 1977, p. 28 (1 illus.).

Krauss, Rosalind E. *Passages in Modern Sculpture.* New York: Viking, 1977, pp. 148, 151 (1 illus.).

*Kuspit, Donald. "New York Today: Some Artists Comment." *Art in America* (New York), vol. 65 (Sept.-Oct. 1977), p. 79 (1 illus.).

Torre, Susanna, ed. [Exhibition catalog.] *Women in American Architecture: An Historic and Contemporary Perspective.* Organized by The Architectural League of New York and shown at The Brooklyn Museum. New York: Whitney Library of Design, 1977, pp. 114, 188-89 (2 illus.).

Wye, Deborah. "Louise Bourgeois." In [exhibition catalog] *From Women's Eyes.* Waltham, Mass.: Rose Art Museum, Brandeis University, 1977, pp. 14-19 (1 illus.).

1978

Ashbery, John. "Art/Anxious Architecture." *New York Magazine,* vol. 11, no. 42 (Oct. 16, 1978), pp. 161-63.

Frank, Peter. *Village Voice* (New York), vol. 23 (Oct. 2, 1978), p. 121 (1 illus.).

Freedman Gallery, Albright College. [Exhibition catalog.] *Perspective '78: Works by Women.* Reading, Pa.: 1978, p. 11 (1 illus.).

Gibson, Eric. "New York Letter: Louise Bourgeois." *Art International* (Lugano), vol. 22 (Nov.-Dec. 1978), p. 67.

"The Great Goddess: Visuals." *Heresies* (New York), vol. 2 (Spring 1978), p. 15 (1 illus.).

Harnett, Lila. [Exhibition review, Hamilton and Fourcade galleries.] *Cue* (New York), vol. 47, no. 21 (Oct. 27, 1978), p. 20 (1 illus.).

"Louise Bourgeois at the Hamilton Gallery of Contemporary Art." *Art Now Gallery Guide* (New York), vol. 9 (Sept. 1978), p. 2 (cover and 1 illus.).

Marandel, J. Patrice. "Louise Bourgeois." *Arts Magazine* (New York), vol. 53 (Oct. 1978), p. 17 (1 illus.).

Poroner, Palmer. "Is Bourgeois Blossoming?" *Chelsea Clinton News* (New York), Oct. 5, 1978, p. 16 (2 illus.).

Poroner, Palmer. "Bourgeois' Special Chem-

istry." *Chelsea Clinton News* (New York), Oct. 12, 1978, pp. 12, 16 (1 illus.).

Ratcliff, Carter. "Louise Bourgeois." *Art International* (Lugano), vol. 22 (Nov.-Dec. 1978), pp. 26-27 (1 illus.).

Ratcliff, Carter. "Making It in the Art World: A Climber's Guide" and "A Prejudiced Guide to the Art Market." *New York Magazine,* vol. 11 (Nov. 27, 1978), pp. 61-67, 68-71 (1 illus.).

Russell, John. [Exhibition review, Biv Gallery.] *New York Times* (June 9, 1978), p. C-18.

Russell, John. [Exhibition review, Hamilton Gallery.] *The New York Daily Metro* (Sept. 22, 1978), p. 20.

Schiff, Gert. *Images of Horror and Fantasy.* New York: Abrams, 1978, p. 96 (1 illus.).

University Art Museum, University of California. [Exhibition catalog.] *Matrix/Berkeley 17: Louise Bourgeois.* Introduction by Deborah Wye. Berkeley: 1978 (1 illus.).

Wilson, Laurie. "Louise Nevelson: Iconography and Sources." Ph.D. dissertation, City University of New York, 1978, pp. 4, 23, 44, 95, 108, 110-11, 112, 129, 148, 201-03, 204 (6 illus.).

Zucker, Barbara. [Exhibition review, Xavier Fourcade and Hamilton galleries.] *Art News* (New York), vol. 77 (Nov. 1978), pp. 177-79 (1 illus.).

1979

Lippard, Lucy R. "Complexes: Architectural Sculpture in Nature." *Art in America* (New York), vol. 67 (Jan.-Feb. 1979), pp. 87, 88, 93 (1 illus.).

Munro, Eleanor. "Louise Bourgeois." In *Originals: American Women Artists.* New York: Simon & Schuster, 1979, pp. 154-69 (5 illus.).

Munro, Eleanor. "The Rise of Louise Bourgeois." *Ms. Magazine* (New York), vol. 8 (July 1979), pp. 65-67, 101-02 (7 illus.).

*Pels, Marsha. "Louise Bourgeois: A Search for Gravity." *Art International* (Lugano), vol. 23 (Oct. 1979), pp. 46-54 (13 illus.).

Rickey, Carrie. "Louise Bourgeois, Xavier Fourcade Gallery." *Artforum* (New York), vol. 18 (Dec. 1979), p. 72 (1 illus.).

Russell, John. "Art: The Sculpture of Louise

Bourgeois." *New York Times* (Oct. 5, 1979), Sec. C (1 illus.).

Stofflet, Mary. *American Women Artists: The Twentieth Century.* New York: Harper & Row, 1979 (3 slides).

1980

Ashton, Dore. [Exhibition review, Xavier Fourcade, Inc.] *Artscanada* (Toronto), vol. 37, nos. 234-35 (Apr.-May 1980), p. 43 (1 illus.).

Cohen, Ronny H. "Louise Bourgeois, Max Hutchinson Gallery." *Artforum* (New York), vol. 19 (Nov. 1980), p. 86 (1 illus.).

[Exhibition review, Max Hutchinson Gallery and Xavier Fourcade, Inc.] *Art News* (New York), vol. 79, (Dec. 1980), p. 189 (1 illus.).

Gardner, Paul. "The Discreet Charm of Louise Bourgeois." *Art News* (New York), vol. 79 (Feb. 1980), pp. 80-86 (9 illus.).

Gorovoy, Jerry. [Exhibition catalog.] *The Iconography of Louise Bourgeois.* New York: Max Hutchinson Gallery, 1980 (31 illus.).

Grey Art Gallery and Study Center, New York University. [Exhibition catalog.] *Perceiving Modern Sculpture: Selections for the Sighted and Non-sighted.* New York: 1980 (1 illus.).

Hilton, Alison. [Exhibition catalog.] "A Look at the Artists." In *Women's Caucus for Art Honors: Anni Albers, Louise Bourgeois, Caroline Durieux, Ida Kohlmeyer, Lee Krasner.* Detroit: Women's Caucus for Art, 1980.

Johnson, Una E. *American Prints: A Chronicle of Over 400 Artists and Their Prints from 1900 to the Present.* Garden City, N.Y.: Doubleday, 1980, pp. 132-33 (1 illus.).

Kramer, Hilton. "Art: Contrasts in Imagery, 2 Views of Louise Bourgeois." *New York Times* (Oct. 3, 1980), p. C-29 (1 illus.).

Larson, Kay. "Louise Bourgeois: Body Language Spoken Here." *Village Voice* (New York), vol. 25 (Sept. 24, 1980), p. 83 (1 illus.).

Larson, Kay. "'For the first time women are leading not following'" *Art News* (New York), vol. 79 (Oct. 1980), pp. 64-72 (in cover group shot of women artists).

Lawson, Thomas. [Exhibition review, Max Hutchinson Gallery.] *Flash Art* (Milan), no. 100 (Nov. 1980), p. 45 (1 illus.).

Max Hutchinson Gallery. [Exhibition catalog.] *10 Abstract Sculptures: American and European 1940-1980.* New York: 1980 (1 illus.).

National Collection of Fine Arts, Smithsonian Institution. *Across the Nation: Fine Art for Federal Buildings: 1972-79.* Washington, D.C.: 1980 (1 illus.).

Ratcliff, Carter. "Louise Bourgeois." *Vogue* (New York), vol. 170, no. 10 (Oct. 1980), pp. 342-43, 375-77 (2 illus.)

Tallmer, Jerry. "An Intimate Life Goes on Show." *New York Post* (Sept. 6, 1980), p. 30 (1 illus.).

Tully, Judd. "Bourgeois' Marbles." *Art World* (New York), vol. 5, no. 2 (Oct. 17-Nov. 14, 1980), pp. 1, 12 (1 illus.).

1981

Brentano, Robyn, and Savitts, Mark, eds. *112 Workshop/112 Greene Street: History, Artists and Artworks.* New York: New York University Press, 1981, pp. 72, 162, 163 (2 illus.).

The Drawing Center. [Exhibition catalog.] *Sculptors' Drawings over Six Centuries: 1400-1950.* Introduction by Colin Eisler. New York: Agrinde Publications, 1981 (2 illus.).

*Gardner, Paul. "Confessions of a Plantain Chip Eater; or, Artists Are Just Like the Rest of Us." *Art News* (New York), vol. 80 (Jan. 1981), p. 138 (1 illus.).

Kingsley, April. [Exhibition catalog.] *The New Spiritualism: Transcendent Images in Painting and Sculpture.* New York: Oscarsson Hood Gallery, 1981 (1 illus.).

Kirshner, Judith Russi. [Exhibition review, Renaissance Society at the University of Chicago.] *Artforum* (New York), vol. 20 (Nov. 1981), p. 88 (1 illus.).

Larson, Kay. "Louise Bourgeois: Her Re-emergence Feels Like a Discovery." *Art News* (New York), vol. 80 (May 1981), p. 77 (3 illus.).

Lippard, Lucy R. "The Blind Leading the Blind." *Bulletin of the Detroit Institute of the Arts,* vol. 59 (1981), pp. 24-29 (7 illus.).

Marandel, J. Patrice. "Louise Bourgeois: From the Inside." In [exhibition catalog] *Louise Bourgeois: Femme Maison.* Chicago:

The Renaissance Society at The University of Chicago, 1981 (6 illus.).

*Miller, Lynn F., and Swenson, Sally S. "Louise Bourgeois." In *Lives and Works: Talks with Women Artists.* Metuchen, N.J., and London: The Scarecrow Press, 1981, pp. 2-14 (2 illus.).

Ratcliff, Carter, "Louise Bourgeois at Max Hutchinson and Xavier Fourcade." *Art in America* (New York), vol. 69 (Feb. 1981), p. 145 (1 illus.).

Selz, Peter. *Art in Our Times: A Pictorial History 1890-1980.* New York: Harcourt Brace Jovanovich, and Abrams, 1981, p. 540 (1 illus.).

1982

Ashton, Dore. *American Art since 1945.* New York: Oxford University Press, 1982, pp. 57-59 (2 illus.).

CDS Gallery. *Artists Choose Artists.* New York: 1982 (1 illus.).

[Engravings from *He Disappeared into Complete Silence.*] *Harvard Advocate* (Cambridge, Mass.), vol. 65 (Summer 1982), pp. 17-36 (9 illus.).

Pincus-Witten, Robert. "Bourgeois Truth." In (exhibition catalog) *Recent Work.* New York: Robert Miller Gallery, 1982. Forthcoming.

Rubinstein, Charlotte S. *American Women Artists: From the Indian to the Present.* Forthcoming.

LIST OF PLATES

Dating of Bourgeois's work was arrived at through discussions with the artist, study of individual photographs and installation shots, and examination of the exhibition history, literature, and other archival materials. In certain cases, a spanning date was the closest approximation possible. Parentheses around the date indicate that it does not appear on the work itself. Measurements are given in the order of height, width, and depth. For most vertical pieces, only the height is given, although in some instances height and diameter are indicated. In a few instances, an alternate title appears in parentheses; in those cases, the work was initially exhibited under the first title and is presently known by the second. All other alternate titles appear in parentheses at the end of the entries.

Pl. 1. Figures. (ca. 1947–mid-1950s). Painted wood, each ca. 66″ high (167 cm). Private collection, New York. Installation, 1979

Pl. 2. The Blind Leading the Blind. (ca. 1947–49). Painted wood, 67⅛ x 64⅜ x 16¼″ (170.5 x 163.5 x 41.3 cm). Private collection, New York. See also pl. 64

Pl. 3. The Destruction of the Father. (1974). Latex, latex over plaster, and mixed media, ca. 9 x 11 x 9′ (274.5 x 335.5 x 274.5 cm). Private collection, New York. (The Evening Meal). See also pls. 133–35

Pl. 4. Femme-Maison '81 (Woman House '81). (1981). Marble, 48⅛ x 47 x 49⅞″ (122.2 x 119.4 x 126.7 cm). Private collection, New York. See also pls. 121, 122

Pl. 5. Connecticutiana. (ca. 1944–45). Oil on wood, 11 x 42″ (28.0 x 106.7 cm). Private collection, New York

Pl. 6. Natural History. (ca. 1944). Oil on canvas, 12 x 18″ (30.5 x 45.7 cm). Private collection, New York

Pl. 7. Reparation. (ca. 1938–40). Oil on linen, 44 x 26″ (111.8 x 66.1 cm). Private collection, New York

Pl. 8. Mr. Follet. (ca. 1944–45). Oil on canvas, 12 x 18″ (30.5 x 45.7 cm). Private collection, New York

Pl. 9. Femme-Maison (Woman House). (ca. 1946–47). Ink on linen, 36 x 14″ (91.4 x 35.6 cm). Collection Ella M. Foshay, New York

Pl. 10. Femme-Maison (Woman House). (ca. 1946–47). Oil and ink on linen, 36 x 14″ (91.4 x 35.6 cm). Collection John D. Kahlbetzer, Santa Barbara, California

Pl. 11. Femme-Maison (Woman House). (ca. 1946–47). Oil and ink on linen, 36 x 14″ (91.4 x 35.6 cm). The Grenoble Collection of Mr. and Mrs. Eugene P. Gorman, New York

Pl. 12. Femme-Maison (Woman House). (ca. 1946–47). Oil and ink on linen, 36 x 14″ (91.4 x 35.6 cm). Collection John D. Kahlbetzer, Santa Barbara, California

Pl. 13. Fallen Woman. (ca. 1946–47). Oil on linen, 14 x 36″ (91.4 x 35.6 cm). Collection John D. Kahlbetzer, Santa Barbara, California

Pl. 14. Untitled. (ca. 1946–47). Oil on linen, 36 x 14″ (91.4 x 35.6 cm). Private collection, New York

Pl. 15. Red Room. (ca. 1947–48). Oil on linen, 36 x 14″ (91.4 x 35.6 cm). Private collection, New York

Pl. 16. Abstract Figure. 1947. Oil on linen, 32 x 24″ (81.3 x 61.0 cm). Private collection, Westport, Connecticut

Pl. 17. Untitled. (ca. 1947–48). Oil on canvas, 32″ x 8'1″ (81.3 x 246.3 cm). Private collection, New York

Pl. 18. Untitled. (ca. 1946–47). Oil on wood, 14 x 36″ (35.6 x 91.4 cm). Private collection, New York

Pl. 19. Untitled. (ca. 1946–47). Oil on canvas, 11 x 32″ (28.0 x 81.3 cm). Private collection, New York

Pl. 20. Untitled. (ca. 1946–47). Oil on linen, 27 x 45″ (68.6 x 114.3 cm). Private collection, New York

Pl. 21. Roof Song. (ca. 1947). Oil on linen, 21 x 31″ (53.3 x 78.7 cm). The Grenoble Collection of Mr. and Mrs. Eugene P. Gorman, New York. (Woman on Roof)

Pl. 22. Drawings on studio wall, 1951. In most cases, India ink on paper

Pl. 23. Untitled. (ca. 1948–51). Ink on paper, 14¼ x 22½″ (36.2 x 57.2 cm). Private collection, New York

Pl. 24. Untitled. (ca. 1953). Ink on paper, 22 x 14″ (55.9 x 35.6 cm). Private collection, New York

Pl. 25. Untitled. (ca. 1950). Ink and collage on paper, 24 x 30″ (61.0 x 76.2 cm). Private collection, New York

Pl. 26. Untitled. (ca. 1948–51). Ink and charcoal on paper, 19¾ x 12¾″ (50.2 x 32.4 cm). Private collection, New York

Pl. 27. Untitled. 1953. Ink on paper, 22½ x 14″ (57.2 x 35.6 cm). Private collection, New York

Pl. 28. Untitled. (ca. 1968). Colored inks and charcoal on paper, 19¼ x 25″ (48.9 x 63.5 cm). The Metropolitan Museum of Art, New York, Purchase, 1982

Pls. 29–37. He Disappeared into Complete Silence. 1947. Text and engravings, each double-page spread, 10 x 14″ (25.4 x 35.6 cm). The Museum of Modern Art, New York, Gift of the Junior Council, 1968

Pl. 38. Country house, Easton, Connecticut, ca. 1947–49

Pl. 39. Spring. (ca. 1949–50). Bronze (cast ca. 1959), 60″ high (152.4 cm). Private collection, New York

Pl. 40. Solo exhibition, Peridot Gallery, New York, 1949

Pl. 41. Solo exhibition, Peridot Gallery, New York, 1949

Pl. 42. Solo exhibition, Peridot Gallery, New York, 1950

Pl. 43. Solo exhibition, Peridot Gallery, New York, 1950

Pl. 44. Observer. (ca. 1947–49). Painted wood, 6'4½″ high (194.2 cm). Private collection, New York

Pl. 45. Portrait of C.Y. (ca. 1947–49). Painted wood with nails, 66¾″ high (169.5 cm). Private collection, New York

Pl. 46. Dagger Child. (ca. 1947–49). Painted wood, 6'3⅝″ high (192.0 cm). Private collection, New York

Pl. 47. Bourgeois's studio, 1950s

Pl. 48. Portrait of Jean-Louis. (ca. 1947–49). Painted wood, 35″ high (89.0 cm). Private collection, New York

Pl. 49. Sleeping Figure. 1950. Wood, 6'2½″ high (189.2 cm). The Museum of Modern Art, New York, Katharine Cornell Fund, 1951

Pl. 50. Woman in the Shape of a Shuttle. (ca. 1947–49). Painted wood, ca. 65″ high (165.1 cm). Private collection, New York

Pl. 51. Pillar. (ca. 1947–49). Painted wood, 61½″ high (156.2 cm). Private collection, New York

Pl. 52. Pregnant Woman. (ca. 1947–49). Painted wood with plaster, 52″ high (132.0 cm). Private collection, New York

Pl. 53. Spoon Woman. (ca. 1949–50). Painted wood, ca. 6'3″ high (190.5 cm). Private collection, New York

Pl. 54. Pillar. (ca. 1949–50). Painted wood, 69″ high (175.3 cm). Private collection, New York

Pl. 55. Persistent Antagonism. (ca. 1949–50). Painted wood, 67⅞″ high (172.5 cm). Private collection, New York

Pl. 56. Breasted Woman. (ca. 1949–50). Painted wood, 54″ high (137.2 cm). Private collection, New York

Pl. 57. Pillar. (ca. 1949–50). Painted wood, 64⅜″ high (163.5 cm). Private collection, New York

Pl. 58. Solo exhibition, Xavier Fourcade, Inc., New York, 1979

Pl. 59. Solo exhibition, Xavier Fourcade, Inc., New York, 1979

Pl. 60. Brother and Sister. (Late 1940s–early 1950s). Stained wood, 69″ high (175.3 cm). Private collection, New York

Pl. 61. Quarantania, I. (1947–53; reassembled 1981). Painted wood on wood base, 6'9¼″ high (206.4 cm). The Museum of Modern Art, New York, Gift of Ruth Stephan Franklin, 1969

Pl. 62. The Listening One. (ca. 1947–49). Bronze (cast 1981), 6'8″ high (203.1 cm). American Medical Association, Washington, D.C.

Pl. 63. Forêt (Night Garden). (1953). Painted wood, 37 x 18⅞ x 14¾″ (94.0 x 48.0 x 37.5 cm). Greenville County Museum of Art, Greenville, South Carolina, Gift of Arnold H. Maremont, 1973. (Black Garden, Garden at Night, Garden in the Night)

Pl. 64. The Blind Leading the Blind. (ca. 1947–49). Painted wood, 67⅛ x 64⅜ x 16¼″ (170.5 x 163.5 x 41.3 cm). Private collection, New York. See also pl. 2

Pl. 65. Untitled. (ca. 1948–51). Ink on paper, 14 x 11'' (35.6 x 28.0 cm). Private collection, New York

Pl. 66. One and Others. (1955). Painted wood, 18¼ x 20 x 16¾'' (46.4 x 50.4 x 42.6 cm). Whitney Museum of American Art, New York

Pl. 67. Memling Dawn. (ca. 1951). Painted wood, 67¼'' high (170.5 cm). Private collection, New York

Pl. 68. Femme Volage (Fickle Woman). (Early–mid-1950s). Painted wood, 6'⅜'' high (183.5 cm). Private collection, New York

Pl. 69. Bourgeois's studio, 1960s

Pl. 70. Spiral Women. (Early–mid-1950s). Painted wood and plaster, ca. 60'' high (152.4 cm). Private collection, New York. (Trilogy)

Pl. 71. Figure. (ca. 1950s–1980s). Painted wood, 65¼'' high (165.7 cm). Private collection, New York

Pl. 72. Figures. (ca. 1950s–1980s). Painted wood, 6'1'' high (185.5 cm). Private collection, New York

Pl. 73. Still Life. (ca. 1960–62). Plaster and wood, 11½ x 19⅛ x 18⅛'' (29.2 x 48.6 x 46.1 cm). Museum of Art, Rhode Island School of Design, Providence

Pl. 74. Etretat. (1960). Self-hardening clay, 10 x 7¼ x 5¾'' (25.4 x 18.4 x 14.6 cm). Private collection, New York. (Summer Sixty No. 4)

Pl. 75. Lair. (ca. 1962–63). Plaster, 18⅛ x 29½ x 23½'' (46.0 x 74.7 x 59.7 cm). Private collection, New York

Pl. 76. Spiral/Summer. (1960). Plaster, ca. 14 x 21'' (35.6 x 53.3 cm). Private collection, New York. (Summer Sixty No. 1)

Pl. 77. Homage to Bernini. (ca. 1967). Bronze, 21½ x 20 x 23'' (54.6 x 50.8 x 58.4 cm). Private collection, New York

Pl. 78. Rondeau for L. (1963). Plaster, ca. 11 x 11 x 10½'' (28.0 x 28.0 x 26.7 cm). Private collection, New York

Pl. 79. The Quartered One. (ca. 1964–65). Plaster, 62¼ x 24 x 20'' (158.1 x 61.0 x 51.0 cm). Private collection, New York. (Lair No. II)

Pl. 80. Untitled. 1953. Ink on paper, 22 x 14'' (55.9 x 35.6 cm). Private collection, New York

Pl. 81. Fée Couturière (Fairy Dressmaker). (ca. 1963). Plaster, 39½'' high x 22½'' diam. (100.4 x 57.1 cm). Private collection, New York. (Hanging Lair, Lair #2, Lair No. III)

Pl. 82. Torso/Self-Portrait. (ca. 1963–64). Plaster, 24¾ x 16 x 7⅛'' (62.9 x 40.7 x 18.2 cm). Private collection, New York

Pl. 83. Labyrinthine Tower. (ca. 1962). Plaster, 18'' high (45.7 cm). Private collection, New York. (Tower and Labyrinth)

Pl. 84. Amoeba. (ca. 1963–65). Plaster, 36 x 29¾ x 12'' (91.5 x 75.6 x 30.5 cm). Private collection, New York. (Pregnancy, Double Negative)

Pl. 85. Solo exhibition, Stable Gallery, New York, 1964

Pl. 86. Solo exhibition, Stable Gallery, New York, 1964

Pl. 87. Germinal. 1967. Marble, 5⅝ x 7⅜ x 6¼'' (14.1 x 18.7 x 15.7 cm). Private collection, New York. (Hands, Partial Figure, The Hand)

Pl. 88. Unconscious Landscape. (1967). Bronze (cast 1968), 12 x 22 x 24'' (30.5 x 55.9 x 60.1 cm). Private collection, New York

Pl. 89. End of Softness. 1967. Bronze, 7 x 20⅜ x 15¼'' (17.7 x 51.8 x 38.8 cm). Private collection, New York

Pl. 90. Portrait. (1963). Latex, 15⅜ x 12⅜ x 4⅛'' (39.1 x 31.4 x 10.5 cm). Collection Arthur Drexler, New York

Pl. 91. Soft Landscape, I. (1967). Plastic, 6¾ x 19¾ x 17¼'' (17.2 x 50.2 x 43.8 cm). Private collection, New York. (Topology)

Pl. 92. Soft Landscape, II. (1967). Alabaster, 6⅞ x 14⅝ x 9⅝'' (17.5 x 37.2 x 24.5 cm). Private collection, New York. (Topology)

Pl. 93. Untitled. (ca. 1948–51). Ink on paper, 9½ x 15'' (24.2 x 38.1 cm). Private collection, New York

Pl. 94. Rabbit. (ca. 1970). Bronze, 22½ x 11 x 6'' (57.1 x 28.0 x 15.3 cm). Private collection, New York. (Home in Him/Home in You, Mudd Club Piece)

Pl. 95. Janus Fleuri (Janus Blossoming). (ca. 1968). Bronze, 10⅛ x 12½ x 8⅜'' (25.7 x 31.8 x 21.2 cm). Private collection, New York. (Innards, Hung Piece)

Pl. 96. Hanging Janus. (ca. 1968–71). Bronze, 10¾ x 21¼ x 6¾'' (27.3 x 54.0 x 17.2 cm). Private collection, New York

Pl. 97. Untitled. (ca. 1970–72). Bronze, tallest: 6¼'' high x 3⅜'' diam. (15.5 x 8.6 cm). Private collection, New York

Pl. 98. Trani Episode. (ca. 1971–72). Hydrocal and latex, 16½ x 23⅛ x 23¼'' (42.0 x 58.7 x 59.0 cm). Private collection, New York

Pl. 99. Point of Contact. (ca. 1967–68). Bronze, 5½ x 10¼ x 3½'' (14.0 x 26.1 x 9.0 cm). The Metropolitan Museum of Art, New York, Gift of Ruth S. Franklin, 1973

Pl. 100. Molotov Cocktail. (1968). Bronze, 4½ x 8 x 4¼'' (11.4 x 20.3 x 10.8 cm). Private collection, New York

Pl. 101. Heart. (ca. 1970). Bronze, 8½ x 8 x 12'' (21.6 x 20.3 x 30.5 cm). Private collection, New York

Pl. 102. Figure Voile (Sail Figure). (ca. 1950). Ink on paper, 9¾ x 12¾'' (24.8 x 32.4 cm). Private collection, New York

Pl. 103. Figure. (1960). Plaster, 15⅛ x 8⅛ x 6⅛'' (38.5 x 20.6 x 15.6 cm). Private collection, New York

Pl. 104. Figure, back view

Pl. 105. Untitled. (ca. 1968–69). Self-gardening clay, 12 x 5 x 3'' (30.5 x 12.7 x 7.6 cm). Private collection, New York

Pl. 106. Harmless Woman. (ca. 1969). Bronze, 11⅛ x 4½ x 4½'' (28.3 x 11.5 x 11.5 cm). Private collection, New York

Pl. 107. Fillette. (1968). Latex, 23½ x 10½ x 9¾'' (59.7 x 26.7 x 24.9 cm). Private collection, New York. (Presence)

Pl. 108. Fragile Goddess. (ca. 1970). Self-hardening clay, 10¼ x 5⅝ x 5⅜'' (26.0 x 14.3 x 13.6 cm). Private collection, New York

Pl. 109. Femme Couteau (Knife Woman). (ca. 1969–70). Marble, 26'' long (56.1 cm). Collection Jerry and Emily Spiegel, Kings Point, New York

Pl. 110. Femme Couteau '81 (Knife Woman '81). (1981). Marble, 5 x 24 x 5⅜'' (12.7 x 61.0 x 13.6 cm). Private collection, New York

Pl. 111. Femme Pieu (Stake Woman). (ca. 1970). Wax and metal pins, 3½ x 2½ x 6'' (8.9 x 6.4 x 15.3 cm). Collection Lucy R. Lippard, New York

Pl. 112. Untitled. (ca. 1970). Marble, 4½'' high x 3⅛'' diam. (11.5 x 7.9 cm). Private collection, New York

Pl. 113. Cumul, I. (1969). Marble, 22⅜ x 50 x 48'' (57.0 x 127.0 122.0 cm). Musée National d'Art Moderne, Centre Georges Pompidou, Paris

Pl. 114. Cumuls. (1970). Sepia and charcoal on paper, 25½ x 39½'' (64.8 x 100.4 cm). Private collection, New York. (Hills.)

Pl. 115. Cumul, III/Avenza. 1969. Marble, 23½ x 42½ x 39''(59.7 x 108.0 x 99.1 cm). Private collection, New York. Installed at Sam's Creek, Bridgehampton, Long Island

Pl. 116. Eyes. (ca. 1972). Marble, 44 x 36 x 36'' (111.8 x 91.5 x 91.5 cm). Private collection, New York

Pl. 117. Sleep, II. 1967. Marble, 23⅜ x 30¼ x 23¾'' (59.3 x 77.0 x 60.5 cm). Private collection, New York

Pl. 118. Avenza Revisited. (ca. 1972). Plaster and cement, 23½'' high x 41'' diam. (45.7 x 104.1 cm). Private collection, New York

Pl. 119. Colonnata. 1968. Marble, 23 x 32¾ x 27¼'' (58.5 x 83.3 x 69.2 cm). Private collection, New York

Pl. 120. Clamart. 1968. Marble, 31 x 24 x 27'' (78.7 x 61.0 x 68.6 cm). Collection Mr. and Mrs. Oscar Kolin, New York. (Echo)

Pl. 121. Femme-Maison '81 (Woman House '81), side and back views. (1981). Marble, 48⅛ x 47 x 49⅞'' (122.2 x 119.4 x 126.7 cm). Private collection, New York. See also pls. 4, 122

Pl. 122. Femme-Maison '81, front and side views. See also pls. 4, 121

Pl. 123. Baroque. (ca. 1970). Marble, 37¼ x 25¼ x 25⅞'' (94.6 x 64.1 x 65.7 cm). Private collection, New York. (Angry Woman, Giallo Siena Baroque, Hostile Woman, Irate Creature, Woman)

Pl. 124. Baroque, back view

Pl. 125. Eye to Eye. (ca. 1970). Marble, 31½'' high x 29⅞'' diam. (80.0 x 75.7 cm). Private collection, New York. (Point of Contact)

Pl. 126. Solo exhibition, Xavier Fourcade, Inc., New York, 1980

Pl. 127. Solo exhibition, 112 Greene Street Gallery, New York, 1974

Pl. 128. *Number Seventy-two (The No March),* detail. (1972). Marble, 10'' x 17' x 10' (25.4 x 518.5 x 305.0 cm). Storm King Art Center, Mountainville, New York, Purchased with the Aid of Funds from the National Endowment for the Arts. *(The Marchers).* See also pls. 131, 132

Pl. 129. *Fountain.* (ca. 1971). Marble, 11⅛ x 49⅛ x 32¾'' (28.2 x 124.8 x 83.0 cm). Private collection, New York

Pl. 130. *Facets to the Sun,* detail. (1978). Steel with granite base, ca. 10' wide x 8' deep (305.0 x 244.0 cm). Norris Cotton Federal Building, Manchester, New Hampshire. *(Radar)*

Pl. 131. *Number Seventy-two (The No March),* installed at the Whitney Museum of American Art, New York, 1973. See also pls. 128, 132

Pl. 132. *Number Seventy-two (The No March),* installed at the Storm King Art Center, Mountainville, New York. See also pls. 128, 131

Pl. 133. *The Destruction of the Father.* (1974). Latex, latex over plaster, and mixed media, ca. 9 x 11 x 9' (274.5 x 335.5 x 274.5 cm). Private collection, New York. *(The Evening Meal).* See also pls. 3, 134, 135

Pl. 134. *The Quartered Ones* (elements from *The Destruction of the Father).* (1974). Latex over plaster, each 17¾ x 8½ x 2¾'' (45.1 x 21.6 x 7.0 cm). See also pls. 133, 135

Pl. 135. Installation of *The Destruction of the Father* in Bourgeois's studio, 1975. See also pls. 133, 134

Pl. 136. Untitled. (1948–51). Ink on paper, 12¾ x 6¾'' (32.4 x 17.2 cm). Private collection, New York

Pl. 137. *Confrontation.* (1978). Painted wood, latex, and fabric, ca. 37' long x 20' wide (1128.5 x 610.0 cm). Private collection, New York

Pl. 138. *Confrontation* in preparation

Pl. 139–43. The performance "A Banquet/ A Fashion Show of Body Parts," October 21,

1978, Hamilton Gallery of Contemporary Art, New York. Photographs by Peter Moore

Pl. 144. Untitled. (ca. 1947). Ink on paper, 12 x 9½'' (30.5 x 24.2 cm). Private collection, New York

Pl. 145. *Maisons Fragiles* (Fragile Houses)/*Empty Houses.* (1978). Steel, 7 and 6' high (213.5 and 183.0 cm). Private collection, New York

Pl. 146. *Structure, III/Three Floors.* (1978). Painted wood and steel, 6'2'' x 45'' x 31'' (188.0 x 114.3 x 78.8 cm). Private collection, New York. *(Triangles)*

Pl. 147. *Structure, IV/Boat House.* (1978). Painted wood and steel, 71 x 48 x 25'' (180.4 x 122.0 x 63.5 cm). Private collection, New York. *(Triangles)*

Pl. 148. Entrance gate to Bourgeois's Brooklyn loft, 1982

Pl. 149. Untitled. (ca. 1950). Ink on paper, 11 x 14'' (28.0 x 35.6 cm). Private collection, New York

Pl. 150. *Partial Recall,* detail. (1979). Painted wood, ca. 9' x 7'6'' x 66'' (274.5 x 228.8 x 167.8 cm). Private collection, New York. *(Couples)*

Pl. 151. *Partial Recall,* detail

Pl. 152. Untitled. 1953. Charcoal and ink on paper, 40 x 12½'' (101.6 x 31.7 cm). Collection Helen Herrick and Milton Brutten, Philadelphia. *(Family Gathering)*

Pl. 153. *"Fences Are Obsolete."* Wood and metal stripping. Backyard of 20th Street residence, 1977

SOURCE NOTES FOR QUOTATIONS IN PLATES

Cited below are the original sources for quotations from Louise Bourgeois that appear in the Plates.

Page 35 Statement, in *The Private Myth: An Exhibition and Statements* (exhibition catalog), Tanager Gallery, New York, 1961, n.p.

Page 43 Taped interview, July 2, 1979.

Page 51 Taped interview, July 11, 1981.

Page 55 Statement, in Belle Krasne, "10 Artists in the Margin," *Design Quarterly* (Minneapolis), no. 30 (1954), p. 18.

Page 60 Statement, in Marsha Pels, "Louise Bourgeois: A Search for Gravity," *Art Inter-*

national (Lugano), vol. 23 (Oct. 1979), p. 51.

Page 67 Interview, Jan. 19, 1980.

Page 69 Taped interview, July 11, 1981.

Page 72 Taped interview, Oct. 14, 1981.

Page 75 Taped interview, Oct. 14, 1981.

Page 79 Taped interview, Oct. 14, 1981.

Page 80 Statement, in Eleanor Munro, "Louise Bourgeois," *Originals: American Women Artists* (New York: Simon & Schuster, 1979), pp. 165–66.

Page 84 Taped interview, Oct. 14, 1981.

Page 92 Interview, Nov. 28, 1978.

Page 95 Munro, p. 167.

Page 100 Interview, July, 1981.

PHOTOGRAPH CREDITS

Courtesy the artist Pls. 22, 38, 47; figs. 1, 2, 3, 4, 5, 6, 7, 8, 9, 10, 12 (Collection Jerry Gorovoy), 13, 14, 15, 16

Bessi, Carrara, Italy Pls. 77, 94, 101, 116, 123, 124, 129; fig. 18

Allen Brandt, New York Fig. 22

Brassai, Paris Fig. 11

Paul Brown, New York Pls. 126, 150

Rudolph Burkhardt, New York Pls. 52, 73, 74, 75, 76, 78, 83, 85, 86, 103, 104

Milly Burns, Courtesy CDS Gallery Fig. 26

Geoffrey Clements, New York Pl. 66

Mary Beth Edelson, New York Fig. 21

eeva-inkeri, New York Cover; pls. 1, 137, 138

eeva-inkeri, Courtesy Robert Miller Gallery, New York Pls. 17, 19, 23, 26, 28, 39, 65, 93, 102, 136, 144, 149

Allan Finkelman, Courtesy Robert Miller Gallery, New York Pls. 4, 21, 44, 45, 46, 62, 71, 72, 92, 109, 148; fig. 27; p. 124

Jerry Gorovoy, New York Fig. 24

Donald Greenhaus, Courtesy Max Hutchinson Gallery, New York Pls. 5, 7, 9, 10, 11, 12, 13, 14, 15, 20, 24, 25, 80

Bruce C. Jones, New York Pls. 16, 50, 51, 53, 54, 55, 56, 57, 58, 59, 60, 145, 146, 147, 151

Kate Keller, The Museum of Modern Art, New York Pls. 29, 30, 31, 32, 33, 34, 35, 36, 37

M. Knoedler and Co., New York Pl. 100

Lisa Little, New York Pl. 131

Babette Mangolte, New York Pl. 127

Robert Mapplethorpe, New York Frontispiece

Helaine Messer, New York Pls. 119, 125

Duane Michals, New York, Courtesy *Vogue,* Copyright © 1980 by The Condé Nast Publications Inc. Back cover

Peter Moore, New York Pp. 1, 12; pls. 2, 3, 48, 64, 69, 70, 79, 81, 82, 84, 87, 88, 89, 90, 91, 95, 96, 97, 98, 99, 105, 106, 107, 110, 112, 113, 118, 120, 121, 122, 128, 133, 135, 139, 140, 141, 142, 143, 153

Hans Namuth, New York Pls. 115, 117

Holly O'Grady, New York Pp. 2, 3

Mali Olatunji, The Museum of Modern Art, New York Pl. 61

Max Raymer, New York Pls. 6, 8, 18, 27, 152

Jeremiah Russell, New York Pls. 40, 41, 63, 67, 68

Bill Schmidt, New York Fig. 25

Lenore Seroka, New York Fig. 20

Mark Setteducati, New York Pls. 130, 134

David Sher, New York Pl. 108

Charles Simonds, New York Pl. 111

Aaron Siskind, New York Pls. 42, 43

R. D. Smith, New Haven, Connecticut Fig. 19

Storm King Art Center, Mountainville, New York Pl. 132

Soichi Sunami, The Museum of Modern Art, New York Pl. 49

Unknown P. 10; pl. 114; figs. 17, 23

Overleaf. Brooklyn studio, August 1982